DANTE'S PURGATORIO

DANTE'S PURGATORIO

Illustrated by Sandow Birk
Text adapted by Sandow Birk and Marcus Sanders
Preface by Marcia Tanner
Introduction by Michael F. Meister, FSC, PhD

CHRONICLE BOOKS
SAN FRANCISCO

Library of Congress Cataloging-in-Publication Data available.

ISBN 0-8118-4719-5

Manufactured in China

Design by Alissar Rayes

Distributed in Canada by Raincoast Books
9050 Shaughnessy Street
Vancouver, British Columbia V6P 6E5

10 9 8 7 6 5 4 3 2 1

Chronicle Books LLC
85 Second Street
San Francisco, California 94105

www.chroniclebooks.com

CONTENTS

PREFACE

Sandow Birk's Commedia Urbana

Believe me, I know I'm not the first to clumsily clatter onto the superstructure of the Divine Comedy *or the last. Fer sure.*
— Gary Panter, *Jimbo in Inferno*[1]

The mind is its own place, and in it self
Can make a Heav'n of Hell, a Hell of Heav'n.
— Satan speaking, in John Milton's *Paradise Lost*[2]

I. Where in Hell Is Purgatory?

In his *Divine Comedy*, Dante Alighieri locates Purgatory—the steep, wedding-cake-tiered mountain that leads to Heaven—at the exact antipodes of the city of Jerusalem. That would place it geographically midway between the southwest and southeast Pacific Oceans, east of Australia, west of the southernmost tip of South America, and just a little north of the Antarctic, directly above the undersea mountain range of the Albatross Cordillera. It's a never-never land as far as earthly human habitation is concerned.

Sandow Birk, however, finds Dante's Purgatory pretty much where he found Hell and where he is likely to find Heaven too: in the inner cities, suburbs, strip malls, freeway exits and underpasses, neighborhoods, and downtown business districts of contemporary urban USA, with side trips to places like Bali and Tokyo for visual and spiritual relief. The settings in Birk's illustrations for the *Divine Comedy*—his three-volume version of Dante's medieval Catholic geography of the afterlife, inspired by the nineteenth-century engravings of Gustave Doré—often look a lot like urban California, where Birk lives: Los Angeles and San Francisco especially.

In his *Divine Comedy* as in previous projects, Birk reenvisages the antique, infusing it with currency. Characteristically, his work appropriates art-historical materials, reinterpreting and updating them with contemporary urban references, imagery, and idioms to create satirical commentaries on American culture and society. He responds to Dante's epic poem and Doré's illustrations by reinventing these monumental works of art, mutating them in ways that make them more accessible to a contemporary audience while drawing new meanings from them.

His "translation" of the text, which Birk coauthored with Marcus Sanders in collo-quial American speech, is compelling, fun to read, and faithful to Dante's narrative.[3] The rendering is true to the poet's intentions as well, since Dante wrote in vernac-ular Italian rather than in Latin—then the preferred language of scholars and poets—so that ordinary people could read his work. Like Dante, Birk and Sanders introduce contemporary public figures as characters, meting out appropriate pun-ishments and rewards. They fold historic information that would usually appear in footnotes into the text itself. They retool Dante's extended similes, using imagery contemporary readers can relate to, and these gritty, witty analogies are among their most vivid and original passages. But they don't pretend it is a definitive text.

"We have no presumption that our version is as scholarly or poetic as existing translations," Birk says. "We're not Dante scholars in any sense, and we always imagined that no one would read only our version. Rather, we want people to read Dante and *also* our version."[4]

Neither Birk nor Sanders is religious, but they aim to represent Dante's convic-tions accurately without falsifying their own more secular—if no less ethical and spiritual—perspectives on the world. How to negotiate this delicate terrain?

Birk's illustrations, riffing on Doré's, take on that challenge.

Doré's landscapes are grand, theatrical, and wild: looming, gloomy, awe-inspiring nowheres embodying Romantic notions of raw Nature as the sublime architecture of God. "What strikes us at first glance in Gustave Doré's illustrations for Dante," commented the nineteenth-century French poet, novelist, and critic Théophile Gautier, "are the surroundings in which the scenes that he draws take place and which have no relation to the appearance of the mundane world."[5]

Birk's desolate cityscapes and vignettes of urban detritus entirely resemble "the appearance of the mundane world"—maybe a little too closely for comfort. Although they adhere to Doré's graphic quality and compositions, and retain that dark Victorian atmosphere, they are set in an altogether different universe. They depict the *Divine Comedy* as a secular, urban, terrestrial human odyssey. In Birk's drawings, all the action happens right here, right now, among us living in the twenty-first century, not in some otherworldly afterlife. As "illustrations" of Dante's often wildly unorthodox fourteenth-century Catholic saga, they sustain a paradoxical, subversive dialogue with the narrative.

"Doré's goal, and strength, to me, is that he took this dreamy poem and depicted it in concrete settings, making the 'vision' of Hell and Purgatory imaginable as real places that one could go to and walk around," Birk observes. "Dante's poem does

that too, but Doré really created the visual idea of what the place would look like. Now that he's done that, I don't have to. I can spin off his 'accurate' depictions and make my own comments on the world."[6]

Birk's license extends to his representations of characters. Doré, true to the original poem, depicts Dante the pilgrim and his spirit guide Virgil as outsiders, strangers in strange lands. His Dante is based on contemporary portraits of the poet; his Virgil is a generically handsome classical bard, robed and crowned with laurel. Birk's Dante, by contrast, is a nondescript, down-and-out white guy, an urban American Everyman, while his Virgil resembles an aging homeless vagabond who's seen better days. Far from alien to their surroundings, they blend right in.

By placing all the action in the world we've made, Birk's drawings reinforce a reading of Dante's epic poem as an extended allegory of urban life as we know it. Birk's Purgatory occupies more upscale real estate than his Hell, but they are in the same world. Like other gated communities, Purgatory fosters anxious striving *and* optimism in its inhabitants, who are assured they will live in bliss forever once they rack up enough suffering to purge themselves of sin. It's a place where the Proud are bent double under the weight of their own extravagant possessions (major appliances in this case; see illustration for Canto XI). Souls in Purgatory are perfectible, but they need to do a lot of work on themselves. They're the privileged ones, upwardly mobile on Hope Hill: a no-pain-no-gain tough-love retreat for redeemable sinners that demands rigorous penitential exercises; offers sing-alongs and extravagant entertainments; is inhabited, like Hell, by people we know as well as ghosts from the past; boasts an exemplary art collection and the ultimate public park, the Garden of Eden; and is staffed by angels, not demons, as personal trainers. It's a land of *Schadenfreude*, strengthened by prayer and sweetened by a sense of entitlement.

Birk's *Purgatorio* drawings, like those for *Inferno*, comment mordantly on the ways in which a culture's built environment mirrors back its values, especially the ways it values human life. *We* create these brutal, chaotic, careless, consumption-driven, soulless spaces—or at least let them happen—and people live, suffer, strive, and die in them. These mean streets are places of the damaged heart. They tell us who we are. They also *make* us who we are. Birk's scenes may be funny—anachronistic, dense with incongruous juxtapositions—but they're based on accurate observation, and they stab the viewer with unwelcome truths. "You know . . . when you watch the news and there's a gang shooting and there's a guy lying in the street, and next to him it says, '99-Cent Tacos,'" Birk says. "I didn't make that up."[7]

If the spiritual exists in life, this is where we'll find it, these drawings suggest. Either it's everywhere, or it's nowhere. Heaven only knows what Birk's *Paradiso* will look like.

II. Two Steps Forward, One Step Back.

Dante's *Divina Commedia* is an extraordinary work of the imagination: a master-piece that laid the foundations for Italian literature and is a cornerstone of the European literary tradition. It is an epic poem divided into three weighty "canticles": *Inferno* (Hell), *Purgatorio* (Purgatory), and *Paradiso* (Heaven). Each of these contains thirty-plus cantos (chapters), totaling one hundred overall. They are composed of thousands of lines of *terza rima*, an intricate, beautiful rhyme scheme Dante invented that mimics the gait of a hesitant yet resolute pilgrim: two steps forward, one step back. His verses offer such vivid representations of Hell, Purgatory, and Heaven that seven centuries later his descriptions still define those domains in Western conscious-ness, whether one believes in them literally or not.

Like all great works of literature, the *Commedia* can be read on many levels. As a testament to his religious faith, it is Dante's fully imagined map of medieval Catholic cosmology and doctrine. As a historical document, it's his often-scandalous com-mentary on the culture, politics, society, and personalities of Italy in his time. It is also his account of a personal journey toward enlightenment: the *Bildungsroman* of a poetic genius, in which Dante progresses from aimlessness and despair to a recognition of his vocation and the focus of his life's work. Birk's drawings suggest yet another layer of interpretation: the *Comedy* as a hallucinatory journey in which "a trippy Dante [is] walking around dazed in his own world, having a big dream or 'vision' of going to the afterlife, imagining things. . . . He mistakes the bums for visionaries, the ranting shopping-cart guys for ancient poets, the helicopters for dragons."[8]

Divina Commedia is a precise title, not just because it has a happy ending but also because it's funny. Dante personally assigns figures from biblical and classical antiquity and many of his contemporaries to their just rewards. He invents deli-ciously malicious, nasty, and ingenious punishments for those he deems sinners. Dante also slyly redeems characters the Church has damned and vice versa. And he heretically creates places, like Pre-Purgatory and the Gate to Purgatory (Cantos I–IX), which were not part of Catholic doctrine. Both Dante and Virgil commit social gaffes and breaches of etiquette throughout their trip. There are moments of slapstick. A secular modern reader might be tempted to interpret Dante's *Comedy* as a social/political satire in the guise of a religious tract.

Sandow Birk is one in a long, continuing line of writers and visual artists who have been inspired by Dante's great poem. Boccaccio's *Decameron*, Chaucer's *Canterbury Tales*, and James Joyce's *Finnegans Wake* are among the literary works that reference it directly, and it has echoed and interwoven itself into the writings of countless fiction writers and poets as well as every form of popular culture since it first appeared. Dante inherited a literary tradition himself, from which he

borrowed freely. His work reflects the influences of many authors, including St. Thomas Aquinas, Aristotle, Horace, Statius, Ovid, Juvenal, and of course Virgil, author of the *Aeneid*. Virgil in turn channeled Homer, who invented the extended similes Birk and Sanders have so much fun rewiring.

Many visual artists, too, have been moved to make images inspired by Dante's poem, and even to illuminate the entire work. Sandro Botticelli, William Blake, Salvador Dalí, Leonard Baskin, Robert Rauschenberg, and more recently Marcel Dzama are among the latter. But even the nineteenth-century French artist Gustave Doré (1832–1883)—whose illustrations for the *Divine Comedy* have defined the physical reality of Dante's Hell, Purgatory, and Heaven for contemporary readers—published his work with translations made by others.

Birk's *Divine Comedy* may be the first "translation" in which the same artist produced both texts and drawings, conceiving and creating them together as an integrated, complementary whole.[9] It is also possibly the first to embody a critique of Dante's religious views while simultaneously honoring his genius and the contemporary relevance of his moral distinctions and political observations. It is probably the first to build on Dante's sense of humor and sociopolitical satire, and the result is a complex, provocative, multilayered work, rich with internal contradictions, profound ironies, and contemporary resonance.

III. A Victorian Trojan Horse.

Like his earlier projects, Birk's drawings for the *Divine Comedy* are representational, satirical, and critical of contemporary society.[10] Their antecedents can be traced to at least as far back as the eighteenth-century English caricaturist William Hogarth and his nineteenth-century French counterpart Honoré Daumier. Both those artists parodied "high art" to comment savagely on the low life they saw around them. Birk's work has roots in twentieth-century American social realism as well, when 1930s artists supported by the Works Progress Administration (WPA)—such as Ben Shahn, Jack Levine, Philip Guston, Jacob Lawrence, and William Gropper—made art a medium for social protest, in the interests of social reform.

Although that tradition has run unabated and concurrently with mainstream art—as in the 1960s, with the powerful agitprop art generated by the California farmworkers' movement, and with contemporary artists such as Robert Colescott, Masami Teraoka, Kara Walker, and Jean Lowe, whose work is also based on historical precedents—it has been devalued until recently. But desperate times call for desperate measures. Social realism with satirical art history references is making a comeback now, along with a resurgence of interest in drawing, cartooning, and illustration.

Birk is an equal-opportunity art bandit. Like Dante's, his sources are many and eclectic. Everything nourishes his imagination, including underground comics, graphic novels, and Hollywood feature films that place Shakespeare's plays in contemporary settings. In his Dante project, Birk's mastery of style and technique visibly evolves as he continues drawing in the new (to him) medium of ink on Mylar, which encourages experiments with dazzling effects of light and dark and has freed his imagination even more than usual. In Canto XIX of *Purgatorio*, for instance, he shows Dante and his entourage at the Alitalia gate at San Francisco Airport, waiting for their flight to Florence. His Garden of Eden is set in the San Francisco strip club of the same name.

Birk's *Divine Comedy* is, as someone close to the project described it, "a Victorian Trojan horse."[11] Or, it's like a finely wrought, gem-encrusted Fabergé egg that, when opened, explodes gently in your face.

—Independent curator, art critic, and writer MARCIA TANNER seeks transcendence in the same mean streets that Sandow Birk depicts

1. Gary B. Panter, "A Ridiculous Mis Recounting of Dante Alighieri's Immortal *Inferno* in Which *Jimbo*, Led by Valise, in Pursuit of the SoulPinx, Enters Focky Bocky, Vast Gloomrock Mallscape," *Jimbo* Number Seven. 1996 Gary Panter, Los Angeles, Zongo Comics, 1997 Bongo Entertainment, Inc.

2. John Milton, *Paradise Lost*, Book I, ll. 246–47.

3. It is not, strictly speaking, a translation, since neither Birk nor Sanders reads Italian. They worked from several different English translations and one in Portuguese, which Birk does read, and made no attempt to reproduce Dante's rhyme scheme.

4. Sandow Birk, in an email to Marcia Tanner, August 15, 2003.

5. *Moniteur Universel*, July 30, 1861, in "Publisher's Note," *The Doré Illustrations for Dante's Divine Comedy*. New York, Dover, 1976, p. v.

6. Sandow Birk, in an email to Marcia Tanner, August 28, 2003.

7. Richard E. Cheverton, "L.A.'s 'Inferno'," *Los Angeles Times Magazine*, February 16, 2003, p. 18.

8. Sandow Birk, in an email to Marcia Tanner, August 16, 2003.

9. Gary Panter's *Jimbo in Purgatory* is a surreal reworking of Dante's *Purgatorio* in comic book form, with original drawings and densely allusive text. Gary B. Panter, *Jimbo in Purgatory*. 2001 Gary Panter, Seattle, Washington, Fantagraphics Press, 2003.

10. *In Smog and Thunder: Historical Works from the Great War of the Californias* was Birk's epic project (1996–2002) documenting a fictional civil war between northern and southern California, in which he created paintings, drawings, propaganda posters, and models. A more recent body of work is a series of paintings of all the state prisons in California in the styles of various classic painters of California landscapes, such as Albert Bierstadt and Thomas Moran.

11. David Salgado, master printer and cofounder of Trillium Press, with a nod to Doug Harvey's essay "Sandow Birk's Fast-Food Inferno," *Dante's Inferno*. Brisbane, California, Trillium Press, 2003, p. iv.

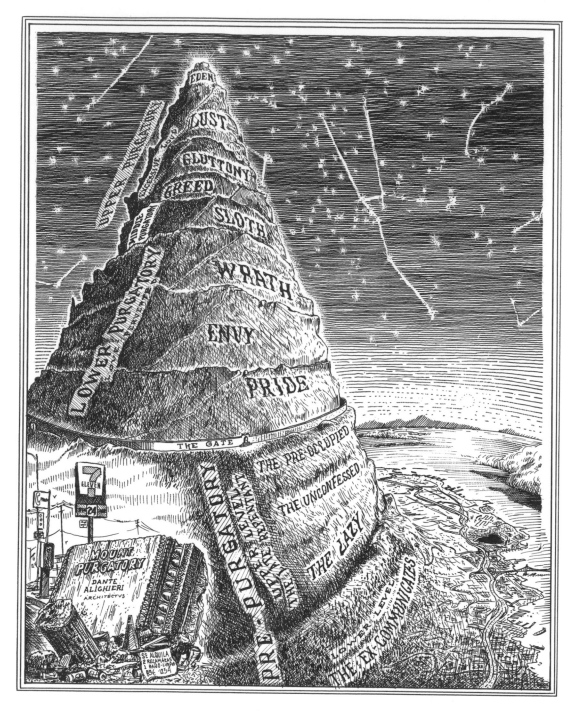

CANTO XXIII, 125—127: THE MAP OF PURGATORY:
This circular mountain
that makes you fix whatever you broke
in your life.

INTRODUCTION

The church's curse is not the final word,
for Everlasting Love may still return,
if hope reveals the slightest hint of green.

—PURGATORIO, CANTO III, 133FF

Inasmuch as the *Inferno* is a tale of woe and despair, Dante's *Purgatorio* is a story of hope. While the *Inferno* may be tantalizing because of its lurid descriptions, the *Purgatorio* appeals to us because it is the place where we feel most at home. More than the *Inferno* or the *Paradiso*, the *Purgatorio* is a reflection of where we often find ourselves as still-living human beings.

The inhabitants of Dante's Hell are damned forever, without hope of reprieve, without a moment of peace. Theirs is a world of numbing darkness, of shrieking and torment, of blood and excrement, of devils and other hideous creatures. Souls in Heaven triumph in joy and peace at the unending experience of the Beatific Vision. In Purgatory, however, the souls are still working out their salvation—much as we in life struggle toward peace, toward goodness, toward what we know to be the best in our nature, though we often fall far short of the goal. But there is hope: even at the last minute of life, there is hope. And this is what Dante celebrates in this second canticle of his immortal poem the *Divine Comedy*.

This is also the second canticle of Birk and Sanders's contemporary rendering. Like their recent *Inferno*, this *Purgatorio* brings Dante to present-day readers with a fresh artistic style by means of a wonderful confluence of pens: one for drawing and one for writing. The visual breadth of Birk's illustrations continues to breathe life into Dante's epic creation, and the lively wording of Sanders and Birk's text enables it to address us where we live. The result is a superb contemporary experience of Dante and his vision of the second realm of the afterlife. And in order to better understand this second realm, let us briefly explore how Dante would have us understand it.

THE DOCTRINE OF PURGATORY.

The Christian doctrine of Purgatory has one of its most striking antecedents in the famed military hero of Jewish history, Judas Maccabeus (see 2 Maccabees 12:42–46). After a battle, he sent an enormous sum of money to the Temple in Jerusalem as an offering on behalf of those who had fallen. This act would have

been foolish if belief in the resurrection were not current at the time, as well as the belief that the living could, in some way, atone for and assist those who had died on the way to their eternal reward.

In the New Testament, Matthew 12:32 and I Corinthians 3:11–15 are often used to support the concept of Purgatory as well, and throughout Christian history there is ample thinking on Purgatory among the Fathers of the Church and other theologians, not to mention more formal enunciation by the Church at the Second Council of Lyons (1274), the Council of Florence (1438–1445), and the Council of Trent (1545–1563).

But what is the *idea* of Purgatory? First of all, it is temporary—not eternal. Purgatory is a place or a condition wherein a soul that is not entirely free of sin at death or not completely repentant is purged, purified, and made worthy to enter Heaven and fully enjoy the rewards of everlasting joy. From its earliest times, the Church has always honored the dead with remembrances, prayers, good works, and especially the Liturgy, believing that these have a wholesome effect, particularly on those in Purgatory.

While the image of fire has frequently been associated with Purgatory—"purging" is often associated with burning—the Church has never specifically defined what the purging involves. It may well be that souls there suffer the pain of loss, because being deprived of the Beatific Vision for a specific time is itself worse than fire. Regardless, the soul in Purgatory, now freed by death from the shackles of human nature and its frailties (sin), can look forward to the fullness of God's presence once its time there is completed.

Next to the long-accepted tradition of Purgatory in the Church, there was a parallel tradition to be found in numerous visions, legends, and stories that accumulated over time. In the Middle Ages, Dante would have known of these—as would most ordinary Christians. For medieval Christians, Purgatory was of such significance to believers that it ranked high among other significant doctrines and religious practices that affected their ordinary daily lives.

DANTE'S PURGATORY.

If Dante's Hell is a place of eternal hate, fueled by insidious pride, his Purgatory is a place where love and humility guide the souls there to the quickest completion of their penance and full reunion with God. In striking contrast to the *Inferno*, the *Purgatorio* is a place where the sky in all its glory—day and night—is visible.

Purgatory is suffused with music and chanting, where prayers and verses of Scripture act as sweet goads to the suffering penitents. Here dramatic examples of art are part of the path the sinners walk. Angels are the chief ministers of this realm, and its very geography is uplifting. When a sinner is ready to see God in the face, the entire mountain shakes with joy as all the souls sing out, *"Gloria in excelsis Deo!"*

Unlike the *Inferno*, Dante's Purgatory is a place of fellowship, of unity, of sharing. And because Purgatory is a temporary state, the sinners "practice" these virtues because they are precursors of what is to come in Heaven. Like Hell, though, the *Purgatorio* maintains its significance as the locus for Dante's journey of redemption. It is a progressive unfolding of the moral map he and Virgil traveled together as pilgrims far below.

At the beginning of the *Inferno*, recall, Dante sought to extricate himself from the moral wilderness of his life by climbing a sunlit mountain. But he was driven downward by three beasts who typified, perhaps, the sins he needed most to face. It may well be that that mountain was the Mount of Purgatory, but he was not fully ready for its ascent.

And so, Virgil appeared and accompanied him on a journey downward—for his own good—because his soul was burdened with such cowardice that he was turned from the noble enterprise of his own salvation and frightened like a savage beast.

In Virgil, Dante saw his better self and followed his old mentor through to the very bottom of Hell to Satan himself. In his state of moral weakness he often fainted or wept at what he experienced. But these curatives also initiated Dante into the healing of his own soul. Not by coincidence, then, do the two poets emerge from Hell onto the shores of Purgatory at dawn on Easter morning. The greatest feast of the Christian Church—the solemn celebration of Redemption—becomes the new dawn of Dante's salvation.

As in the *Inferno*, so in the *Purgatorio*: Dante is "bodily" present. His physicality is at times a curiosity and at other times a fright to the souls he encounters. Unlike Hell, Dante's Purgatory is a place of light, and his body casts a shadow that blocks the light. This bodily presence is not merely a feature of his poetic imagination— it is the assurance of reality in the poem, the certainty of Dante's participation in what he sees and experiences, and the evidence of our presence as readers and fellow travelers.

The Geography of Dante's Purgatory.

Having traveled through the horrors of Hell with his guide, Virgil, Dante continues his journey through Purgatory. But *where* is Purgatory? Dante situates it, poetically and geographically, between the *Inferno* and the *Paradiso*. Purgatory is the next logical stage in the sequence of his journey, and to understand this "place" better, one needs to visualize Dante's geography and his mythology.

In his geography, the Earth was a globe. According to the cosmography of the times, the Northern Hemisphere contained mostly the landmasses of the then-known world, and the Southern Hemisphere was thought to be mostly water and uninhabited. At the top of the globe sat the city of Jerusalem. For Christians, its significance was obvious as the most holy of places on Earth. If one drew a line across the middle of the globe in Dante's day, the far west of the known world was the Straits of Gibraltar and at the far east lay the Ganges River.

Dante conceived of Hell as a vast, cone-shaped cavity that opened under Jerusalem and funneled down toward the center of the Earth. Purgatory was a mountain peak, a kind of mirror image of the infernal cone.

In Canto XXVI of the *Inferno*, we had a subtle glimpse of that peak as Ulysses described his final fatal voyage to Dante. He told Dante that a mountain appeared to them after they had sailed for months into the Southern Hemisphere of water, but not until now, in the *Purgatorio* itself, do we come to understand fully what that mountain was.

In Dante's geography, this was the only landmass left in the Southern Hemisphere. While his story about Satan's fall and the creation of Hell and Purgatory are part of his poetic mythology, he also had a Scriptural basis for his creation in both Testaments. As Dante reworked the material, then, the Southern Hemisphere was originally landed and contained the Garden of Paradise, while the Northern Hemisphere was covered by water. In an unparalleled cataclysmic event, Lucifer fell into the Southern Hemisphere and down to the core of the Earth, where he was stopped. The land of that hemisphere recoiled in horror and covered itself with water, raising other landmasses as it did so. All of these—with the exception of the Earthly Paradise—then moved into the Northern Hemisphere of water. At the same time, the water of that hemisphere moved south, surrounding the Mountain of Purgatory (topped with the Earthly Paradise) that had been created out of the Earth that rushed up from the place of Lucifer's fall. Thus, Dante shaped the Earth to accommodate both his *Inferno* and his *Purgatorio*.

The Structure of Dante's Purgatory.

The *Commedia* comprises one hundred cantos, thirty-three in each of the three canticles and one as an introduction to the entire poem at the beginning of the *Inferno*. In the thirty-three cantos of the *Purgatorio*, Dante takes us to the very top of this extraordinary mountain and, as in the *Inferno*, he introduces us along the way to its inhabitants and their stories, he explains its geography, and he describes in detail the punishments of the sinners that are being purged there.

Dante's Mountain of Purgatory is divided into three parts, each with separate levels or progressions. Beyond the waves at the shore begins the Ante-Purgatory with its two levels. On the first level are the souls of those who were still under the penalty of excommunication at the time of their death. Their entrance into Purgatory proper is delayed because they delayed their earthly repentance or died without benefit of the Last Sacraments. On the next level of Ante-Purgatory are several groups of negligent souls: those who were careless or indifferent about their religious and spiritual obligations and waited till death was upon them; those who had not confessed their sins and died suddenly without the benefit of the Last Sacraments; and those who were so taken up with the affairs of the world that they neglected to attend to the life of the spirit until late in their lives.

The second zone of Purgatory is the largest and rises in seven terraces beyond a great wall separating it from Ante-Purgatory. This is Purgatory proper, and each level is devoted to the purging of one of the seven deadly sins. As Dante is admitted through the Gate of Purgatory, a guardian angel carves seven *P*'s (Latin for *peccatum*, "sin") into his forehead—one for each of the deadly sins purged within: Pride, Envy, Anger (Wrath), Sloth, Greed, Gluttony, and Lust. He is enjoined to see that each mark is removed as he passes from level to level, thus indicating his own participation in this purgative journey.

As in the *Inferno*, there are divisions and levels specific to particular sins and their punishment, and the *contrapasso* (Dante's representation of punishment fitting the crime) is still very much in evidence: the negligent sinners in Ante-Purgatory wait—sometimes for centuries—for their passage through the Gate. In Purgatory proper, the proud are bent over carrying great stones, the envious have their eyes stitched shut with iron thread, the angry suffer in a smoky blindness, the lazy run constantly, the greedy and the prodigal lie with their faces in the dust (we learn here that opposite sins are punished together), the gluttons starve, and the lustful walk in flames.

Among the many curious features about the mountain, several are noteworthy. One can climb it only in the daytime, for example. At night, one's will to climb is utterly powerless. Secondly, the mountain is not subject to the various meteorological conditions experienced on the Earth below. Third, when a soul is released from its purgation, the mountain shakes and the air is filled with the chants of the *Gloria in excelsis*. And finally, in spite of the steep and precipitous climb from level to level, as Dante ascends higher and higher, his arduous climb becomes almost effortless.

At the top of the Mountain is the third zone of Dante's *Purgatorio*, the Earthly Paradise. The approach to it is separated from the seven terraces below by a wall of flame that purges those on the seventh level from the sins of lust. Here in the Garden of Eden, vacant since the sin of Adam and Eve, are beauties of nature such as Dante has never seen. Two rivers flow through this Paradise: the first is the River Lethe, which washes away all memory of sin and evil; farther on, crossing through the River Eunoë, one's memory of all the good one ever did is restored. Only after passing through these two rivers is a soul finally purged and ready to ascend into Paradise.

DANTE'S THEOLOGY.

According to Dante, the literal subject of the *Commedia* is the state of the soul after death. Allegorically, the poem is about humankind, our freedom of will, and the justice of our rewards or punishments according to how we have lived. The entire poem, but especially the *Purgatorio*, is motivated by love and charity. Beatrice loved Dante so deeply that she set the entire *Commedia* in motion in order to save him. Bringing the doctrine of Purgatory to bear on his poem, and because Purgatory was for the sinners there a "final step" toward Heaven, Dante makes this love its ultimate motivating force. In his view, the seven deadly sins purged there are each representative of an errant love. Pride, Envy, and Anger are various perversions of genuine love. Sloth is love without its zeal. And Greed, Gluttony, and Lust are excessive loves for unworthy objects.

As a whole, the poem can be read as a story about the moral and religious conversion of Dante. As the central character and narrator of the poem, Dante represents all of us—not just in that he stands for us as an alter ego, but in that he actually carries our interests and concerns in the face of all he experiences.

The punishments Dante witnesses are always restorative. As he constructs each scene for us, he supports it (and the sinners) on either side with "goads" and "curbs" designed from Scripture texts (particularly the Beatitudes), allusions to classical literature, and classical figures good and bad. In addition, these checks on the sinners' progress can be sculpted in stone, chanted, in visions, or in shouted exclamations. From all of these, the sinners "learn."

Alongside the driving force of love, the *Purgatorio* is suffused with a sense of hope. Because the purgation there is temporary, Heaven is always assured, and the sinners humbly endure their torments knowing what awaits them. Divine justice mandates this place, but—even at the end of an otherwise wicked life—hardened sinners who appeal at the bar of divine mercy are spared an eternity of damnation. In the *Inferno*, Dante directly faced the reality of God's immutable justice. But in the *Purgatorio*, he is utterly consumed by God's generosity, and he celebrates this with every step he climbs until he comes at last to behold that generosity personified in Beatrice.

BEATRICE THE CONFESSOR.

A discussion of the *Purgatorio* is incomplete without some consideration of Beatrice. She was the angel of Dante's poetic inspiration, and perhaps her greatest gift to humanity was to inspire his *Commedia*. The *Inferno* and the *Purgatorio* are, among other things, a confession by Dante that he was a desperate, weakened sinner, and nowhere—in such an epic fashion—do we encounter an act of contrition to parallel this one in magnitude and significance.

Dante endows the penultimate scenes of the *Purgatorio* with a growing sense of anticipation—forcing himself, perhaps, to realize what is at stake—and then leads us to the final outpouring of his need for genuine repentance in his encounter with Beatrice. The seventh and last terrace of Purgatory is where the sins of lust are purged, and the *contrapasso* is a wall of flames through which the sinners must pass. The only thing that pushes Dante through the flames is the idea of seeing Beatrice.

After Virgil finally leaves Dante to "become a lord of himself," Dante wanders through the Terrestrial Paradise without his guide and witnesses its mystic pageant of great beauty and glory filled with allegorical meaning. A Griffin at the center of the pageant draws a magnificent chariot, and Beatrice is riding in the car.

From across the river, the still-veiled Beatrice calls Dante by name—the first time his name is used in the poem. She tells him not to weep for he will soon have to weep from a deeper wound. Commanding him to look at her she sharply rebukes him for not having discovered sooner that true happiness is to be found above, not in the world below. He suffers deep shame at her reproaches and feels a terrible guilt.

Addressing Dante directly, she commands him to speak and agree to the truth of what she spoke. Furthermore, she tells him that he must now seal his agreement with confession. Nothing else will suffice.

Dante struggles to speak, but he can only cry. Beatrice is unrelenting, and she continues to interrogate him. In desperation, Dante sobbingly replies that he let himself be led astray by worldly pursuits when she was no longer alive to inspire him.

This begins to appease his harsh interrogator who tells him that had he said any-thing else, God Himself would have still known the truth. But when the sinner himself condemns his own sin, the mercy of God outweighs His justice. In words that Dante tells us were like venom itself, Beatrice then tells him to look her directly in the face. As he thinks about it, Dante now begins to feel remorse and hate for having loved things that substituted for Beatrice herself. He is so stunned by guilt that he faints.

When he awakens, Dante finds himself being drawn through the River Lethe in which all remembrance of sin is forgotten. His confession is complete, his guilt is washed away, his repentance is true. Now on the other side of the river, he is led to where the mystic pageant had stopped. Beatrice is standing in the chariot looking into the eyes of the Griffin, which signifies Christ. That her eyes are referred to as emeralds is not without significance, for green is the color of hope, and the entire *Purgatorio* is a celebration of hope. Only now does Beatrice unveil and reveal herself in her true glory to Dante, who has traveled so far to see her. Stunned by her true beauty, he can only stare and wonder who could possibly describe what he beholds.

When, at length, the mystic pageant is dispersed, Dante is led through the River Eunoë, where remembrance of all the good he has ever done is restored to him. Overcome by his desire to describe the ineffable taste of this last draft, but realizing that he has run out of space, the final "check" in his Purgatory is that he has reached the limit of his art. Reborn and renewed, he returns to Beatrice ready to ascend to the stars.

> *In the sanctuary where Religion "is married to immortal verse"*
> *stands Dante as high-priest,*
> *and consecrates all modern Art to its vocation.*

> —HENRY WADSWORTH LONGFELLOW
> ON DANTE'S *Divina Commedia* (QUOTING SCHELLING)

—MICHAEL F. MEISTER, FSC, PhD, Saint Mary's College of California

CANTO I

ARGUMENT

Finally free from the pits of Hell, Dante calls out to the muse Calliope to help him find the words to describe his eventful journey through Purgatory, the second realm of the Afterlife. Standing with Virgil in the early dawn he sees four stars above him and feels renewed. (These stars represent the Cardinal Virtues of Justice, Prudence, Temperance, and Fortitude.) An old man approaches and questions the two travelers as to how they managed to escape from the Underworld. The man is Cato of Utica. Virgil explains that Dante is a living man and that he has been sent to guide Dante through the Afterlife for the purpose of his salvation. Cato lets them pass, but tells Virgil to tie a reed around Dante's waist and wash away all of the stains and grime from Hell. The two descend to the beach as the sun rises, and stop to wash their faces in the dew. At the beach, Virgil plucks a reed from the ground and another one miraculously springs up in its place.

Now it's time for me to paddle this little canoe
of my keyboard toward calmer seas and leave the
swirling waters of Shit Creek behind. I'll do my best
to write about this second region, don't worry—it's
where the souls of the dead not condemned straight to 5
Hell are sent to purify themselves on their long climb
toward Heaven. I'm gonna reach deep down to raise my
rhymes up from the descriptions of Death and Hell in hopes
that I might do justice to Life and Honor and the Muses.
Hopefully my words'll flow at least as beautifully as Calliope's, 10
whose song rang out over Pierus's daughters when
she turned them into magpies for their insolence.

What a relief it was. We were finally free from
the oppressive darkness and miseries of Hell
that had depressed me for so long. I watched 15
as the east grew softly red with the dawn,
spreading its glow across the skies and filling
my eyes up with hope. Then, slowly, Venus,
the flickering source of all love, warmed from
red to yellow as she rose, outshining all of 20
the stars that followed behind her. It was beautiful.

Then I turned to my right and looked at the sky behind me.
There were the four stars no living man had seen since
Adam and Eve had been driven from the Garden of Eden.
The whole sky seemed to sparkle with their glow, and as I 25
stood gaping at them, it bummed me out to think that the
Northern Hemisphere would never be able to see them.

As I turned back to face the north—where the
stars of Ursa Major should have been, but
weren't visible from where we were standing—I saw 30
this old man coming toward me, all alone, with
an expression that commanded the kind of respect
a father deserves from his son. He had a
long beard and hair down past his shoulders,
with strands of gray running through it. 35

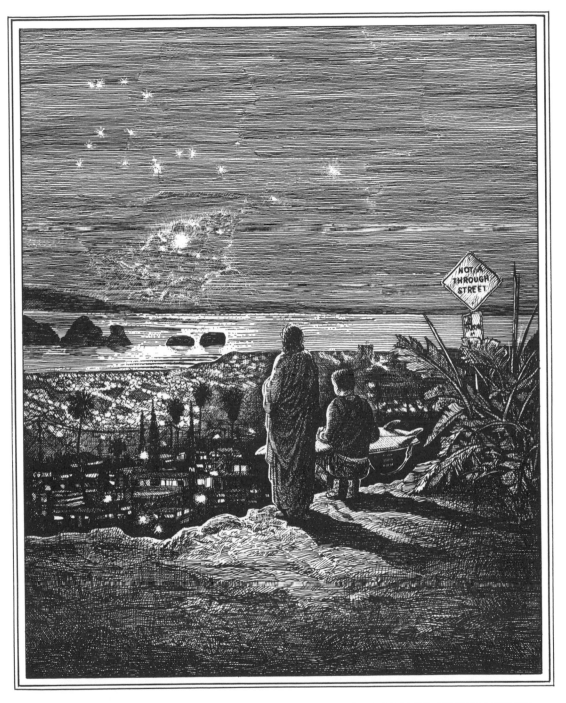

CANTO I, 13–15: ON THE SHORES OF PURGATORY:
*What a relief it was. We were finally free from
the oppressive darkness and miseries of Hell
that had depressed me for so long.*

As he came toward us, those beams of
fading light from the four stars fell across
his face and made it glow as warm
and bright as if it were lit by the sun.

"Who are you two?" he demanded, brushing back 40
his hair. "And how have you managed to follow that
stinking stream and escape from the pit of Hell?
What light did you use to make your way out of
that oppressive dark and eternal blackness?
Have all the rules of the Underworld been broken? 45
Has God Himself made some changes that
I don't know about that let even the Damned
like you find their way to my shores?"

Before I could say anything Virgil put his hand on
my shoulder and gave me a look that told me to show 50
respect. I fell slowly to my knees and bowed my head.

"I didn't come here on my own," Virgil answered.
"A woman straight from Paradise asked
me to be this man's guide. But since you
demand to know how we made it out of there, 55
I'll tell you, out of respect. You see, although this
man has made many mistakes in life and has squeaked
through many close calls, he's not quite dead—yet.
And there's still time for him to pull it together and
get back on the proper path. Like I said, that's why 60
I've been asked to guide him," he explained.

"The only way for him to be saved is by bringing
him on this trip. So far we've come through the
land of the Damned and now I want him to
see the sinners who are purging themselves 65
on this mountain. To tell you everything
that we've been through already would
take quite a long time. Suffice to say,
the power that has protected him and
brought him this far is Heaven-sent. 70

"He travels in search of freedom, and all
those who have died for it know how much
that can cost. You yourself sought the peace
of death for the sake of it back in Utica. In taking
your life there, you shook off a cloak which 75
will shine again on Judgment Day.

"The two of us haven't broken any of the laws of Heaven.
He's still living, and I don't come from the depths of
Minos's curses but from Limbo, where your wife,
Marcia, lives. She still talks about you and wishes 80
you'd take her back. For her sake, let us pass
through the Seven Terraces of this land and I will tell
her how you helped us out when I see her again.
That is, if you'll allow me to speak your name in Hell."

"Oh, man, my Marcia was so beautiful," Cato 85
sighed, remembering. "When we were together
I would have done just about anything for her.
But now she's down there and there's
nothing in Hell I can do for her, at least by
the laws of this Afterlife. But wait a second— 90
if you've really been sent on this journey
by a woman from Heaven, why are you
kissing my ass? Her word from up above
is good enough for anyone here. Around
the base of this island, where the waves 95
break along the beach, you'll find reeds growing
in the sand of the shore break. No Earthly plants
except those soft reeds can grow in such a
place, withstanding the relentlessly pounding surf.

"Take your little friend down there, pick out a 100
smooth reed, and tie it around his waist. Then,
wash his face clean of all that grime and filth that
built up in the Underworld. It wouldn't be right
for him to meet the ministers of Heaven with the
muck from Hell clouding his sight and his mind, right? 105

When you're all done and ready, I don't want to
see you come back this way. You'll see the right
path to climb as the sun rises higher, don't worry."

Suddenly he was gone. Just like that.
Slowly I got up from my knees and went 110
over to Virgil, looking at him for answers,
as usual. "Let's go," he said. "Follow me.
We'll follow along this field here and
make our way down to the beach."

By then the sky was almost clear. The last of 115
darkness was ebbing and in the distance I could
hear the dull thud of the surf. As we headed back
down the hill I had that helpless feeling like when
you've missed an exit on the freeway and every mile
past seems wasted until you get turned around. 120

Soon we came to a place in the shadows where
the mists and fogs of night hadn't yet been
dried by the morning sun. Virgil stopped and
put his palms in the dampness of the dew.
Since I knew what he was going to do I just 125
stood there in front of him with my eyes closed
while he cleaned my face off, scrubbing away
the dried tears and the grit and grime of Hell
until the color came back to my cheeks.

We walked on and finally came to the empty 130
beach and saw the sea which has never been
sailed by anyone who has lived to tell about it.
As per Cato's advice, Virgil pulled a reed
from the shore break and put it around my waist.
Miraculously, the second he plucked it, 135
a new reed sprang up in its place.

CANTO II

ARGUMENT

As the sun rises, Virgil and Dante stand on the shore wondering which path to take up the mountain of Purgatory. Dante sees a reddish light zipping toward them, which turns out to be an angel piloting a ship carrying the Redeemed who are singing the psalm "In exitu Israel de Aegypto." All the souls get off the boat and are confused about which way to go, so they ask Virgil and Dante for directions. Virgil tells the souls that they're pilgrims too, and then the souls realize that Dante's alive and stare at him in amazement. Dante sees an old friend among them, the musician Casella, and tries to hug his friend three times unsuccessfully— but Casella has no body. Dante asks him to sing and his song blows everyone away. Then Cato, the Just Old Man, comes along and yells at them all to stop lagging and start their journeys up the mountain.

The sun was just starting to peek up where
Virgil and I were standing. Meanwhile,
over in Jerusalem it was setting, and
by the Ganges River it would already
be near midnight. Fall was finally here 5
and the days were getting shorter.
We could see Aurora, goddess of the
dawn, with her pale cheeks turned all
golden in the warm and glowing light.

We stood on that beach, and as you can 10
probably imagine, we were stressing a little
about the road ahead of us. All of a
sudden I looked west and saw a glowing,
red light—at first glance I thought it might
be Mars burning through the morning fog. 15
It was moving faster than it seemed
possible for anything to move across
the water. "I'd like to see that again!"

I looked over at Virgil, all wide-eyed, and by the
time I looked back out to sea again, the light 20
was way bigger and glowing brighter than before.
There was this vague whiteness that seemed to be
sort of hanging on both sides of the light, and there
was another white glow coming from under it, too.
Virgil didn't say anything the whole time, 25
but as it got closer we could see that the lights
were actually wings, and when Virgil realized
who it was, he straightened up in a hurry.

"Get down on your knees!" he commanded me.
"You are about to see an angel of God. Put your palms 30
together, and start praying. You can bet we're
going to be seeing more like him around here.
See how he doesn't need our puny technology?
No oars, no sails, not even a two-stroke motor—
only his wings guide him from shore to shore. 35
And notice how they point straight up toward Heaven?

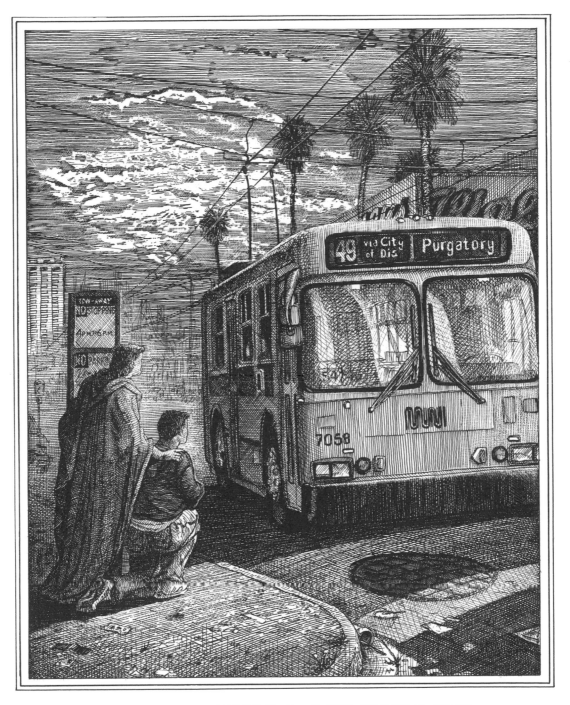

CANTO II, 39–41: THE CELESTIAL PILOT:

The angel came closer and closer, dazzling bright and shining brilliantly until I couldn't look at it anymore and I had to bow my head.

They brush through the air, all delicate wisps,
not like Earthly feathers found down below."

The angel came closer and closer, dazzling
bright and shining brilliantly until I couldn't 40
look at it anymore and I had to bow my head.
He came straight at the shore and his boat
went so fast and light over the waves that
it left no white-water trail or wake behind.

The Heavenly sailor stood at the bow of the boat with a 45
look of calm and bliss on his face. There must have been
more than a hundred souls on his craft, all thanking God
by chanting together *When Israel came out of Egypt.*
As they landed, the angel made the sign of the cross to
each of the spirits, and then they quickly climbed ashore. 50
As soon as they were off, the angel turned and sped away.

We watched the souls wander around a bit
on the beach. It seemed like they were pretty lost
and just checking everything out, trying to get a handle
on where they were and what was happening. 55

By now, the brightening sun's beams completely
hid the stars in Capricorn and daylight was
spreading across the sky. After a while, a soul looked
over at us and called out, "Hey! If you guys know
the way up the mountain, could you give us a hint?" 60

Virgil called back to them, "You seem to have the
misconception that we are somehow locals here;
but we're like you—merely pilgrims in this place.
We only just got here ourselves, right before you did.
But we came by a much tougher road, I'm sure. 65
Compared to it, this mountain will be a walk in the park."
Just then some of the souls realized I wasn't one of
them; I still breathed, and I was actually alive.
They all started freaking out like a crowd of reporters
at a press conference, yelling questions all at 70
once and elbowing each other out of the way.

Those souls of the Redeemed happily stared at
my face, so excited that they almost forgot the
journey they were about to make.

One of them came to the front of the crowd with 75
his arms spread out like he was going to hug me.
I didn't know who he was but he was so sincere,
I was moved and opened my arms. But the thing is,
even though he looked human he was just a ghost!
I tried three times to hug him and each time 80
I only got air and ended up hugging myself.
I must've looked pretty confused, 'cause
the guy was grinning as he backed away, even
as I kept trying to put my arms around him.

The soul smiled calmly and told me it was no use, 85
but as soon as I heard his voice I knew who he
was and charged forward to hug him again.

"I loved you back when I still had my body, and
even as a ghost I still care for you," Casella said.
"Of course I'm here for you, man. But what's up with you?" 90

"Oh, this is kind of a recon mission," I told my old friend
the musician. "I'm hoping I'll come back through this way
again sometime. But how come you're still down here?"

"Well, I can't really blame the boatman," he answered,
"even though he usually refused me, which kinda sucks. 95
He can choose his passengers however he wants 'cause
he's being guided by a higher power. But, man—for
the last few months it seems like the guy's been taking
every single soul across who wants to go! 'Cept me, that is.

"So I went down to the shore again and this time 100
he gave in, thankfully, and he let me board. Now
he's heading back toward Ostia, down near
Tiber's river mouth. That's where all the dead meet
to wait for the boats. Except for the ones sent
to wait down at the stinking Acheron, I mean." 105

"Well, hey," I said. "As long as there's no rules
that bar you from singing those beautiful love
songs of yours I used to like so much back in
the world, why don't you bust out a song for us,
for old time's sake? I could use it, 'cause I'm totally 110
wiped out after the long trip we've made so far."

"Love that speaks to me in my mind," was the
first line in that sweet song he sang then. It still
warms my heart when I think of it, even now.
Me and Virgil and all the other souls that showed 115
up with Casella were completely lost in happiness,
as if nothing else existed in the world but his song.

And while we stood around transfixed in the
music, all of a sudden there was a gruff yell.
"What in the heck is this, you lazy souls?" cried old Cato. 120
"Standing around like this is a total farce! You should
be running up that mountain to rid yourselves of those
Earthly sins that prevent you from seeing God!"

Try to picture a bunch of seagulls on the beach,
hanging around and picking away at some old 125
garbage and dead fish, oblivious to everything else.
But then some dog comes bounding along and
scares them and all at once they take off in
a huge flock, leaving their feast to rot in the sun.
That's what that flock of souls did, forgetting 130
their song and hurrying away up the
mountain toward who-knows-what.

And Virgil and I were just as quick to hoof it as they were.

CANTO III

ARGUMENT

Virgil is ashamed that they lingered so long to listen to music, but the two set off again and Dante gazes up to the heights of the mountain as it reaches toward Heaven. When he looks down he first sees only his own shadow and for a moment he's afraid that he has been abandoned. Virgil explains to Dante the nature of the souls in the Afterlife. As they talk they reach the base of the mountain, but find that it's too steep to climb. They notice a group of sinners moving along very slowly and ask them for guidance. These are the Excommunicates, and they are blown away at Dante's shadow. A soul named Manfred speaks to them and tells how he was excommunicated by the Church, but even so has been saved from Hell by repenting at the last moments of his life. Because he waited so long to repent, however, he now must spend thirty times as long here in Purgatory before ascending to Heaven. He explains that his wait can be shortened by the prayers of those still living.

At Cato's yell the crowd of souls took off running
across the field toward the mountain as if
the doors had just opened on a closeout sale.
But I hung back with old Virgil. After all,
where was I gonna go? Who was going to 5
help me out and lead me if not old Virg?

Virgil looked bummed out, like he was embarrassed
or ashamed about something. It's weird how one
little thing can make you feel guilty so suddenly,
out of nowhere. After a moment he shook it off, 10
whatever it was, and started walking again. I went
after him, quiet and pretty relieved. Following him
through the fields I let my mind wander as we
walked, thinking how great it had been to see
Casella again as I looked up at the mountain 15
reaching toward the clouds in front of us. The sun
was still rising behind us all red and beautiful
and its rays cast my shadow far in front of me.

Suddenly I had the sense that I was alone,
abandoned, and I spun around, confused, 20
because the only shadow I saw was mine.
But the rush passed in a second as I saw
that Virgil was right there beside me.

"What are you so nervous about?" he
asked calmly. "Did you think I'd leave you? 25
Don't let my lack of shadow upset you, dear son,"
he said. "Let me explain: my body is buried
in Naples, where it was moved after they
dug me up from my first grave in Brindisi.
It should be evening there about now. This body 30
of mine you see makes no shadow, sure,
but I can still feel the cold and the heat and still
suffer pain. Don't ask me why, that's just how it is.

"You'd go completely mad trying to figure out the Infinite,
the One Who is Three at Once, and His ways. Just 35
accept that there are things you'll never understand.

Think about it: if humans here knew everything, then
Mary would never have needed to have a son.

"Remember when you met Aristotle and Plato
and all the others back there in Limbo? You saw 40
the futility of their endless arguing and trying
to figure everything out, right? If they could have
been more accepting of the unknown, they'd be
suffering less now." Virgil was silent then, and I could
tell that he was thinking about what he'd just said. 45

As he was talking we came to the base of the
mountain. When we got to the rocky walls, we saw
that they were so steep there was no way to climb
them. The cliffs were so vertical that they made the
rocks of Yosemite or the coastline around Monaco 50
look as easy as a Stairmaster® to climb in comparison.

Even Virgil seemed confused. "How are we ever going
to find a place where this rock isn't so steep that
you'd need wings to get up it?" he asked out loud.

We stood there awhile, looking at those cliffs— 55
Virgil lost in thought, scratching his chin, me
looking for some way to climb them. I looked
to the left and saw a crowd in the distance coming
toward us, but they were shuffling along so
slowly it seemed like they were standing still. 60

"Hey, Virg," I said, interrupting his thoughts. "Maybe
those guys over there know how to get up this thing.
I mean, if you haven't already sorted something out yourself. . . ."

He looked up, relieved. "Well, they're not exactly sprinting,
are they? Let's go meet them or we'll be here forever 65
waiting. And let's hope they know something that we don't."

We were still a good distance away from
the crowd as we walked, when all of a sudden
they caught sight of us and the whole
gang of 'em stopped and pressed against 70

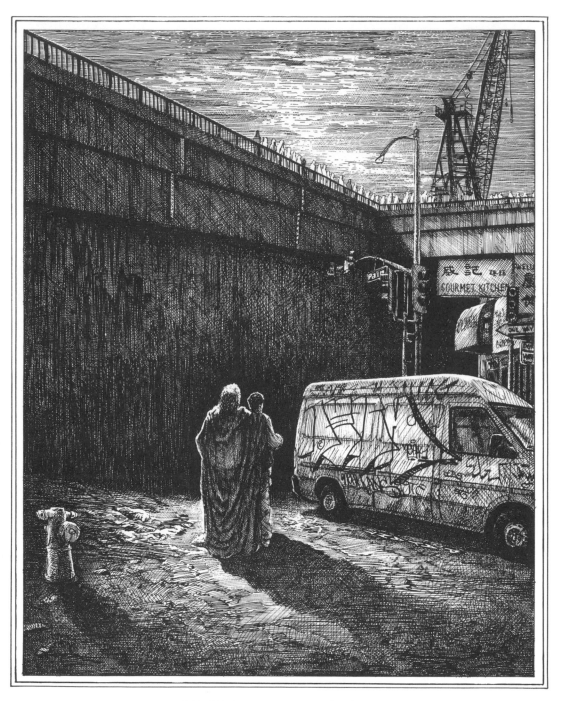

CANTO III, 47–49: AT THE FOOT OF THE MOUNTAIN:
*When we got to the rocky walls, we saw
that they were so steep there was no way to climb
them.*

the cliff, cowering and frozen as they
watched us coming toward them.

"Please excuse me, all you who chose the right
path at the end of your lives," Virgil called to them
as we came near. "In the name of the eternal 75
peace that you'll all one day attain: could you
please point us in the right direction? Where
can we begin to climb this mountain?"

You know how traffic jostles down city streets at the peak
of rush hour, with first one vehicle gunning ahead 80
and the others following along behind, erratically,
only to catch up again and bunch up together
at the next red light, and then for one to race
off again at the instant it turns green while
the others straggle along behind? The leaders of 85
that crowd started toward us warily, respectfully,
and the rest came along behind, less sure, but
drawn forward by the others. And when those
in front came close enough to see my shadow
stretched along the ground on my right, they 90
stopped and drew back slowly as the rest came
up and wavered, unsure as to what
had caused the delay in their advance.

"I know, I know," Virgil said to them, holding
up a hand. "Yes, the shadow you see is cast 95
by the body of a living man. But don't be
afraid. Think for a moment and you will
realize that there is no way he could
be here if Heaven did not want him to be."

The sinners mumbled among themselves, concerned and confused, 100
until they seemed to reach a consensus and began
waving us off. "Go! You lead the way!" they yelled back.

Virgil shrugged, and as we set off away from
that confused group, a voice rose above the
others. "Whoever you are, before you go, 105

stop and see if you might remember me!"
I stopped and looked hard at him:
blond hair, good-looking, with a scar
across one eyebrow. But I couldn't
quite place him and I told him so. 110

"Hang on a sec, check this out," he said,
smiling, and he pulled open his robe to
show me a ragged gash on his chest.
"I'm Manfred," he said confidently,
"the grandson of the empress Constance, 115
wife of Henry VI. Please, before you go, can
I ask you to visit my daughter if you return down to
the world below, and tell her that you've seen me here?
Tell her that in my last breaths, as I lay dying
by these two wounds, I accepted the 120
forgiveness of the Lord. My many sins
were horrible and cruel, but even so, mercy
awaits any who ask for it, just like they said.

"If the Archbishop of Cosenza could
grasp the words of the Book he would 125
never have dug up my body, even though
Pope Clement told him to. I would still be
resting now by the bridge crossing of Benevento,
rather than on the banks of the Verde River,
in the rain and wind, beyond the territory 130
of the Church where he threw me. Tell my
daughter that the curse of the Church can
be overcome through belief in Everlasting Love—
if there is even the slightest glimmer of hope.

"Even if one hates the Church in his very 135
heart, and yet repents at the end of his life,
he will end up here, wandering on
this island for thirty times as long as the
years he spent in denial. But even so, the
prayers of those down in the world below 140
can shorten that time before his eventual ascent."

CANTO IV

ARGUMENT

After they listen to Manfred's spiel, Virgil and Dante are finally shown a way up through the rock. It's an intense climb, and they have to scramble up using their hands and feet. By the time they reach a little ledge, Dante is so tired he has to stop and rest a bit. He's also confused by the fact that the sun is on their left, until Virgil gives him a lesson in Purgatory geography and explains that the mountain actually gets easier to climb as you get higher. Their whole conversation is overheard by Belacqua, an old acquaintance of Dante's, who makes a snide remark. Belacqua—along with everyone else on this level—belongs in the first class of the Late Repentant, the Indolent. They must wait outside Purgatory's gates for as many years as they put off repentance down on Earth. Then Belacqua reminds them that prayer on Earth can shorten their time here—but only if it comes from a pure heart.

Some people believe that our bodies can have
more than one soul, but they're tripping.
Think about it: when any one sense is stimulated
by either intense pleasure or intense pain,
our soul totally gives over to that one 5
sense, completely ignoring everything else.
That's when we can lose track of time;
when we're completely wrapped up
in something that captures our soul.
Our sense of time is completely different 10
from every other sense in our bodies,
because it's free while the others are physical.

Well, that's what happened to me. I was
so caught up in what Manfred was saying
that three hours had already passed since 15
sunrise. I had no idea it had gotten so late. Right
about then, as we walked along, all the souls said
in unison, "The gap you're looking for is right here."

There was a gap, sure, but it was so narrow
that a manhole cover would've completely 20
hidden it. You could've easily stepped
right past it without even noticing it at all.
But the two of us did our best to climb up through it,
alone, once we had left the group below.

I mean, sure, San Leo and Noli and Everest are 25
tough climbs, and so is Mount Bismantova,
but this was so steep you almost needed wings.
I'll tell you, it took everything I had to make it,
trusting in the way Virgil had guided me so far,
and the way he had given me hope and inspiration. 30
Squished in between the steep granite walls,
we clambered upward through the rocks without ropes
or pulleys, our arms and legs our only tools.

When we finally reached the end of that crack
we came to a little plateau above the high cliff. 35
"Well, Virg," I said, "where do we go now?"

"Do not waver," he said, looking at me kinda seriously.
"Keep climbing upward and stay next to me.
We need to find someone else who knows the way."

The top of the cliff was so high above us that 40
I could barely even see it, and it was so steep
that it loomed over me like a skyscraper.
It made me go weak in the knees. "Hey, Virgil,"
I said. "Try and keep an eye on me as we go, huh?
Unless you slow up a bit, I'll be lost from here on out." 45

He looked at me and then up at the rock. "All we
have to do is make it to there," he said, pointing
to a little ledge that circled the face of the mountain.

Virgil's words got me psyched up and I powered
on behind him, on hands and knees, clambering 50
until we finally reached the ledge and could chill a bit.

We both sat there, winded and resting, facing east,
looking down at all the way we'd come so far.
Sometimes a good look back is all you need to
keep you charging forward. I looked at the beach 55
way down below, then looked back up at the sky.
It was weird, but now I noticed that the sun was
on our left. Virgil saw me looking around and
he could tell that I was confused to see that ball
of flame passing between us and the north. 60

"Let me explain," he began. "If the constellation of
Gemini's twins, Castor and Pollux, were in cahoots
with the bright sun which shines over everything,
then you'd see the whole Zodiac spinning nearer
to the Bear constellations of the North Pole. 65
Unless the sun changed its path, that is.

"The best way to understand this, dear son,
is to think of this mountain as the exact opposite
of Jerusalem. And they are both aligned so that,
while each occupies the opposite hemisphere, 70
they share the same horizon. The sun's path—

which Apollo's son Phaeton couldn't hang on to—
had to circle up here on one side, while at the
same time circling on the other side over there.
If you think about it, it makes sense." 75

"I think it all kinda makes sense, now," I said.
"I think I'm finally starting to get a handle on
some of the stuff that's been confusing me so far.
What you're saying is that, of all the circles in Heaven,
the one in the middle (the equator, I think they call it, 80
which is always in between summer and winter)
is just as far north from where we are now as it is
south from where the Hebrews are, right? It's just
like you explained, but it took me a moment to
get it. But to change the subject—do you 85
have any idea or guess at how much farther we
have to climb? I can't even see the top of this thing."

"This particular mountain is not like any others,"
he chided. "It starts off very difficult to scale,
but the higher up you climb, the easier it gets; 90
to the point where, eventually, the slope's so
gradual and almost flat that the going feels about
as easy as floating downriver in an inner tube.
And when you arrive at the end of the road . . .
well, that's where you can finally rest. You can 95
believe what I say, and that's all I'm going to tell you."

He'd barely finished speaking when we heard
a voice interrupting from somewhere close by:
"But you'll probably wanna sit down before then!"
Both of us turned to where we thought it came 100
from and there was this giant rock just to our
left that we hadn't even noticed before. We got
up and walked over to it, and saw that behind it
there were a bunch of people sitting huddled
in the shade, all sprawled out and relaxing. 105
There was one guy who looked super-tired,
sitting there with his arms around his knees
and his head hung low between his legs.

DANTE'S PURGATORIO

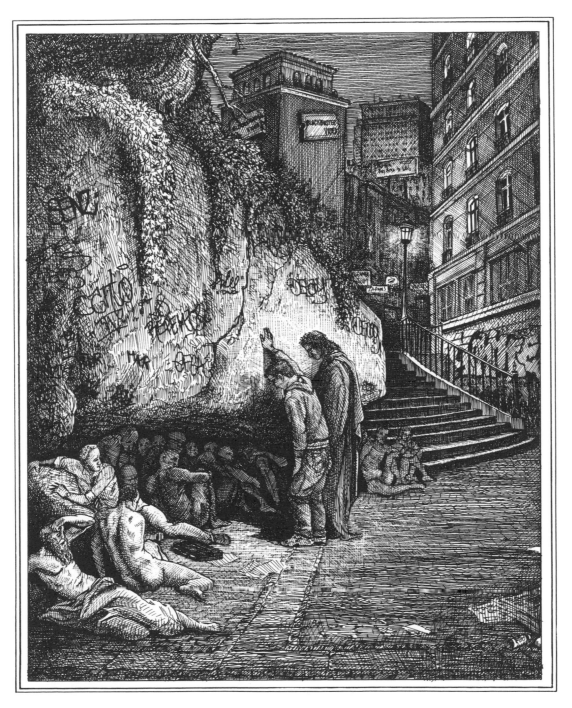

CANTO IV, 104–105: THE LAZY:
There were a bunch of people sitting huddled
in the shade, all sprawled out and relaxing.

"Check him out, Virg," I said, nodding toward him.
"See that guy? He couldn't look any lazier, 110
even if 'Lazy' was his middle name!"

The soul looked over at us and was barely able to lift his
face up higher than his thigh. "If you've got so much
energy, why don'tcha run on up there yourself?" he said.

Right then I knew who the guy had to be. Even 115
though I was still tired and out of breath myself
from the long climb, I stumbled over toward him.
When I got near, he raised up his head a bit and
said to me, "Hey, genius, have you finally figured
out why the sun passes over to your left?" 120

He was so weak and his sarcasm was so pathetic it
almost made me smile. "Belacqua!" I said to him,
"At least I don't have to worry or wonder about
what happened to you! But what're you hanging
around for? You waiting for a guide or something? 125
Or are you just exploring your Inner Sloth again?"

"There's no good in me climbing up there,"
he said. "God's angel, sitting over at the gate,
won't even let me start my sentence inside. Before
I even start serving my time behind the gates, 130
I have to sit around here for as long as I lived,
since I waited right 'til the end of my life to repent.
Sure, prayers could shorten my time here, but they
only work if they come from someone with a pure
heart—any other prayers aren't even heard up there!" 135

But Virgil had already started climbing again.
"We need to get going," he said. "Just look how the
sun is directly overhead, at Heaven's highest point,
as dusk is falling over the deserts of Morocco."

CANTO V

ARGUMENT

The two travelers leave the souls of the Indolent behind and start out again up the mountain when one of the group shouts out to the others that Dante has a shadow. Virgil tells him to ignore them and hurry on, that their real purpose is up ahead. They continue climbing and come across another group of sinners chanting. They are members of the second class of the Late Repentants, the ones who died by violent ends and managed to squeeze in a last-second repentance right at the end of their lives. From the crowd steps Jacopo del Cassero, from Fano, who tells how he died bleeding in a swamp after being jumped. Buonconte of Montefeltro then tells how a devil and an angel came to him at the moment of his death and fought over who would get his soul, but since his very last breath had been in the name of the Virgin he had ended up here, even though his body had been snatched by the demon and had been thrown into the river to be washed downstream in a storm. Finally, La Pia asks that Dante remember her, too.

We had already started off again, climbing
up the mountain with me following behind Virgil,
when one of the crowd below pointed and
shouted to the others. "Look at that guy,
the one behind! He's casting a shadow 5
on his left! He looks like he's still alive!"

I turned and looked back and saw them all
staring right at me in amazement as we climbed—
and they were all looking at my shadow.

"Come on, hurry up!" Virgil urged. 10
"What are you waiting for? Forget about
them, what do you care what they think?
Just keep moving and ignore them.
If you're going to be all flighty and
distracted by everything around, you'll 15
never get to the top of this mountain.
You have to stay focused and strong, like
a bridge in a storm, sturdy in the wind."

I could feel my face flush with embarrassment.
I mean, how would you have felt? Jeez. 20
"OK, OK," I said, "I'm coming."

We started up again and I saw a group passing along ahead
of us. They were chanting together in alternating parts,
a psalm called *"Miserere"* asking God for mercy. But as they
passed us, first one and then the rest caught sight of me 25
and saw my shadow and then the whole lot of them went
from chanting to one big gasp, all together: "Ohhhhh!"

They all stopped, staring. Two of them came
closer, egged on by the others, and asked,
"Please, please! Tell us who you are!!!" 30

"You can go back and tell the rest of
your pals that this guy here is still a living
human being," Virgil answered, kinda proudly.

"I can tell they are amazed to see his shadow,
and now you can tell them why he has one. 35
It would be in their best interest to respect him."

You should have seen those two guys.
They ran back to their group like kids after an
ice cream truck. Quick as a flash they were
gone, and as soon as they told their gang about 40
me the whole lot of them came charging
toward us like groupies after a rock star.

"Oh, heavens, here they come," Virgil said as we walked.
"Now every one of them is going to ask you for a favor.
Whatever you do, just keep moving as you listen to them." 45

"Please, mister, please!" they called as they
surrounded us. "You who still wear your human
body on your hike on up to Heaven! Hold up for a
second and look at us! Maybe you know one of us
and can take news of us back to the world when you go! 50
Hang on! Stop for a sec! Where are you going?
All of us died violently after lives spent in sin.
At the last moment, we accepted the Truth of
Heaven into our hearts and with our last
breaths we asked for forgiveness. At 55
peace with God, we slipped out of life
and now we dream only of meeting Him."

Still walking, I answered, "Looking around
I don't think I recognize any of you, I'm
sorry. But if there's anything I can do 60
for you just tell me and I'll do it. I promise,
even as I follow this great guide of mine
from one place to another."

"You don't have to promise," one of them said.
"All of us here trust you and we know you'll do 65
the best you can. But listen, let me ask you this favor

on my behalf: if you ever get over to the area around
Romagna, could you please ask the people in Fano
to pray for me up here? Their prayers will help
me purge my sins faster. They all know me there 70
because I'm from Fano myself, though that's not
where I died. That was in Padova, Antenori's land.
Ironically, that's where I thought that I would be
safest, hiding out there. But Azzo from Este sent
his thugs after me and they found me there. 75
(He hated me so bad that he wasn't going to
stop at anything and there was no escaping him.)
If only I had gone to hide out in Mira instead of
Fano I'd still be alive today. His guys found me and
they jumped me at Oriaco. I took off running, 80
trying to get away, but I didn't know the area and
ran into a swampy pond and got hung up in the reeds.
They got me, and I fell and watched as my own
blood pooled up around me from my wounds."

"I hope that you make it up this mountain soon," 85
another guy butted in from the crowd. "And I hope
you can help me out, too. My name is Buonconte
and I'm from Montefeltro, where my wife, Giovanna,
and my daughter don't give a shit about me anymore.
Now I'm here, ashamed, with the rest of these guys." 90

"I heard about you at the battle of Campaldino," I said.
"They never found out where you were buried. What happened
that dragged you away from there—or was it just bad luck?"

"I was wounded in the neck in the fighting and
staggered alone across the fields near the Archiano River, 95
below the town of Casentino, and just above the convent.
I think as it gets farther down the river it's called something
else. But anyway, I wandered around, trying to get away,
bleeding everywhere, until finally I went blind. By the
end I was so exhausted and weak that I fell. I couldn't 100
even speak. But even so, as I lay dying I managed to
whisper the name of the Virgin with my very last breath.

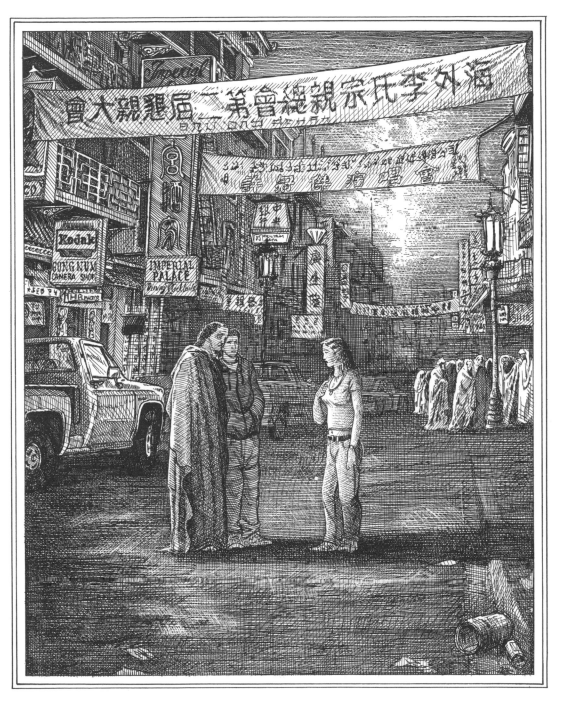

CANTO V, 132—134: LA PIA:
*"But please,
once you're rested, remember me, too!
My name is Pia."*

"But here's the thing," he went on, "And you should tell this
to people back down below: As my soul slipped from my body an
angel came and lifted me gently up. But a devil also appeared and 105
screeched at the angel saying, 'You can't steal him from me, he's mine!
You get to take his immortal soul (and just barely, too, if it wasn't for
that last teardrop of his!) but I've got my own ideas about his body!'

"Well, remember from science books how water
evaporates and rises up into the sky to form 110
clouds, then when it gets cold enough it rains
back down on Earth? Let me tell you, that devil
bent the very forces of Nature to his evil ends!
First he called up a thick fog that drifted down,
so that by the end of the day it had filled the 115
whole valley from Pratomagno to the mountains.
The fog became dense clouds and before long it
started to rain. It rained buckets, just pouring down,
until the ground was muddy and soggy and couldn't
take any more. The runoff filled the river and 120
overflowed even the deepest gullies. The Archiano
swelled to a rushing torrent that busted over its
banks in a flood near where my cold, dead body
lay. It swept my corpse away in its rush to the Arno,
dragging me along the banks and along the 125
riverbed, washing away the sign of the cross
that I had made on my chest in my final moments,
covering me in mud in its headlong rush,
and carrying me away to demonic ends."

"Excuse me, please! I know you'll be tired 130
when you finally get home," a third voice
blurted out from the crowd. "But please,
once you're rested, remember me, too!
My name is Pia. I was born in Siena and died in
Maremma, as the one who pledged himself 135
to me with his ring knows very well!"

CANTO VI

ARGUMENT

All the souls who died a violent death continue to hound Dante. A partial list of those present includes: Benincasa from Laterina, Guccio Tarlati from Pietramala, Malcolm X, Martin Luther King Jr., Federigo Novello, John F. Kennedy, Farinata, Count Orso from Mangona, and Pierre de la Brosse from Turenne. After finally getting away from all the souls, Dante asks Virgil about how prayer can affect Heaven's will. Virgil explains a little bit, but tells Dante that Beatrice will clear everything up for him. Virgil and Dante then notice a quiet soul sitting close by and they ask him directions; he turns out to be Sordello, who's from Virgil's hometown of Mantua. Dante takes a step back and goes off on a little monologue about the corruption and evil in Italy.

After the blackjack game finishes, the loser, all
bummed and questioning, often stays behind,
reliving each hand, as if he'll learn something new.
Everyone else cruises down the sidewalk with the winner,
some of 'em in front and others behind, while the rest 5
stay right at his side, pleading for a bit of recognition.
The winner keeps on walking, listening to everyone;
knowing the ones who receive gifts won't bully in,
and using that as protection from the rest of the crowd.

I was like the winner, stuck in a traffic jam of bodies, 10
checking everyone out as we moved along
and trying to scam my way out with promises.

Looking around, I saw the judge Benincasa da Laterina,
who was killed in vengeance by Ghin di Tacco, and
Guccio Tarlati da Pietramala, who drowned in the Arno. 15
I saw hands reaching out at me, guys like Malcolm X,
Martin Luther King Jr., Federigo Novello, and Farinata, whose
death allowed Marzucco, his victim's father, to forgive him.
I saw Count Orso, and I saw Pierre de la Brosse, who said
his soul was torn from his body, not because he did anything 20
wrong or anything, but out of hate and envy and greed.
And while she's still alive, Lady Brabant—who falsely accused
Pierre—best take care of herself, 'cause otherwise
she may find herself in a worse place than this.

Once I managed to pry myself away from all the ghosts, 25
whose only hopes were that other people pray for
them so they could get up the mountain quicker, I said
to Virgil, "I could be wrong here, but I seem to remember
in one of your poems you said prayer wasn't *that* strong;

that it couldn't bend Heaven's will or anything.
But these ghosts here seem to think it can.
Does this mean they're totally out of luck?
Or did I just not understand what you meant?"

Virgil replied, "It's true I once wrote that, and I
meant it, too. If you think about it for a second,
you'll figure out how they're not deceived.
God's justice wouldn't be compromised if
serious and true love and prayer cancelled
out the penitent's debts. You're referring
to the things I wrote about the guys who had
sins that couldn't be cleansed by prayer
because their prayers couldn't make it to God.

"But don't try to figure it all out now—Beatrice
is going to clarify everything I'm saying. She's the
one who stands between prayer and intelligence
and will illuminate the difference for you.
She's going to be at the top of this mountain and
soon you'll get to see her smiling in happiness."

"Hey, Virg," I said. "Let's get the heck outta here.
I'm not as tired now as I was earlier, and look:
the mountain's starting to cast a shadow—it's late."

"Don't worry, my son," Virgil replied. "We'll keep going
as long as there's light in the sky, and as fast as possible.
But things aren't always how they seem, you know.
Listen: before we make it to the top, you'll see
the sun come out from behind the slope
that's preventing you from casting a shadow.

30

35

40

45

50

55

CANTO VI, 74–75: THE MEETING OF SORDELLO AND VIRGIL:
"Oh, Mantuan, I'm Sordello! We're from the same town!"
And the two of them hugged, like brothers.

But do you notice that ghost sitting over there
all by himself, the guy who's looking over at us?
He's the one that will show us the way." 60

As we walked over to the guy, I was suddenly
impressed with Virgil's whole attitude and stride.
He was so noble and steady it was amazing.
The guy didn't say anything as we approached
but just sat there watching us come nearer, 65
checking us out and giving us the stink eye.
But Virgil wasn't fazed and went right up to him
and asked directions for the best way up
the mountain. The ghost ignored his question, and
flipped us off instead, asking us who we were and 70
where we were born. Virgil started to tell the guy,
"Mantua . . ." And the guy, who'd been so full of himself
a second before, jumped up and went over to him.

"Oh, Mantuan, I'm Sordello! We're from the same town!"
And the two of them hugged, like brothers. 75

(Clueless Italy! You're as useless and sorry now
as a blown-out tire by the side of the road. No
more kings and queens there, just hookers and
bums. See how stoked Sordello was just to hear
Virgil say the name of his hometown? That's how they 80
greeted each other in the old days, proud and happy.
But now, no one that lives inside your borders
knows any peace—even people who live in the
same house are at each other's throats! Fucked-up
Italy! If you looked in every corner, in every 85
town, up every garbage-strewn alley, you wouldn't

find a peaceful corner anywhere. What does it matter
that Emperor Justinian gave you a jump start with
Roman law in the sixth century—there's no one in
the driver's seat now. It would've been better if we'd 90
never heard of it! And all you priests so concerned
with divine inspiration and the pursuit of God;
you should let Caesar do what he needs to do.
See how the country's been running out of control
and in need of a major tune-up? It's gone to shit ever 95
since you priests decided to take the helm.

Not to mention you, Albert of Austria!
You gave up on her, letting her spin into chaos,
when you should've been steady at the wheel!
But you'll get what's coming to you, I'm sure, 100
and it's going to blow everyone away when
it comes, including your heir, Henry VII.
You let Italy's most fertile fields rot away 'cause
you and your dad were always too concerned
and preoccupied with your money. 105
You should come and see the Cappelletti,
the Monaldi, the Montecchi, all totally wrecked;
even the Filippeschi are scared shitless.
Get over here, you heartless prick, and see how
the dignified suffer; help 'em lick their wounds; 110
come see how safe Santafior is these days.
Come see how your city Rome is in mourning,

all alone and widowed, crying hopelessly 24/7:
"Why in the hell did Caesar leave us?"
Come see how much love lines the streets now! 115
If you don't have it in you to pity us, maybe you
can feel your head hit the ground with shame.

Oh, God above, You were crucified right here on
Earth for all us mortal men. But let me ask You
something: don't You see us down here anymore? 120
Or is this some secret part of a grand plan
that Your supreme intellect came up with
that we don't have the powers to understand?
'Cause every single town in Italy is chock-full
of complete tyrants: any idiot who thinks he's smarter 125
than the constitution, like Marcellus, is considered a hero.

But Florence—my favorite city! You're fortunate to be
excluded from all the shit that's stinking up other towns;
your citizens are *way* too smart for all that, right?
Some guys have justice in their hearts; they think first 130
and then shoot their decisions with guns—
your people just shoot their mouths off!
Some guys have second thoughts about public
posts, while your citizens think of only one thing,
shouting, "Of course I'll make the sacrifice!" 135
Celebrate while you can, 'cause you deserve it,
being so rich and wise and peaceful!

The truth is as clear as the facts that prove it.
Athens and Sparta are still famous
for wise laws and civilized punishments, 140
but they're utter and complete chaos
compared to you, who are so sharp
that Halloween's rules and laws become
irrelevant by Thanksgiving weekend.

How often in recent history have you changed 145
currency and customs, rules and offices,
and all the random politicos in town?
Think about it, Italy, and if you figure it out,
you'll see you're like a fat man with a bad back
who can't get any rest in a soft bed, 150
but hopelessly tosses to escape the pain.)

CANTO VII

ARGUMENT

As Sordello and Virgil finish hugging each other, Sordello learns that not only is Virgil from Mantua, but he is also the famous poet. Sordello praises him even more. Virgil asks Sordello to point out the quickest way up the mountain. Sordello explains the laws of Purgatory, which prevent any climbing after sunset. He takes them to a place to spend the night, leading them to an overlook above the Valley of the Princes. From there they look down on a group of Negligent Rulers who represent the Third Class of the Late Repentant, the Preoccupied. Sordello points out several of the more renowned figures as Rudolf of Hapsburg, Henry VII from Luxembourg, Ottokar II of Bohemia, Philip III of France, Henry the Fat of Navarre, Peter III of Aragon and his son Charles of Anjou, Henry III of England, and William VII, also known as "Longsword."

After the two of them had hugged and backslapped and
shook hands enough times, Sordello finally stepped back and
had a look at us, smiling, and said, "Now then. Who are you guys?"

"I am Virgil, dead since the reign of Octavian,
the first of the Roman emperors. I have been in 5
Limbo since before the souls worthy of climbing this
mountain were brought here by the grace of His Son.
And the only reason I wasn't brought here as well was
because I lacked faith," my guide replied honestly.

Sordello looked at him closely, shook his head and 10
pulled back, then opened his eyes and looked at him
even harder, as if he had just turned on a light and
his eyes weren't used to the glare. "It's impossible!"
his expression said, but he was silent. Then he bowed his
head in honor and stepped forward for another embrace. 15

"You are the glory of the Italian race, the one who proved
the worth and value of our language! Tell me, what did
I do to merit such a huge honor? Man! To meet *you*!
Please—if I can just bother you a little—did you come
from Hell? What part? What's it like down there?" 20

"I've actually come through the entire maze of Hell," Virgil replied.
"Through all its pits and valleys, ditches and caverns,
guided and aided by a power from Heaven.
The meaning of the light above that you're all
climbing toward was not explained to me until 25
it was too late. I am condemned to Limbo forever.
Not for my mistakes in life, no—but for what I
didn't do when I had the chance. It's dark down there,
and while no one is in physical pain, we all suffer from
our sorrows and the hopelessness of our situation. 30

"The innocent souls of children are there with us,
the ones who were not baptized before their
death and therefore could never erase the
Original Sin. There are also those who led
virtuous lives but were not able to clothe 35

themselves in the three virtues. But listen, please,
do you know the fastest way up this mountain?
Can you tell us how to get to the heights
where Purgatory actually begins?"

"Sure, I know," he answered. "We're allowed to 40
roam around here all we want, up and down.
I can take you up as far as they'll let me go.
But the thing is, no one is allowed to go up
in darkness and the sun is setting now. The
best thing would be to find a place to crash 45
for the night. Follow me. Over here on the right
there's a bunch of guys I know. I'll introduce you
to them. You'll like them, they're all cool."

"Just a moment there," Virgil said. "What do you mean?
Are you saying that if I tried to climb at night somebody 50
would stop me? Or that I'd be frozen in place? Or what?"

"Check it out," Sordello said, and drew a line in
the dirt with his finger. "As soon as the sun sets
you won't even be *able* to cross that line.
Nobody's going to stop you or anything, but the 55
darkness becomes more like a mental block.
It takes away your *will* to ascend. Now, we can
go downhill if we want, and we can stroll all
around anywhere we want to go on the mountain,
but as long as it's dark we can't go up at all." 60

Virgil stood there thinking, amazed, until he finally
gave up and said, "Alright then, lead the way. Show
us this place where we can get some rest tonight."

We all set off and pretty soon we came to a valley
in the mountainside, just like an arroyo back down below. 65
"It's just down here a bit," Sordello said over
his shoulder. "There's a place that levels
out into a nice sort of hollow just below
and we can hang out there until dawn."

We followed a mellow little side trail along 70
to the lip of a bowl in the hill where one side
leveled off a bit. From there we could see down
into the most beautiful valley, full of green grass
and blooming flowers of all kinds, smelling
better than a field in springtime mixed with 75
the warm smells of a bakery. If you can imagine
all the colors of nature and all the lights of
Las Vegas sparkling like a diamond Rolex®
and the Queen's jewels, this place was more
beautiful and brilliant than you can even imagine, 80
smelling like nothing you've ever smelled before.

From where we stood I heard a chorus of voices
rising together and singing the hymn "*Salve Regina*,"
and down below the rim of the glen I saw a group
of souls. "Let's not go down there to meet them 85
until after sunset," Sordello said. "You can check
them out better from up here anyways, because
you can get an overview of them all at once.
They call those guys the 'Negligent Rulers.'
Sounds like a motorcycle gang or something, huh? 90
That guy over there, sitting highest up and looking
like he forgot to turn off the coffeepot at home,
that's Emperor Rudolf of Hapsburg, who neglected
Italy during his reign when he could have
saved her from the troubles she's in now. 95
It'll be a long time before things get better there.

"The guy comforting him is Ottokar II,
King of Bohemia, who was once Rudolf's
worst enemy. Now he's here trying to
make amends. His son, Wenceslaus, isn't 100
half what Ottokar was when he was his age,
with all his womanizing and laziness.

CANTO VII, 72—73: ABOVE THE VALLEY OF THE PRINCES:
From there we could see down
into the most beautiful valley.

"See that one over there with the pug nose talking
to the fat guy next to him? That's Philip III of
France with the schnoz, and the other one is 105
Henry the Fat of Navarre. Philip's kid married
Henry's daughter and he's been nothing but
bad news for France ever since. He's become
a mean, corrupt dictator asshole and that's
why both of them look so bummed out, 110
after they had such high hopes for their kids.

"Over there is Peter III, who became king of Sicily.
The guy with the huge honker he's talking to is
Charles I of Anjou, who lost his throne to old
Peter there. They hated each other on Earth 115
and now here they are singing together!
Behind him you can just see his son,
who took over for a little while but didn't
get the chance to do as much damage
as he could have. His other two sons, 120
James and Frederick, took over after that
and spent all their time arguing over
who was going to rule Sicily. It's a good
example of how rare it is that the good
of a father can carry through to his sons. 125
And that goes for the big-nosed guy, too.
All Provence and Puglia have suffered under him.
And the skinny dude in the corner is Gray Davis,
who 'forgot' to balance California's books.

"Over there is Henry III of England, off by himself. 130
At least his kids have done better by him, even
though he didn't do all that much himself.

"And the one sitting at their feet is Marquis William,
whose failure at controlling things in Alessandria has
been nothing but a disgrace and shame to Montferrat." 135

CANTO VIII

ARGUMENT

Dante looks out over the valley in time to see one of the souls start to sing the hymn "Te lucis ante"; he's quickly joined by the rest of the souls, and together they sing it beautifully. As they're finishing the song, a couple of angels come down from Heaven to protect the group from the serpent that's about to show up. Sordello tells Dante and Virgil it's time to get down into the valley with the rest of the souls. A few steps downward, and Dante runs into Nino Visconti, who's super-indignant and spouts tirades about widows who remarry. Meanwhile, Virgil is explaining constellations and suchlike when suddenly, Sordello announces the coming of the serpent—which is scared off by the guardian angels. Dante meets up with Corrado Malaspina and begins praising the man's family while Corrado replies that Dante will eventually have good reason to praise his family.

It was that time of day when the trucker
thinks of all the roads that lead back home
and his girlfriend waiting with a beer; when the
Eurailpass backpacker sits starry-eyed with
love in some youth hostel; when we all hear the 5
clock ticking toward the end of another day.

In other words, I was tired and sat there
zoning out until I noticed a ghost who stood up
and was motioning like he had something to say.
He threw his arms up and put his palms 10
together in prayer, facing east, as if he meant
to say, "All I can think of is You, dear Lord."

Then he began to sing the hymn "*Te lucis ante*"
in a soft, beautiful voice that swept me up
and I lost myself in the sweet music. 15
The rest of the sinners joined in, gradually,
in complete harmony, all the way through,
with all their eyes looking up at the stars.

Now pay attention to this part, dear Reader:
I'm going to tell you what I saw next and it shouldn't 20
be that hard to figure out the symbolism of it all.
As I watched, the souls kept singing, and
they all looked up at the stars expectantly,
and a bit afraid, it seemed to me. And then
I saw two angels coming down from way up 25
on the mountain. They carried these stubby
little swords, which seemed to be burning hot,
and they wore robes as green as a golf course,
which billowed out behind and around them as they
came, floating along on huge, elegant wings. 30
One stopped and hovered on our side of the
valley and his buddy went to the far bank, so
that the crowd of souls was between them, protected.
I was able to see the golden sheen of their hair,
but their faces were way too bright to look at, 35
the way it's hard to stare straight at a lightbulb.

"Both those angels are sent from Mary's side,"
Sordello explained. "They came to guard us
from the serpent. You'll see why in a minute."

That sorta freaked me out. I didn't know what 40
to expect, so I hung back by the guy I could trust,
since I didn't know where the monster would appear.

"We should move down into the valley now,"
Sordello continued. "We can go hang with those
guys and talk to them. They'll be glad to see us." 45

I think I only had to walk, like, three steps,
it seemed, and I was already in the valley.
One of the ghosts came up and was
staring at me, checking me out, because
by then it was pretty dark, but not so 50
dark that you couldn't see anything.

The ghost came closer and I finally saw it was
Noble Judge Nino. Man, was I glad to see that
he wasn't down in the pits of Hell or anything!
We looked each other up and down, like old friends. 55
"How long did it take you on the ferry over to
the base of the mountain?" he asked. "Nice trip?"

"Oh, there," I replied. "I left that horrible place early this
morning. Thing is, I'm actually still alive, and I'm hoping
to assure my Afterlife by sussing things out over here." 60

Sordello overheard what I said and both he and
Nino started backing away from me nervously—
they couldn't believe that I was actually alive.

Sordello looked at Virgil and Nino tugged
on the robe of a soul next to him. "Hey, Corrado, 65
check this out!" he shouted. "See what God brought down!"

He turned back to me, excited. "I'm begging you,"
he began. "I know that God's will is beyond us,
but, in His name, mate, please: once you get back

CANTO VIII, 96–97: THE GUARDIAN ANGELS AND THE SERPENT:
*A snake came sliding along the low side
of the valley.*

across the water to the land of the living, could you 70
tell my sweet daughter Giovanna that she should pray for
me? It's only the prayers that come from pure hearts
that do any good. I don't think her mother, Beatrice, loves
me anymore, because she's already taken off her widow's
dress—which she'll need again the second after she remarries. 75

"We can learn a lot about how fickle women are
by Beatrice's gesture; how soon they forget about
love when their husband's not around to touch them.
I'd bet that the Milan's family emblem, the snake,
wouldn't look as good on a tombstone as the rooster of 80
the Gallura family. She should have stayed my widow."
Nino was all worked up by then, all righteous,
and his face was twisted up with anger
in that semijustified fire of the jilted lover.

Meanwhile, I kept watching the center of the sky, 85
where the stars seem to move slower, in the same way
that the axle turns slower than the rim of a bike wheel.
Virgil glanced over and asked me what I was looking at.

"I'm looking at those three bright stars over there,"
I said. "See the ones lighting up the polar zone?" 90

He nodded, "Remember those four bright stars we
saw this morning? By now they've set under the
mountain and these three have risen in their place."

Suddenly Sordello grabbed Virgil's arm in a panic.
"Here comes the snake now!" he said, pointing. 95

A snake came sliding along the low side
of the valley. It could even have been the same
exact one that tempted Eve with the apple.
It slithered along slowly through blossoms and
the grass, stopping every now and then to lick 100
itself, lubricating its disgusting body as it slid
along. I can't tell you how they took off, because
I didn't see it, but I did see those two holy falcons

swoop across the valley toward the snake. As soon
as it heard the sound of their flapping wings, the 105
snake took off like a shot, while the falcons turned
back and flew over to their posts on the hill.

During the whole thing, the guy who
Nino had called over to look at me
stood beside him staring at my face. 110
"I pray that you'll have enough gas
in your tank to make it all the way up
this mountain," he began, kissing up to me.

"Dear sir, if you have heard anything recently
about Val di Magra or anyplace near there, could 115
you give me some news? I used to be pretty
famous in those parts. My name was Corrado
Malaspina (not the older one, that was my grandfather)
and I'm here now to purge my pride of family."

"Hmm," I replied. "I've never been to your 120
hometown, but everyone in the whole of
Europe has heard about your fabulous province.
Your family is famous, and almost everyone
knows about your rulers and the countryside
where you're from, even if they've never been there. 125

"And because I'm hoping to reach the top myself,
I'll swear to you that I'll help honor your family line
and their great reputation as much as I can.
Their strong traditions have made it possible
for them to resist all of the evil that perverts 130
the world—and they're just about the only ones."

He answered me with a weird little prophecy:
"Let me assure you," he started, "that the
sun will not pass over the bed of Aries any more
than seven times before the opinion you just 135
expressed will be pounded into your brain by
nails more true than the words you just spoke—
unless, of course, God's plan is cut short."

CANTO IX

ARGUMENT

Dante dreams he's been snatched up in the claws of an eagle, and when he wakes up he discovers that while he slept he and Virgil have been carried up to the very Gate of Purgatory by St. Lucia. Dante and Virgil are then confronted by the Gate's doorman. When they explain that Lucia sent them, he tells them to come up the three stairs before the Gate. Each is a different color and represents the Three Steps of Penitence—Confession, Contrition, and Satisfaction. The doorman marks Dante's forehead with seven letter P's, (for peccatum, *which means "sin" in Latin), one for each of the Seven Deadly Sins, which must be purged through suffering on the Seven Terraces of the mountain of Purgatory before a soul is ready to enter the Kingdom of Heaven. Then the porter opens the Gate for them using the Keys of St. Peter. The two poets enter Purgatory and in the distance they can hear the hymn "Te Deum laudamus" in the air.*

Before long the goddess of the dawn, Aurora,
glowed faintly on the eastern horizon, as if she was
just rising from the arms of her lover, Tithonus.
The light sparkled and gleamed like freshly
polished silverware lining the tablecloths of 5
some really fancy restaurant. It was for
sure past last call—probably closer to three
in the morning—when suddenly everything
seemed to hit me all at once (remember, I was
the only one still in my human body). I couldn't 10
hang any longer. I curled up right there on the soft
warm grass where we had been sitting and talking.

It was the time of night when the wind calms down and
the echo of foghorns in the harbor carries melancholy
over the bay and reminds you of the regrets and 15
loneliness you'd almost been able to forget. It was the
time when you float halfway between the clear, sober
thoughts of day and the half-conscious drifting of inebriation
and the early morning. In other words: I fell asleep.

And as I slept I dreamed that I saw a golden eagle 20
flying through the sky, beating its wings as if it was
waiting to swoop down and strike me. I felt like Ganymede
on the mountain, just before he was snatched up by the
eagle Jove and carried away to serve the gods above.

'Maybe the eagle is just hunting food,' 25
I thought to myself in my dream. 'Maybe
this is the only place he likes to hunt.'
In the dream, I watched him circle above me for
a while, then dive suddenly down toward me like
a bolt of lightning. He snatched me up and we 30
swung up toward the sun. As we rose higher it
seemed that we were both catching on fire and
it started to sear and burn me so much that I woke up.

Way back in Greek mythology, Achilles was taken from
Chiron by his mother and carried away while he slept to 35

Skyros, where he would later be tempted away
by the Greeks. I woke up just as he must have,
confused and dazed and not knowing where
I was, looking around quickly and trying
to remember the night before. I could feel the 40
fear creep into my face and the color drain
away because I couldn't figure out how I got there.

But then I saw Virgil right beside me, alone, and
I felt better. It was light by then, maybe a couple
hours past dawn, and the sea sparkled down below. 45

"Relax, dear Pilgrim," old Virgil said to me quietly.
"Chin up. We've come a long way already.
Wake up and get ready for another push up the
hill today, because you are now at the edge of
Purgatory proper. See this wall that surrounds it? 50
Over there, in that arroyo, is the front gate.
While you were sleeping with your soul all
warm and tucked in your body, lying in the grass of
that beautiful valley last night, a woman
came to us just before dawn. She said, 55
'I am Lucia, and I've come to carry this man
while he sleeps to speed him on his journey.'
She picked you up in her arms as the sun rose
and carried you here, leaving Sordello and the other
souls behind. I followed along, and just before she 60
set you down she pointed out the gate to me
with a glance of her lovely eyes. Then she left,
and took the sleep from your eyes with her."

I felt like a guy who has just walked into a surprise party.
You know: at first all startled, thinking something's wrong 65
or that I was being attacked. But I gradually understood
what was happening and calmed down with a bit of relief and
some confidence. When Virgil saw that I was OK, he got up
and started off up the hill with me following behind.

Now you'll be able to see where I've been going with all 70
this. I'm going to try my best to use some fancier words and
smoother rhymes to describe everything, so don't get all

bent if it seems a bit weird. As we came up the crest of the
hill, I thought I could see a gap in the big wall ahead, but as
we got closer I saw that it was really a gate. There were 75
three steps going up to it and they were each a different
color. At the top of them there was a guy who
seemed like a doorman or like he was guarding it or
something. When we came up he was sitting there
on the top step and when I looked up at his face he 80
was so good-looking I turned away. He held a naked
sword in his hands and the rising sun reflected off
its gleaming blade so much that every time I tried to look at
him without shielding my eyes, I couldn't see because of the glare.

"Hold it right there," he said. "Tell me what you want 85
and how you got to this place. Where's your guide? And watch
what you say or you might regret coming here!"

"A lady came to us just before dawn," Virgil responded, "saying
that she had been sent from Heaven. She must know what's she's
doing because she pointed out the gate and told us to come here." 90

The doorman smiled. "Ah, may her guidance continue
to lead you toward what is good," he said kindly.
"Come on then, come up our stairs over here."

We came closer and I saw the first step
was beautiful white marble, so polished 95
that I could see my own face reflected in it
like a mirror. The second step was black
and rough like lava rock, all covered
with cracks and crumbling as if
it had been burnt in a fire. The third 100
step sat heavy at the top of them and it
was a deep red, like new nail polish or
like a drop of blood from a fresh cut.
The doorman, who was an angel, sat on
the sill with his feet on that red step. 105
I followed old Virgil up the three steps to the
very feet of the angel. Then he stopped and said,
solemnly, "Now, in all humility, I ask that you turn the key."

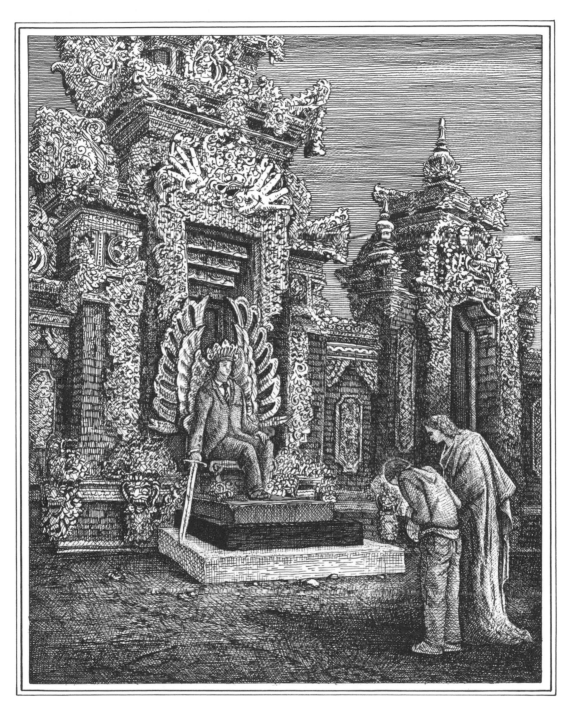

CANTO IX, 75—77: THE GATES OF PURGATORY:
There were
three steps going up to it and they were each a different
color.

I went down on my knees before the angel,
touched my chest three times, and asked him 110
to have mercy on me and to please let me in. He
watched, then raised his sword and gently scratched
seven letter *P*'s across my forehead. "When you get
inside," he warned, "be sure to clean off these marks."

Up close I could see that his robes were as 115
gray as fresh concrete under a summer sun.
He took two keys from under them,
one silver and one gold, and he put them
one at a time into the lock on the gate and
turned them, and then the gate swung open. 120

"If both of the keys don't turn the locks,
the gate won't open," the angel explained,
"and you wouldn't be allowed inside.
The gold key is more valuable, but the silver
one requires more skill and wisdom for it to turn 125
because it's the one that actually opens the locks.
Peter gave them to me and he said, 'It's better
to let in too many people than not enough,
if they make it here and are asking to be let in.'"

He put a hand on the gate and pushed it open. 130
"Go ahead," he said. "But don't look back
or you'll be sent out again. Believe me." The
heavy metal gate swung open on its sacred
hinges, and the sound of it rang out like the
clanging of an enormous iron bank vault 135
opening for some rich lady making a withdrawal.

As the great door swung open I heard the sound
of voices in the distance, chanting or singing what
sounded like the hymn "*Te Deum laudamus*,"
which chimed in with the ringing of the gate. 140
The sweet harmony of the two sounds reminded me
of people singing in church when an organ plays.
Or like a good song on the radio where sometimes
the voices and the music blend together so well
that it's hard to make out the words. 145

CANTO X

ARGUMENT

Dante and Virgil walk through the gate, which shuts loudly behind them, and along a narrow trail until they reach a little ledge. One of the sheer cliff walls next to them is covered in white marble sculptures, all of which depict examples of the virtue of Humility. The first scene Dante describes is the Annunciation; the second is of David, who traded all his kingly pride for humility; the third shows a scene of Emperor Trajan holding back his entire army just to speak to a helpless widow. Dante is blown away by all the famous examples and Virgil tells him to look at yet another group of souls coming toward them. These are the Proud, who must now carry huge stone slabs on their backs, wailing and beating their chests.

We passed through the threshold of the gate,
which is shut to those whose love isn't worthy
(you know, love that only *seems* straight and true)
and it slammed shut behind us with a solid
boom. If I had looked back, you couldn't 5
really have blamed me. From there,
Virgil and I followed a narrow path that
meandered up through a narrow hole in the
rock like a drunk stumbling home from a bar.

"Now we're in the zone where we have to use 10
our heads," Virgil said. "When this pathway bends,
we must stay to the other side of the curve."

We had to take these really tiny steps,
and the going was so slow that the moon had
already set by the time we finally squeezed 15
through the needle's eye at the top. When
we came out onto the mountain again we
were on this little ledge of rock, where we
took a break from climbing and stopped for
a bit. It was a desolate and lonely place 20
and we were both pretty tired and lost.
It was a small ledge, too: from the edge
of the shelf to the sheer cliff face was
no wider than about eighteen feet or so.
As far as I could see along the path, 25
looking both ways along the Terrace,
the shelf was the same width the whole way.

As I stood there looking I realized that the
rock was made of pristine white marble, and it was
carved with the most intricate and detailed 30
reliefs. They were almost more realistic
than Nature herself could have done, and
they all depicted historical scenes of Humility.

The first carving we saw was of the Annunciation—
a scene where an angel appeared before Mary to 35
tell her of her pregnancy, bringing a peace to the world
that would open the gates of Heaven to common men.

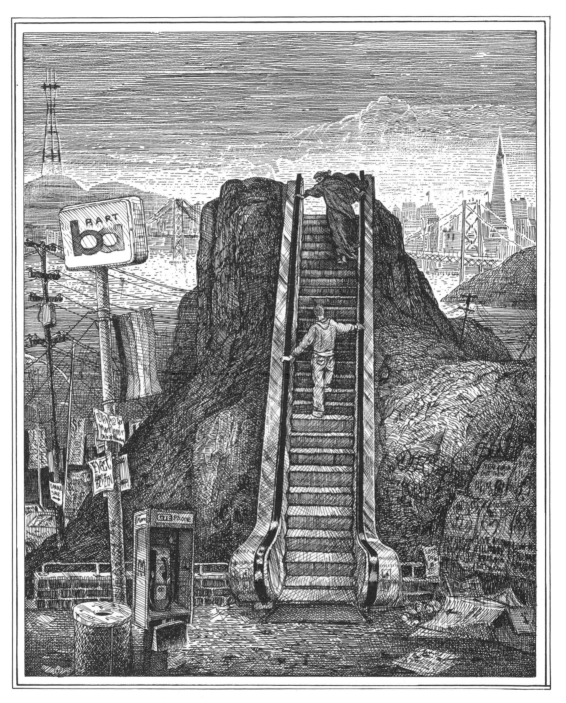

CANTO X, 7–9: THE EYE OF THE NEEDLE:
Virgil and I followed a narrow path that
meandered up through a narrow hole in the
rock like a drunk stumbling home from a bar.

It was carved right into the white marble cliffside, and
it was so beautiful I don't have the words to describe it.
You would've sworn the angel was speaking out loud as 40
you looked at it. Even the Virgin Mary, who unlocked
God's love, was carved perfectly into the marble,
and the curve of her sharp profile seemed to say,
"Behold the handmaiden of God," as clearly as
if it were tattooed on her very flesh or something. 45

"Why don't you have a look around at the
other carvings?" Virgil suggested, as I
stood on his left examining the wall.

I looked across the expanse of the cliff,
past the depiction of Mary, to where Virgil 50
was pointing. Among the carvings I saw
a whole new scene engraved in the
rocks and I walked past him so that I
could check the whole thing out.

The scene I saw there was epic. It showed 55
a yoke of oxen pulling the cart with the
holy Ark—a warning that one shouldn't
exceed one's competence. Ahead of the
cart marched seven choirs, so realistically
carved that I almost thought they were singing. 60
And ahead of them, the smoke of the censers
was carved so lifelike and true that my eyes
and nose almost didn't believe each other.

Way up ahead past the Ark, with his robe billowing
around him as he moved, David the psalmist was 65
dancing, both more and less than a king, if that makes
sense. And Michal, David's first wife, was up over on
the other side, looking out from a palace window,
all moody and bitter at her husband's humble dance.

I kept going along the wall, past the sad face 70
of Michal until I came to another scene.
It depicted the legend of Pope St. Gregory the
Great, who prayed for the grace of repentance

for the Emperor Trajan, calling him back
from death itself to repent and be saved. 75
In the carving in front of me, Trajan sat
on horseback while a widow stood
beside him, bawling—all sculpted into the
white marble. The whole scene was chock-full
of knights on horseback and eagles that 80
seemed to fly through threads of stony wind.
The widow was almost lost in the crowd and
the brilliant carvings were so realistic that
it seemed like the scene played out before
my eyes like an Imax® movie. I could almost hear 85
what must've been their conversation in my mind:

"Please, avenge my son's death!" she seemed to plead.
"Wait for my return," he seemed to answer. But
she insisted, frantically, "And what happens if you
don't return?" "Then my successor will carry on." 90
"But how could another take Your place?" she cried.
"Don't despair. For I must do my duty now, before
I leave. Justice demands it and pity overwhelms me."

It was an amazing display by the One who has
seen it all. The way He made speech visible in 95
a sculpture is completely unheard of back on Earth.
I stood there totally absorbed by those fantastic
carvings and their scenes of humility, thinking
that here I stood before the very hand of God,
when Virgil whispered to me, "Look over there. 100
See how slowly those souls are coming toward us?
They'll be the ones to lead us up from here."

Even though I was wrapped up in the carvings,
I turned my head to see who he was talking about,
as I'm always open to seeing new things. 105

But, dear Reader! When I tell you how God makes
the penitents pay for their sins, don't back out of your
decision to repent or anything. Please, don't focus on the
punishments, but think about what comes afterward,

after they're done. And remember, in the worst-case 110
scenario, they can't last longer than Judgment Day.

"I can't see anyone at all over there,"
I said to Virgil. "Maybe my eyes are bad, but
I dunno what it is you're looking at."

"The heinous nature of their punishment makes 115
their bodies slouch over almost down to the ground,"
Virgil said, looking. "At first I couldn't figure it out either,
except look close and focus on each of the different shapes
you see moving under the weight of the stones—
see how they're all beating on their chests?" 120

O you conceited so-called Christians, pitiful and pathetic,
all you who've got the wrong idea about everything,
believing in things that pull you back instead of lifting
you up. Don't you see that we're all just caterpillars,
born only to become part of the angelic butterfly 125
that flutters and flies naked before the Final Judge?
Why are you so full of yourselves, so pretentious?
You're nothing more than bugs smeared on the
windshield, premature caterpillars, waiting to evolve.

In some old civic buildings you might see columns 130
carved in the shape of a figure, holding up part of a roof
or ceiling, and usually they're hunched over and doubled
up so that you feel sorry for them, even though they're
just statues. Well, what I was looking at made me feel like
I was seeing that for real—not just carved in stone. 135
Some of the souls I saw were less bent over
than the others, some more, as they carried
huge stones on their backs. But no matter what,
all of them seemed to be crying, "I can't go on!"

CANTO XI

ARGUMENT

The Canto begins with the Prayer of the Proud, sort of an extended version of the Lord's Prayer, which is being chanted by a crowd of souls who approach very slowly, carrying heavy stones along this First Terrace of Purgatory. Virgil calls out to them and asks them for directions and one says he can point out the way. This is Omberto Aldobrandesco, who admits that his sins of pride ruined him and his whole family on Earth. Stooping for a better look, Dante recognizes the painter Oderisi of Gubbio, who goes off on a speech about the uselessness of pride in artists in the bigger scheme of things and of the fleeting quality of fame. Oderisi points out another guy in the crowd, Provenzan Salvani, the ex-dictator of Siena.

O Father, who lives in Heaven,
(not because He has to but because
He likes the view better from way up there)
Your name is sacred and so is Your power
to all of us, Your creations, who should 5
give our thanks for Your great kindness.
We hope that Your promised kingdom will come
soon and bring us all peace, and we realize
that if it doesn't come we cannot bring
it about ourselves no matter how hard we try. 10
All humans should offer themselves to You
as Your angels do when they sing Your praises.
Give us strength and hope to continue, Lord,
because without Your blessing, even those of us who
most desire to ascend will slip back down this 15
barren mountain. And as we must forgive those
who have trespassed against us, so please forgive
our own trespasses, Lord, rather than considering
us unworthy. Do not lead us toward the temptations
of our old enemy, our strength is but weakness. 20
Instead free us from the one who tempts
us astray. We ask this more for those still
down on Earth than for ourselves, as we know
that we here are beyond that need.

These were the words chanted by that crowd of prideful souls 25
as they lumbered slowly along under their oppressive stones,
praying for us and for themselves. They moved so slowly,
like in a dream when you try to run but you can't, and their
weights seemed off balance and tottering as they plodded
along the First Terrace, purging the sins of their earthly lives. 30

Stop and think for a sec: all of them up there are
praying for us! Just think what good we can do if we
pray for them on Earth, too. I mean, shouldn't we help
them, through our prayers, to wash away the sins of
their lives so they can climb that mountain faster, 35
and lighter, until at last they can fly purely toward the stars?

"With hopes that justice and pity both join
to lighten your heavy burdens," Virgil called over
to them fondly, "so that you might all float freely up
toward your destination; please, can you point us to the 40
quickest way to find the stairs? And if there are different
ways, can you tell us which one is the easiest to climb?
My friend here carries a burden, too. Except it's that of
the living flesh of the sons of Adam, and it slows him
down as he climbs no matter how hard he tries." 45

A voice came back from that plodding,
pitiful group in answer to Virgil's call.
I couldn't really tell who it was who
answered my teacher, though. The voice said:

"If you follow along this path on the right like 50
we are, you'll see a trail that's easy enough for
any living person to climb. If it wasn't for this
stone I have to lug around that keeps me bent over
with my nose to the ground, I'd love to get a look
at this guy to see if I might know him, since you 55
haven't told us his name. Maybe I could get some
sympathy from him for my aching back.

"I'm an Italian myself, and my dad is a famous Tuscan.
His name was Guglielmo Aldobrandesco, maybe
you've heard of him? My giant family and all the 60
great things they have done in history made me
forget that I came from the same Earth as everyone
else—and I thought I was better than other people.

"My arrogance was the death of me. Ask anyone
in Siena or any high school kid in Campagnatico. 65
My name is Omberto and Pride was my sin.
Not only did it ruin me, but my whole family,
too, which was dragged into ruin by me. By
not carrying my own weight when I was alive,
now I'm condemned to carry this enormous 70
one here among the dead, until the day that
God is satisfied with my penance," he explained.

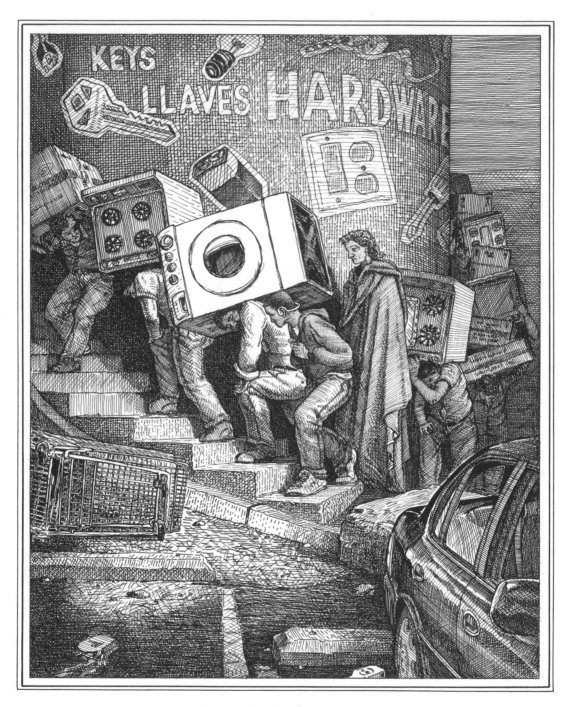

CANTO XI, 76–78: THE FIRST TERRACE AND THE PROUD:
*He strained with his load to get a better look
at me and called out as I scrambled along beside the
group.*

I crouched down low and tried to see under the stone
slabs to see who was talking. As I did, another guy right
nearby caught sight of me from underneath his punishing 75
burden. He strained with his load to get a better look
at me and called out as I scrambled along beside the
group, all bent over like them but without a weight.

"Wow," I said when I saw him. "You're that famous guy
from Gubbio named Oderisi! You're great at 'illuminating' 80
manuscripts, as they say in French, right? Hmph!"

"The most beautiful painted pages nowadays are
done by my brother Franco Bolognese," he said.
"My stuff is nothing compared to his work,
although I would've never admitted that when 85
I was still alive. I always wanted to be the
best, and that's why I'm up here now. That's
what you get for being too proud. I wouldn't
even be up here at all if I hadn't turned to
God when I was still a sinner on Earth. 90

"The futility of vanity is bottomless!" Oderisi went on.
"Cimabue used to be the hottest painter around,
but now Giotto's the one everyone's talking
about and Cimabue's laying in the dust. It's the
same way with the poets, too: Guido Cavalcanti has 95
been stealing the limelight from Guido Guinizelli
lately, and there's probably some hot young kid out
there already that'll put his rhymes to shame when
he grows up, like Eminem. Fame down on Earth is
nothing but a tumbleweed, rolling around whichever 100
way the wind blows, whatever the latest thing is,
whatever's in fashion. Does someone who
dies in old age instead of dying in his prime
earn a greater place for himself in the history
books? What does a grip of centuries matter 105
compared to eternity? It's like the click of a mouse
in the span of the whole Internet. Just check him out
up there crawling along. He used to be really

famous all over Tuscany and now no one in
Siena even mentions the guy. He used to be a 110
big shot there and defended the town
when it was attacked by Florence, a power
so proud and cocky back then, and now
as corrupt as a Bush Street whore.

"Like I said," he went on, "fame on Earth is like green 115
grass: it fades and grows again, and the One who
makes grass grow in the first place will also let it fade again."

"What you're saying is true," I said. "And it makes
me ashamed at my own moments of overconfidence.
But who was it you were just talking about?" 120

"Provenzan Salvani," he answered. "He was
presumptuous enough to think that he could
control all of Siena and that's how he ended
up here. Since the day he died he's been crawling
around like that without a break. That's what happens 125
to people who get too cocky in life, like Jayson Blair."

"I thought only those who asked for forgiveness
at the end of their lives had to spend the same number of
years hanging out here as they did on Earth before repenting,
until they can climb further up this mountain, no? Unless 130
others pray for them to speed it up, I mean. How come
Salvani's managed to make it up this high already?" I asked.

"When he was at the peak of his power, he
went on his own to Siena's marketplace and set
up a stand. Without regrets he humbled himself 135
and begged for the ransom money to get a friend
out of King Charles's jail, even though he was
scared to death of doing so," he answered.
"That's all I can say about it. I know it's probably
confusing, but soon enough your own neighbors 140
will help you figure out what I mean," he explained.

"It was that favor that made his ascent so speedy."

CANTO XII

ARGUMENT

As Dante and Virgil leave the Proud in the First Terrace, Virgil points out a bunch of intricate carvings in the stone underneath their feet. These depict examples of the Prideful who never repented: Satan, Briareus, Nimrod, Niobe, Saul, Arachne, Rehoboam; Alcmeon killing his mom, Eriphyle, and Sennacherib's sons murdering him; Tomyris killing Cyrus; Holofernes's death; and the fall of Troy. As they continue walking along, Virgil tells Dante to keep his chin up because the angel of Humility will come to remove one of the P's on his forehead. As they head up to the Second Terrace, they hear the sweet song "Blessed Are the Poor in Spirit." Dante feels lighter now that one of the letters has been scrubbed off his forehead and he can climb easier.

Like chain gang Corrections Department road crews
keeping step, me and poor Oderisi shuffled
along, as fast as good master Virgil would let us.
Finally, he said, "Now you must leave this ghost
behind, because from here on out, we each must 5
row our own boats with all the strength we have."

I straightened up then and walked tall again, like
a man. But though I may have seemed a bit bigger,
I was totally humble inside my head. Really.
I was feeling much better then as I followed 10
along behind old Virgil. I felt lighter and looser,
like I had done some yoga and was ready for a hike.

"Take a look down and you'll be pleased," Virgil said.
"This stone pathway underneath us will undoubtedly
make your trek through this place much easier." 15

You've seen how some gravestones are decorated
with ornate carvings and etchings that tell
about the deceased and his life on Earth in
order to uphold the man's memory. Some of
them can be very moving, and they can even 20
bring a sincere and pious person to tears. The
stones we walked on were carved in scenes like
that, but much more realistically and beautifully.
No surprise, really, since God Himself was the artist.

I saw Satan, who thought he was the most noble 25
being created, carved in the ground. He was
shown in the middle of his tumble from Heaven to Hell.
I saw the giant Briareus, who challenged Jupiter, carved
beside him as he was stabbed by a heavenly thunderbolt,
lying dead and hopeless on the frozen ground. 30
Other scenes showed Apollo, Pallas, and Mars,
still packing weapons, next to their dad, looking down
at the dismembered corpses of the giants below.
I saw that idiot Nimrod by his Tower of Babel, standing
stunned and looking out at the other idiots who 35
shared his stupid fantasy on the plains of Shinar.

O Niobe, with your crying eyes! Your boastful ways
ended in the death of your fourteen kids and your
tears seemed to soak your image on that pathway.
O Saul, stabbed to death by your own sword! 40
I saw you lying in death on the plains of Mount
Gilboa, where it still hasn't rained since you died.

O crazy Arachne! I could even see you there,
in despair and half-turned into a spider after
losing the weaving challenge against Minerva. 45
O Rehoboam! The image here of your arrogance
was almost laughable, pitifully fleeing the scene of your
crimes in a fast chariot, even though no one's chasing you.

I also saw that guy Alcmeon, who killed his mom for
being bribed by a necklace to betray her husband. 50
His image was etched in the cool white stone as well.
As was Pol Pot, Hitler, Idi Amin, Nikita Khrushchev, Saddam Hussein.
And there were the sons of Sennacherib, beating their dad
while he arrogantly prayed at the temple. Queen
Tomyris was carved there, too, along with the 55
chaos and slaughter she caused, and her words
to Cyrus, "If you want blood—you got it!" Finally,
there was etched the defeat of the Assyrians, who
all took off after their general, Holofernes, was
killed. His headless corpse was carved in detail. 60
I saw the fallen city of Troy lying in ashes.
And Ilium, you were shown at your lowest
point, etched forever in that marble path.

No artist could ever have created images
like those, so amazing and lifelike. Their 65
suppleness and grace was mind-blowing—the
dead seemed like ashen corpses and the living
seemed pulsing and alive. I walked with my head down,
looking at the scenes as I went along.

(But hey, why bother with them, you sons of Eve? 70
Just keep on walking with your chins up, ignoring
the warnings carved in that path—at your peril.)

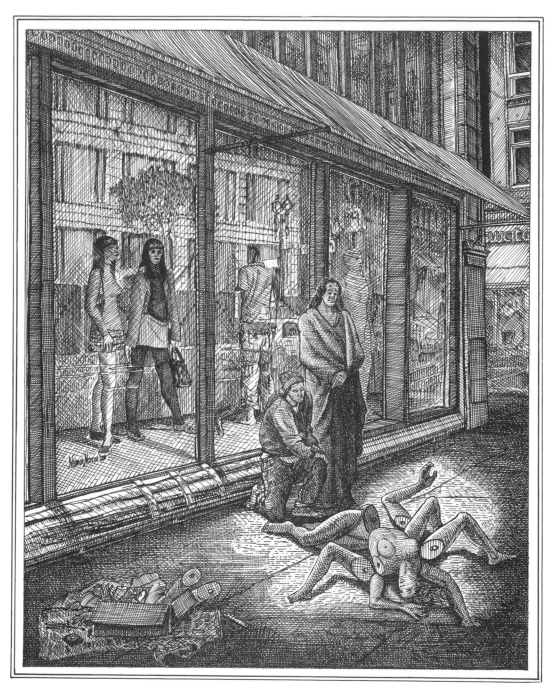

CANTO XII, 43–44: ARACHNE:

> *O crazy Arachne! I could even see you there,*
> *in despair and half-turned into a spider.*

By then we had hiked further around the
mountain than I thought, but as you can tell,
I was kinda zoning out on all the art and stuff. 75

But Virgil was on it, as usual, and as he
walked ahead he said to me, "Pay attention,
son—you've been completely lost in your
head for a while now. If you look over there
you'll see an angel coming toward us. 80
And did you notice it's nearly noon already?
Show the angel some respect by your attitude
so he'll be glad to give us a hand upwards;
we'll never have another day like this one."

By this point, I was used to old Virgil telling 85
me to hurry up or to pay attention or to follow him
or to look over there. It didn't bother me anymore.

I saw the angel all dressed in white coming
toward us. He was radiant, shining, with his
face glowing like a neon sign at twilight. He spread 90
his arms and his wings opened with them.
"Come," he said in a soothing voice, "the stairs
are nearby and the climbing's about to get much easier."

What does someone say to something like that?
O humankind, we're all born to go to Heaven— 95
why do we let such petty things hold us back?

The angel led us to a crack in the rock,
where he brushed a *P* off my forehead
with his wing, then bid us a good trip.

If you climb the steps to the mountaintop 100
with the church, up past the Rubaconte Bridge
and overlooking that orderly town of Florence,
there are steps carved out on the right of the
steep face that must've been made back in
the days when you could trust politicians— 105
the steps we climbed then were similar,
with the steepness of the climb to the Second

Terrace made easier by a series of steps cut
in a narrow passage. And while we climbed,
the song *"Blessed Are the Pure in Spirit!"* rang out 110
more beautifully than I'd ever heard it before.

Man! The pathways there were so different from
the ones in Hell. Down there all you hear is screaming
and moaning, but up here everyone's singing all the time!

As we climbed those sacred stairs I felt 115
like I had lost a bit of weight, like I was
lighter than I was back down on Earth. "Hey, Virgil,"
I said. "What's up? Did I just lose a bunch of
weight all of a sudden? Now I feel like climbing
up this mountain is going to be a cakewalk!" 120

"When the other *P*'s on your forehead
are removed like the first one—even though
they've already faded a bit—" he started, "then your
feet will feel lighter with desire. You'll barely
even feel the road beneath them. They should get 125
lighter and lighter as we hike higher up the mountain."

When someone looks at you funny, like
they're trying to tell you that you have
food in between your teeth or that you have
something weird on your face, the natural 130
thing to do is to use your hands to try
to figure out what they're staring at.
Using my right hand, I felt around and could
tell that now there were only six letters
left of the seven that had been on my forehead. 135

Virgil saw me doing this and just smiled.

CANTO XIII

ARGUMENT

The two travelers reach the Second Terrace, where the sin of Envy is purged. They hear voices in the air listing examples of Generosity: first mentioning the parable of Jesus at the wedding of Cana, second singing of how Pylades posed as his friend Orestes to spare his life, and last quoting the biblical commandment to "Love your enemies as yourself." They see a group huddled against the rocks chanting the Litany of the Saints. Dante speaks to Sapia from Siena, who tells him her story.

Soon we reached the top of the steps and
stood on the Second Terrace cut into the cliff face
of the healing mountain of Purgatory.
It was the same as the first, wrapping
all the way around the mountain, but, since 5
it was higher up, it made a tighter curve.
There was no one around and there weren't
any carvings, just bare rock and the cliffs
and the pathway, all dark and ashen colored.

"If we stand around here waiting 10
for someone to come along and
show us the way, we might be here
forever," Virgil said. He looked
up at the sun, squinting, and
turned to his right to face it full on. 15

"O sun above who never fails,"
he begged, "please show us the way on
this strange road, as we need guidance
now. You brighten and warm the world, and
unless there's a reason to hold us back, 20
may your light please guide us now."

We went on at a good pace for what
must have been about a mile back
down on Earth, when the sound of
singing voices came floating toward us 25
like a breeze. The voices were sweet and
welcoming and reassuring. The first
voice I heard loud and clear, flying
past me in the air singing, *"They
have no wine."* Before the words had 30

faded into the distance, another song came
distinctly through the air: *"I am Orestes!"*
it rang as it flew past us, echoing as it went.

"Where are those voices coming from?" I asked Virgil.
But just as I spoke, a third song came out of the air 35
around us singing, *"Love even those who hurt you."*

"This Terrace is for the purging of the sins of Envy,"
Virgil explained. "That is why the punishments
are lovingly dispensed. The restraint must
seem to be its opposite. You'll probably get 40
to hear it before we reach the Pass of Pardon.
Pay attention, though," he went on.
"If you look hard enough, you can just
make out a bunch of people huddled
up over there against the cliff face." 45

Squinting, I could barely make out a
group of souls dressed in shredded
rags nearly the color of dirty sidewalk.
As we got closer I could hear them all
crying out together, "Pray for us, Mary. 50
Pray for us, Michael, Peter, and all the Saints!"

Man, you'd have to be pretty
hard-hearted not to be bummed out
by what I saw when I got close
enough to make them out better. 55

Their penance was pitiful and just
about brought tears to my eyes. They
were dressed in the dirtiest clothes,
bunched together and resting their heads on
each other's shoulders, all pressed up 60

against the cliff. They were like homeless
people living in Golden Gate Park, or like the
kids selling Chiclets® at the border in Tijuana,
leaning on each other and making you feel
sorry for them—as much by their teary faces 65
as by their pleading phrases in broken English.

And in their penance, just like the blind back
on Earth, these souls were denied the very
light of the sun. Their eyelids were actually
sewn shut with iron threads, darkening 70
their eyesight like a blanket thrown over a
birdcage to quiet a squawking parrot.

Even though they couldn't see me, it felt
wrong to be there walking along and checking
them out when they didn't know it. Kinda creepy. 75
I turned to Virgil, but he knew what I was
going to ask even before I said anything.

"OK," he nodded, resigned. "But keep it short."

There I was with Virgil on one side,
between me and the edge of the cliff (there 80
wasn't even any railing or anything), and
on the other side was the whimpering crowd
of sinners huddling all around with tears
running from between those hideous threads.

"I know you all want nothing more 85
than to see the light of Heaven," I called
to them, "And you all know that sooner
or later you will. I hope that God's grace
will soon come and lift the fog from
your minds as it will from your eyes. 90

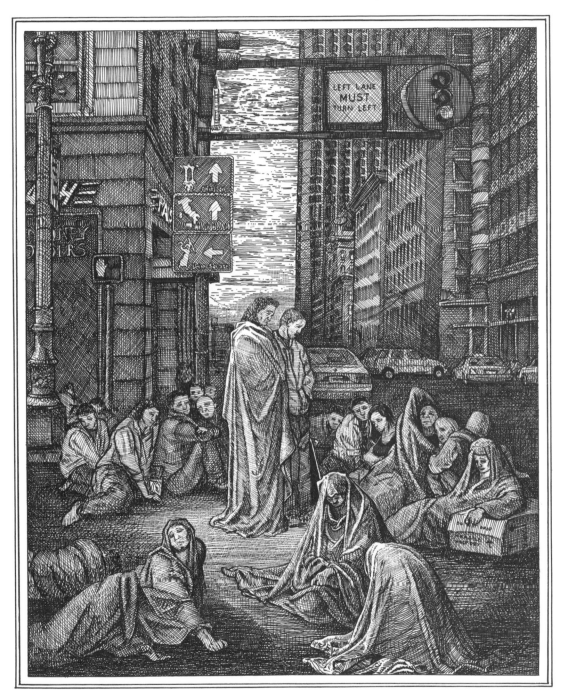

CANTO XIII, 73–75: THE ENVIOUS OF THE SECOND TERRACE:
*Even though they couldn't see me, it felt
wrong to be there walking along and checking
them out when they didn't know it.*

"But in the meantime, can I trouble you to
ask if maybe someone here is an Italian?
It'd sure be a big help if there was one."

"All of us are citizens of the True City,"
a voice called out mysteriously. "Are you 95
asking if any of us has ever lived in Italy?"

It seemed like the voice came from somewhere
farther along in the crowd, so I moved ahead
so they could hear me better at that end. I saw
one face in the group that seemed to be listening 100
for an answer because her chin was raised like
a dog sniffing the wind. "Please," I said, "you poor
soul who is learning to control yourself on your long
climb—if it was you who just said something,
please, tell me your name and where you're from." 105

"I'm from Siena," she said, "sent here to
pay for the sins of my life with tears,
begging for forgiveness and asking
Him to let us see Him. Although I wasn't
so smart, I was named Sapia. I used to love 110
watching other people's tough times more
than anything else. It's hard to believe,
but it went so far that by the end of
my long life I was even happy when
my own town was defeated! Crazy, I know. 115

"It was in a battle near the town of Colle and I
was actually praying to God that we'd lose. Our
troops were overrun and forced to retreat,
and as I watched them run I was thrilled
to see them chased by the enemy. I got 120
so excited that I raised my arms and
shouted to the sky, 'Aha! Now I'm not
even afraid of you anymore, God!'

"I never made peace with Him until my deathbed.
And even then nothing on Earth could've 125
saved me from a longer penance for my
sins if it weren't for the kindly prayers of
Pier Pettinaio, who graciously included me
in his thoughts out of kindness. But now
you tell me who *you* are, coming along 130
with your eyes open, I would think,
and breathing with life among the dead."

"I'm sure that my eyes will be sewn shut
one day, too," I answered, "but not for long.
Envy is maybe the least of my many sins. 135
What really worries me is the rocks those guys
down below have to carry around all the time.
It seems like I can feel their weight already!"

"If you're going to end up down there, how did you
get up here already? Who brought you?" she asked. 140

"You're right, I'm still alive," I answered,
"My friend here, who hasn't said anything,
 brought me along. If you want, I'd be happy
 to do you a favor when I get back down to Earth."

"It's a miracle!" she said. "It's obvious that God 145
 must love you. Please, yes, please mention me in
 your prayers now and again! But even better,
 if you ever find yourself near Tuscany again, could
 you mention me to my friends there and tell them
 you saw me? They'll be hanging out with those 150
 who are wasting their time digging for the Diana
 River—which is as lost a cause as those who
 dream of turning Talamone into a harbor.
 In the end, of course, the admirals will lose the most."

CANTO XIV

ARGUMENT

A couple of the blind souls are cackling and gossiping about Dante's live presence in this place and they finally ask who he is. When he answers, one of the ghosts goes on a long rant against Tuscany. Dante asks who they are and the speaker says he's Guido del Duca and his buddy is Rinier da Calboli. Then he immediately goes off again ranting about the degeneracy of Romagna, as well. As Virgil and Dante leave the Second Terrace and the souls of the Envious, they hear voices screaming out various examples of Envy. First they hear the voice of Cain, followed by the voice of the Athenian princess Aglauros, who was turned into stone because she envied her sister, who was loved by the god Mercury.

"Who in God's name is sauntering around
our little mountainside alive and breathing and
opening and closing his eyes whenever he wants?"

"Who knows? All I can tell is that he ain't alone.
You ask him, go on: he's closer to you. Just be 5
nice for once in your life and maybe he'll answer."

I heard two ghosts cackling off to my right, and it was
obvious they were talking about me. Packed
together, they lifted their faces like they wanted
to say something. Finally, one said, "Hey you! Lurking 10
in the prison of your skin but somehow on your
way to Heaven: in the name of God's green Earth,
please tell us who you are and where you're from!
We can't believe that you're here and still living.
We've never seen anything like it before." 15

"There's a river that flows all across Tuscany,"
I told them. "It starts in Falterona and snakes
through the landscape for more than a hundred miles.
I've brought myself here from that river's banks.
But I guess there's no point in telling you my name, 20
really, because I'm not famous or anything—yet."

"Hmm. If I'm fully getting what you just said,
or even just the gist of it," replied the ghost,
"then I think you're talking about the old Arno River."

"Hah! Why do you reckon he'd not want to say 25
the name of the river?" the other one asked.
"It's not like it's bad or anything, right?"

The first guy thought about it for a second.
"I've no bloody idea, really, but I do wish to

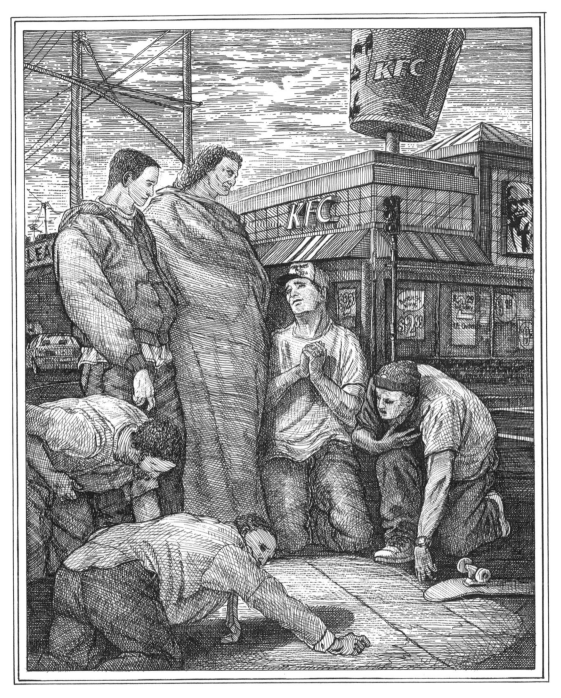

CANTO XIV, 1–3: GUIDO AND RINIER:

*"Who in God's name is sauntering around
our little mountainside alive and breathing and
opening and closing his eyes whenever he wants?"*

God that valley's name would dry up. 30
Virtue is a bad word all along that river
from its very source up on the steep
mountains that shadow Pelorus—where
they have the best water in the world—
all the way down to where it puts back 35
the water that the sky stole from the ocean!

"People avoid that place like it's a snake.
Either it's totally cursed, or they're all
corrupt in those parts, but either way . . . cripes!

"And the people who live in that horrible valley 40
have let themselves completely slip. It's like
they're feasting on Circe's foul wounds or something.
That river runs past a bunch of disgusting
excuses for humans who should be
eating bananas like the monkeys they are. 45

"And in its lower stretch—pah!—the whole area
is populated with rabid, snarling dogs, before
the river itself bends away in disgust.

"The water snakes down from there, and as
that stinking, swirling sewer gets wider, the 50
yapping dogs give way to vicious wolves.
It falls through some deep gorges and
runs through a region where they're all
like conniving foxes, full of shit, and
couldn't care less about human laws and traps. 55

"Oh, don't try to stop me, he heard what I said!
And it'll do him good to hear what I foresee"—
he ranted. "I see your grandson leading the hunt,
killing those bloody wolves—the same ones who

live in terror on the edge of that river. And you know 60
what? He sells their flesh while they're still alive!
And then slaughters 'em like dumb cows.
He has no honor. He kills it like he kills them!
And then he walks out of the stinking woods of
Florence, which are so gnarly and screwed up that 65
even a thousand years could never set things right."

You know how news of some big, natural disaster
in another part of the world is shocking to people
watching TV, even though it doesn't affect them?
The second ghost looked something like that 70
as he listened, overcome by sadness and
helplessness as he listened to the first guy babble on.

The way the sinner went on and got so worked
up about everything and the way the other
guy seemed to care so much about it all— 75
well, it made me want to find out more about
them, so I begged them to tell me their names.

"And why should I tell you what you won't
tell me?" the first guy asked. "But, seeing as you
must be in good with God, I shouldn't be so stingy, 80
I guess. My name used to be Guido del Duca,
and lemme tell ya, mate, I used to get so ticked off
and jealous! Whenever someone near me was happy
about something it seemed to really piss me off.
It's the envy of others—like Tonya Harding—that put 85
me here. What a sorry-ass bunch we make, huh?
Hopeless! We never were able to have partnerships,
never able to form bonds or join teams or anything.

"My buddy here is named Rinier, and he's
famous back in Calboli. But now his family 90
is so ruined that there's nothing left to inherit!
From Po to the mountains and from Reno to the sea,
you'll find a lot of families stripped of everything good.
That whole region is practically being picked apart
and overgrown by the noxious weeds of Envy, 95
which destroy any chance of good sprouting up.

"All the good ones are gone," he went on. "Mainardi,
the righteous Lizio . . . Where is Pier Traversaro?
Guido di Carpigna? Now, Romagnols are all bastards!
When is Bologna gonna produce another 100
Fabbro? What about a Fosco in Faenza,
who rose so high from such a low start?
Oi, Tuscan, I break down in tears when I remember
the great guys like Ugolin d'Azzo and Guido da Prata,
who used to walk among us. And that's not even 105
mentioning Federigo Tignoso and his pals,
nor the Traversaro family, nor the Anastagi—
both clans with no heir. And don't get me
started about all the ladies and gents there, all
their loves and so-called courtly play, which used 110
to be full of joy but is now full of pus and bile.

"I wish the whole town of Bretinoro would dry up!
All its good, noble families have already left,
fleeing the corruption and vice in its streets!
It's a good thing Bagnacaval has no sons, 115
and a damn shame that Castrocaro and Conio
even bothered breeding such sons as theirs.

And I'll tell you, we'll be way better off once Pagani's
demon Maghinardo Pagano da Susinana finally
kicks the bucket—though his scars remain. 120
And Ugolin de' Fantolin! Ha! At least your
name is safe, since you never had any kids
to even remotely taint your future lineage. But
that's enough. You better a get a move on, Tuscan.
I'd rather bawl my eyes out than say another word. 125
Just thinking about all this shit has bummed me out."

We knew those two must have heard us move
on, and we figured we were going the right
way since they didn't say anything as we left.

We went on along that lonely road until 130
a voice as loud as a backfire in a parking lot
rang out from up ahead of us. "I'll be killed
by whoever finds me!" it cried, and it seemed
to rattle past us in the air like an empty
garbage can rolling in the street. 135

We had just about recovered from the
surprise of it when the cry of another voice
came rushing past us in the air like dynamite:

"I am Aglauros, and I was turned to stone!"
it shouted. It was a bit hairy, and hearing the pain 140
in those voices on the wind, I snuck up a little
closer behind Virgil, but we didn't hear anything else.

"That was an iron fence," Virgil said, pointing.
"It was designed to keep men within fair boundaries.
But you humans stupidly take the bait and let Satan 145
reel you in like some fly fisherman, and nothing can
seem to rein you in once you're off. It's amazing,"
he said, shaking his head. "The very Heavens
are right over your heads, offering their eternal
beauty, but you keep staring only at the ground, 150
where God will eventually strike you down."

CANTO XV

ARGUMENT

A brilliant white light appears in front of the two travelers, startling Dante. It is the angel of Generosity. The song "Blessed Are the Merciful" comes floating up from below and this sets Virgil off on a long speech about love. They reach the Third Terrace, where Meekness, the opposite of the sin of Wrath, is exemplified by three visions. First Dante has a dreamlike vision of the Virgin Mary asking young Jesus why he lagged behind at the temple. Next, he sees a vision of Pisistratus refusing to take revenge on the guy who went after his daughter, even while his wife is egging him on. Finally, he sees a vision of St. Stephen asking forgiveness for the very mob stoning him to death. Then a thick cloud of smoke appears and ominously engulfs the two poets.

About the same amount of time was
left in the day as the time it takes for
the sun to go from dawn to midmorning.
Or, I should say, it was about midafternoon
up there on Purgatory (and it's midnight now, 5
here, as I write these words). The rays of the
setting sun were directly in our eyes then,
because we had walked so far around the curve
of the mountain that now we were heading west.

Suddenly an intense light hit me in the face 10
and made me look down. It was brighter than
anything I'd ever seen before. I was a bit
stunned by it and I cupped both my hands
over my eyes and squinted into the light,
trying to get a look at where it came from. 15

If you shine a flashlight at the surface of
the water or at a mirror, it will bounce off
and reflect back in the same, but opposite,
angle that the beam hits the surface.
So the reflection angle is equal to the 20
striking angle, as a simple experiment will
prove. The light that now shone in front of me
seemed to be reflected back at me in that same
way, and it made me turn away from its intensity.

"Jeez, Virg, what in Heaven's name is it?" 25
I asked. "It's so bright I can't shut it out!
Something's coming toward us, isn't it?!"

"Relax," Virgil smiled. "You'll be amazed when
you meet the guys coming down from Heaven.
This is our big chance to move up a smidge. 30
Pretty soon a sight like this isn't going to hurt
your eyes anymore, but instead will seem
better than anything you've ever seen."

Right in front of us stood an angel.
"Come right in," he said, all cheery. "This way to 35
stairs much easier to climb than those down below."

I followed Virgil on up, past the guy,
and down below us I could hear the song
"Blessed Are the Merciful" sung in the
distance mixing in the air with the words, 40
"Conqueror, rejoice." As the two of us
went up the stairs I was lost in thought
and I turned to Virgil and asked him, "What
did that one guy back there mean when he
went on about 'partnership' and 'denial'?" 45

"Because he knows how much he's paying for his sins,
he tries to put a good spin on it," Virgil answered.
"He hopes it will make it easier on the others. You see,
when people spend their lives chasing after the kind of
material things that lots of people in the world can have, 50
then envy of others becomes a driving force for them.

"But if people loved spiritual things more than material
objects, they'd be driven to seek them without
any fears of losing something. Listen: the more
of them there are joined spiritually, the more 55
they benefit together as a whole and the more
they help each other. That's called 'Charity.' OK?"

"The more you explain stuff the more questions I have,"
I frowned. "Even more so than when I was keeping all my
thoughts in my head and didn't say anything. Like, 60
how is it really possible that a lot of people can all
share something in a way that's better than if just a
couple of people have it for themselves?"

"Since it seems like you can only think about material
things," Virgil sighed, "you can't learn anything from 65
the light you see right in front of your face. There
is an intangible, infinite Good that exists in Paradise
that rebounds instantly into love, just like a tennis ball
off a wall. As much love as you hit at it, it bounces back,
and the more love you devote to it, the more you'll 70
get back in Eternity. Or rather, the more souls there
are up there that are loving, the more of them there are
worth being loved. Simple. When everyone loves everyone,

it's like mirrors in a dressing room, with all the love
bouncing around and reflecting from one to another. 75

"If this still sounds like gibberish to you, just wait
and ask Beatrice to explain it when you see her,
then you'll understand everything," he went on.
"What you should be concerned with right now is
working on getting those last five *P*'s off your forehead. 80
Suffering will heal them, just like it did the last two."

I was just about to answer when I saw that
we had come to the next Terrace up, and in my
excitement I forgot what I was going to say.

As I stood there it was like I instantly fell 85
into a trance or something and suddenly I
started to hallucinate. At first I saw a big temple
full of people and I could see this lady by the
door whispering, all nice and concerned, like a mom,
saying, "Why did you do that and scare us, my son? 90
Can't you see how worried your father and I were,
looking for you?" But before I could hear an answer
the view faded away just as suddenly as it appeared.

Then a new vision of a different lady appeared
in front of me. She was crying and distraught and I 95
sensed that her grief came from a frustrated
desire for revenge. "If you're really in control
of this town, Pisistratus—whose very name caused
trouble between the gods and that now stands
as the center of all the arts—then do something 100
to punish the guy who went after your very
own daughter!" And in the vision I saw the face
of the man she spoke to, calm and quiet as he
answered slowly, "What would we save for our
enemies if we go around harshing on our friends?" 105

Then a new vision faded in: I saw a huge,
angry mob surrounding a young guy, with
everyone throwing rocks at him at once,
shouting, "Kill him! Kill him!" I saw the
kid knocked to his knees by the deadly 110

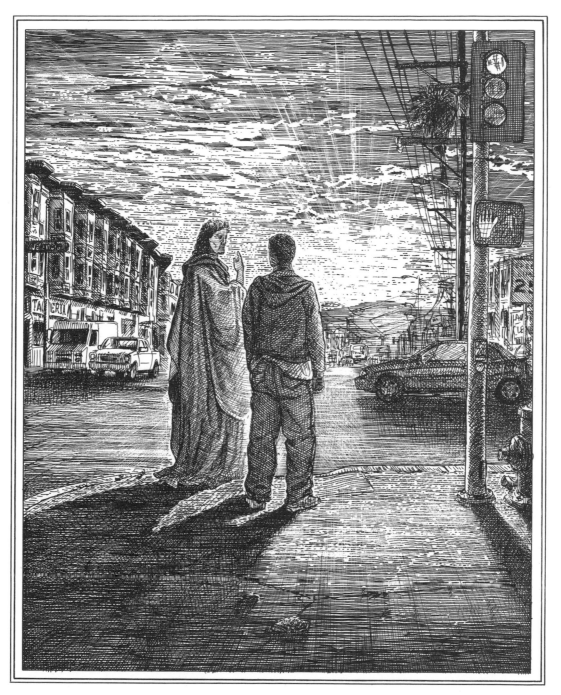

CANTO XV, 139–141: ON THE THIRD TERRACE:
As the sun descended in front of us,
the two of us kept walking, heading toward
the brilliant sunset.

blows but his eyes were still open and he
prayed, despite his agony, asking for
forgiveness for the murdering crowd, his
face shining with compassion to the very end.

A second later I started to come to my senses 115
and I realized where I was again and that
I had just been tripping out or something.

"Are you feeling alright?" Virgil asked
me when he saw how shaken up I was.
"You've been stumbling along now 120
like you're drunk or tired for about
a mile. You look like you're a bit
tipsy or groggy or something."

"Oh, man!" I said, sobering up.
"You wouldn't believe the weird 125
visions I just had! I just saw . . ."

"That's alright," he stopped me, putting up
his hand. "Even if you pulled your shirt
over your head you couldn't hide even
the smallest thought in your head from me. 130

"You saw those things for a reason. They
were meant for you to learn to relax and let
yourself be flooded by the peace trickling
down from above. When I asked you if you
were feeling OK it wasn't because I didn't know 135
what was going on with you. I asked because
I was trying to encourage you, like when a
single dad tries to get his kids up and off to school."

As the sun descended in front of us,
the two of us kept walking, heading toward 140
the brilliant sunset and looking into it as
far as we could. But slowly smoke started to
rise around us and came closer, dark and
thick, until we were surrounded and trapped
inside it. It turned the fresh air rank and blinded us. 145

CANTO XVI

ARGUMENT

Blinded by the smoke, Dante grabs onto Virgil. From out of the mist, they hear voices of the Wrathful singing "Agnus Dei." A ghost emerges from the smoke and Dante invites him to walk with them. He is Marco the Lombard, and he and Dante end up discussing the extent of corruption in society. Marco plays down the importance of astrology, then confirms the fact that Free Will exists and complains about the lack of leadership in politics and religion.

Even when I was down in the dark depths
of Hell, or in a subway when the power
went off, or under a starless, moonless
night sky, I had never been so engulfed
by such a thick blindfold of darkness. 5

The smoke swirled and stung my skin
and I couldn't keep my eyes open.
Virgil could tell I was stressing, and he
came to me and offered up his shoulder
for support. I stumbled and staggered 10
along like a blind man without a guide dog,
who moves slowly and carefully so he
doesn't run into something by mistake.

"Take it easy, son!" Virgil cautioned.
"This isn't a good place to get lost." 15

As we went I kept hearing voices in the dark
singing prayers to Jesus, the Lamb of God
who washes our sins, to be merciful and
give them all peace. Every prayer they sang
started with "*Agnus Dei,*" and they all sang 20
together, in one voice, in perfect, angelic harmony.

"Are those *souls* singing?" I asked Virgil.

"They are indeed," he answered. "Here for the sins
of Wrath. By singing, their sentence may be lessened."

"Who are you, whose body cuts through the smoke?" 25
a voice boomed from out of the darkness. "You're talking as
if you have one foot in the world that actually uses a calendar."

Virgil leaned closer to me and said softly,
"You should probably answer his question first.
Then ask him if he knows the way up this mountain." 30

So I called into the dark: "O you, who are here deep-cleaning
your soul so it's beautiful when God calls it back—come
along with us awhile and you'll hear some amazing stuff."

"I'll come as far as I can," he replied. "And
even if we can't see each other or anything, 35
at least we can hear each other, eh?"

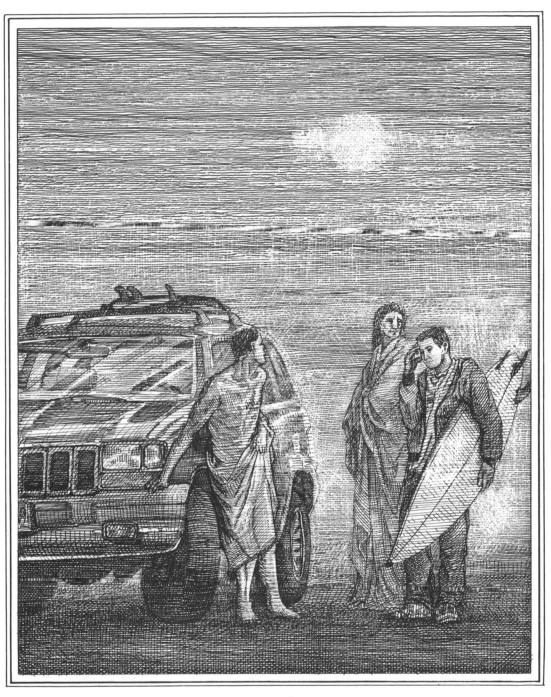

CANTO XVI, 25–26: MARCO THE LOMBARD:
"Who are you, whose body cuts through the smoke?"
a voice boomed from out of the darkness.

As we went I told him my story. "I'm still
human, and even though I'm not dead yet
I'm on my way up to Heaven. Believe it or not,
I've come by way of Hell. God gave me this special 40
trip as a gift. He wants me to see what goes on up
there in a way that's never been done before.

"But, hey: could you please tell me who you were—
well, before you died, of course—and tell us
how the heck we can get out of here?" 45

"They once called me Marco. I was from Lombard,
and, man, did I know about the ways of the world! I loved
the kind of good life no one even strives for anymore. Don't
worry, you're right on the path that leads to the stairs.
And could you do me a favor? Could you please 50
pray for me when you're back down in the world?"

"I promise I'll pray for you," I told him.
"But there's something that's been nagging
me for a while and I can't ignore it anymore.
I first thought of it back when I was in Hell, 55
and lately it's been bugging me again.
Something you just said reminded me of it.

"I completely agree with you: the world is totally
messed up and it seems to be getting worse.
It's like no one sees what's true anymore. But why 60
is it like that *now*? If you have any idea, tell me, so I
can spread the word around. It seems like some people
look to the stars for guidance, and others to the Earth."

"Jeez, that's a tough one," he said, sighing.
"You see, the world is essentially blind, 65
and that's obviously where you're from.
You guys in the world below blame everything on
astrology and chakras and suchlike, believing
that everything moves along on some grand plan.

"But if this were true, then there couldn't be 70
Free Will at all. If everything was pre-decided,
you'd never be able to make your own choices.

"Sure, the stars influence you a little bit, but not
for everything. But, hey: even if they did, you'd
still be able to clearly see what's right from wrong. 75
And though your Free Will might seem weak at first,
during its early battles with Fate, if you take care of it,
listen to it, nurture it—it can overcome everything.

"So it's like this: you are all free, but you're all
subject to a higher power at the same time. 80
Astrology can't control the noble logic of your
mind or anything. So if the world's all messed
up then it's basically your own fault, not the stars'.
Listen, and I'll explain what I'm getting at:

"God magically creates this simple soul, see, and 85
He loves the soul even before it's given flesh and bone.
Once born, it's playful and blissfully ignorant,
laughing when happy and crying when sad, leaning
toward pleasure, moved by a joyful Creator.

"But then the soul ends up following its own desires. 90
At first, it's attracted to some stupid little toy,
chasing after it all the time, enthralled with it, until
some guide comes and curbs its chaotic love.

"And that's the point! Men need the restraint
that laws bring, and they need a strong ruler 95
who knows right from wrong and can say so.
Of course the laws are there, but who polices 'em?
The Shepherd who leads you can offer a spiritual life,
sure, but at the same time he doesn't necessarily
have the power to make certain distinctions. 100
The flock isn't stupid, they see how their Shepherd
really only wants worldly things, and of course
they're more than content to eat what he eats.
Or to put it even simpler: the point is that corrupt
leadership is what's screwed the world up so 105
much. It's not Nature or Fate or anything else.

"Two suns used to shine down on the city of
Rome, and each lighted a different path. There
was a road of this world and there was God's road.
Well, now it seems the one has snuffed out the other, 110

the gun is now in the thief's hand, in other words,
and if things stay like this, chaos is inevitable. But if
both lights are joined, neither will fear the other.
Or if you need another example, think about when
a harvest is ready. Each plant is judged on its own merit. 115

"But, man, that area up around Po and Adige
used to be full of honest types and courtesy,
at least until the chaos of Frederick II's reign.
And now? If you're the kind of guy who's embarrassed
to talk to honest men—or be seen talking to 'em, even— 120
you can go there and be welcomed with open arms.

"But there are still three old codgers living there,
who remember the good old days. And you can
bet they're just waiting for God to call their number.
They are Currado da Palazzo, good Gherardo, 125
and Guido da Castel—who could've been
called 'the simple Lombard' as the French say.

"So spread the word: the Church of Rome, which once
blended the spiritual and worldly powers into one,
has sunk into filth and has thrown its reputation away." 130

"You make some pretty good points there, Marco,"
I said. "And now I get why Levi's sons
weren't allowed to own property or anything.
But who is this Gherardo guy you're talking about?
He sounds like a wise old man who lives 135
a peaceful life, removed from all that filth."

"Surely, you're pulling my leg!" he replied.
"How can you even speak Tuscan and
not know who the great Gherardo is?
I don't think he has any other name, unless 140
you wanna call him Gaia's dad as well.

"Well, God bless you, now. I need to get going.
See how the smoke's starting to thin out?
That means the angel's coming, and
I gotta split before he sees me." 145

And he left before I could ask anything else.

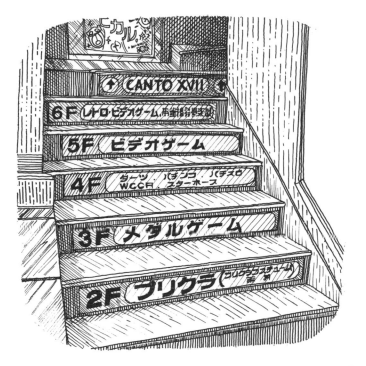

CANTO XVII

ARGUMENT

Dante and Virgil emerge from the smoke of the Wrathful at sunset. Three more visions then come to Dante: they are from the tales of Procne, Haman, and Amata and show examples of the sin of Wrath. The angel of the Meek appears before the two, erases the third P from Dante's forehead, and directs them to the next stairway up the mountain. As they climb the stairs they hear the beatitude "Blessed Are the Peacemakers" sung in the air around them. They reach the Fourth Terrace, the Level of the Lazy, at twilight and Dante suddenly feels weak and exhausted. They rest and Virgil delivers a long speech about love, explaining that all the sins purged on the slopes of Purgatory are derived from three basic forms of corruption of love.

If you've ever been stuck in a dense fog,
whether along the coast or up in the mountains,
and you were driving along and couldn't see
anything at all; and then you could slowly just
make out the sun through the mist like a pale 5
circle, then you know exactly what it was like
when I came out of that smoke and finally could
see the sun again, just as it was setting.
Following along behind Virgil, I strolled
out of the smoke into the last dying light of the 10
sun on the mountain, while far down below
the coastline was already lost in shadow.

You know, there are those moments when you suddenly
become sort of lost in a waking dream, oblivious to any
noise around you, almost in a daze. What is it that 15
calls up images to your mind even when your senses
are starved and lost in a cloud? I'd bet it must be
light itself, Heaven-sent, coming down from above.

A vision overcame me: I saw before me in my mind's
eye the hideous acts of Procne when she killed 20
her own son and fed the corpse to her rapist husband.
The vision was so powerful that nothing from
the real world could have snapped me out of it.

And then my dream took off and a new vision
came flooding in. I saw Haman on a cross, 25
crucified, his face twisted in rage and contempt even
in his last moments. At his side was Ahasuerus,
king of Persia, and his wife Esther, along with the
honest Mordecai, true in his words and actions.
And just as suddenly, this image disappeared, too, 30
like a soap bubble pops as it floats along.

In its place I saw a young girl sobbing and
saying, "My queen, Amata, why did you let
rage destroy your life? You committed suicide
out of your anger and despair over Turnus. 35

Well, now I'm the one who's lost you, Mother,
and it turns out you were mistaken and that
he's fine after all, not dead like you thought.
You let your anger get the better of you, and we lose."

If you're sleeping and suddenly a light hits your 40
closed eyes, it'll wake you up—although it takes
a little while before sleep fades away and you're
fully awake. The visions faded from in front of
me in just the same way, as if a bright light,
brighter than anything on Earth, had been 45
shown in my eyes. Blinking into the glare I looked
around to get my bearings and heard a voice say,
"Over here is the way up." I instantly focused
on the voice and wanted more than anything
to see who it was that spoke. I was so curious 50
and intent that I felt like I'd never be satisfied until
I found out who it was. But it was like trying
to look directly at the sun—no matter how
hard you try, you can't really see anything.

"Here is an angel of God who's come to guide us 55
on our way up, even before we've asked for help,"
Virgil said. "He hides himself with his own light
and treats us as one should treat another who
knows of a desire. Those who wait to be asked are
already half-guilty of denying the request, you know. 60
Let's get moving and follow his advice and
try to go as far as we can before nightfall,
since we can't climb upward in the dark."

When he finished he pointed and,
together, we started toward the stairs 65
ahead. As I touched the very first step I
heard words in the air again, like a breeze,
singing, *"Blessed are the Peacemakers,*
who never feel the sin of Wrath."

CANTO XVII, 75–77: REACHING THE FOURTH TERRACE:
As we reached the
top step I suddenly felt all the strength
go out of my legs.

By then the sun had sunk lower, its 70
last rays hitting the mountaintop now
high above us, and it was almost night.
The first stars appeared scattered across
the sky. 'Why am I so tired all of sudden?'
I thought to myself. As we reached the 75
top step I suddenly felt all the strength
go out of my legs and we stopped dead,
as if we'd just run into a wall. I stood
there for a moment, listening for some
noise on this new level, then turned 80
to Virgil and asked: "Hey, Virg? Where
are we and who gets punished on this
level? Just because we've stopped here
doesn't mean you have to stop talking to me."

"Those who meant well but were never able 85
to finish anything they were supposed to are
purged on this ring," he answered. "The lazy
are now put to work. But if you want to really
understand things then listen up—now's a good
time to fill you in on things while we rest. 90

"Neither God nor any of his creations ever
lack love," he went on. "If you stop to think
about it, there are only two kinds of love that
exist: natural love and rational love. Now,
natural love is always pure. But rational love 95
can go astray—by loving not enough or too
much, for example. As long as it's focused on
good and doesn't get sidetracked by worldly
objects too much, then it can't go wrong—if it
isn't sinful. But if it turns toward something 100
evil, or even if it loves the right things but loves
them too much or not enough, *then* one is going
against God Himself. So you can see why love
is the basis for all the good inside you, and
of the things you do that should be punished. 105

"Now then: a thing can't *not* love itself. It has to take
care of itself, so nothing that exists can hate itself.
And since it's impossible for any living thing to
exist completely on its own, separated, cut off from
the First Thing, from God, then no creature has the 110
power to hate God, either. So you can see, if you follow
my explanation, that the only thing left is the love
of harming one's neighbor, or, love perverted.

"This love demonstrates itself in three ways:
There is Pride—the one who sees his success 115
at the expense of his neighbor. (As if
healthy rivalry is taken much too far.) Next,
there is Envy—the one who fears that his
neighbor will succeed over him. (A fear of losing
through competition.) And finally, there is Wrath— 120
when one who has been wronged seeks only
to harm his fellow man. (A love of revenge.)

"The sins of these three types, in that order,
are being purged on the three Terraces below us.

"And now let me explain the other 125
kinds of love: Everyone has at least a
slight understanding that he desires some true
Good in life. This is the love of God. Simple.
If you fail to go after this love in life,
to work toward it, then you'll suffer the sin 130
of defective love, Sloth, or laziness, and
this is purged here on the Fourth Terrace.

"And there are even more divisions of good—those
of excessive love. This is love that is good as far as
it goes, but which cannot truly bring you to 135
Paradise because it is not the love of God, the
basis of all good. This love in excess comes also in
three forms, and they are purged on the Terraces above
us. But I'd rather you figure those out on your own."

CANTO XVIII

ARGUMENT

Dante asks Virgil to continue his lofty lecture on love, and it's so good that Dante's mind promptly wanders off into dreamy contemplation. All of a sudden, the two are overcome by a bunch of souls who turn out to be the Slothful. They are on the Fourth Terrace. A couple out in front start ranting about Zeal, using the Virgin Mary and Caesar as examples. Virgil has a quick exchange with the Abbot of San Zeno as the souls rush by. A couple souls in the back go on about their sins, citing a few Israelites with Moses in the desert and some of Aeneas's cohorts who stayed behind as examples of Sloth.

After Virgil finally finished his lecture,
he looked right into my eyes, trying
to make sure that I got what he said.
And I *did*, though I was still curious.
But I didn't say anything, 'cause I thought 5
he might be sick of my silly questions.
But old Virgil is more intuitive than that and he
knew I was too shy to keep pestering him, so he
encouraged me to keep asking whatever I wanted.

"Look, Virg," I started, "your explanation was so 10
crystal clear—I mean, I can see your point about
everything you said and what it meant and all.
You've been a great teacher and a big help. But, could
you please say more about what love means? You said
it's the root of every virtue and every vice, right?" 15

"OK, pay attention to what I'm about to say,"
he replied, "and you'll completely understand
about the folly of the blind leading the blind.
When it's born, the spirit is quick to love
and goes toward anything that pleases it, 20
fueled by its own pleasure-seeking impulse.
Your powers of perception will take one image
from the real world and imprint it on your
mind, forcing you to pay attention to it.
Now if you're attentive and inclined toward 25
something, that inclination is love. And *through your
pleasure*, Nature itself is born anew in you.

"It's exactly the same as how the flames of a fire
always burn up, reaching higher, obeying
their nature, seeking their true element. 30
So, too, does the restless spirit begin its journey.

"And, of course, the soul can't ever rest until it
gets and enjoys the thing it loved to begin with.
It should be clear by now that the people
who somehow think that every single love is a good 35
love are completely ignorant. They think that because

the *elements* of love are good, then the *object*
of love must be good, as well. But even if you start with
fresh ingredients, the meal depends on how it's cooked."

"Well, now I get it about love," I said, "thanks to 40
your explanations to all my questions. But
I'm still super-confused about how it all works:
I mean, if love comes from someplace outside of us,
and the spirit can't choose, how can you fault
it for loving something good or bad?" 45

"I can only explain about things that have to do
with Reason," Virgil replied. "You'll have to wait for
Beatrice to explain the rest—that's all stuff about faith.
Everything's particular essence, or substantial form,
is different from—though related to—actual matter, 50
and each has a particular, specific power
that's never really visible to us, except as it
manifests itself in actions and deeds—like how
you can tell a plant is alive because it's green.

"So, humans can't know where their knowledge 55
of these primal ideas comes from, or why
they desire certain primary things;
this is all just a part of you, instinctual, like
bees making honey. You can't blame or
control the primal human will or anything. 60

"And that other will, the more intellectual one,
could indeed conform to the more primal one,
but it's up to you and your sense of reason.

"And this is the key point," he said. "How you marry
your different wills is how your merit is judged and 65
how you can separate good love from bad love.
The guys who used their sense of reason to deconstruct
the world understood that man is free to make certain
decisions, which then gives us the concept of ethics.

"Assume for a second that every single love 70
that burns inside you is inevitable.
You can still 'Just Say No' to that love, right?

"Beatrice understands this human power
as Freedom of the Will; remember that term,
if she ever brings it up with you," he concluded. 75

It was close to midnight and the moon glowed
brightly, like the tip of a cigarette in a dark
room, making the stars seem dim as it
followed its monthly course westward,
same as the fiery sunsets the Romans see 80
between the islands of Corsica and Sardinia.

Old Virgil, who had made his hometown of
Pietola the most famous village in Mantua, was now
off the hook from the pressure I'd been giving him.
And because he'd given me such clear and 85
precise answers to my deep, muddled questions,
I relaxed a bit and let my mind wander.

That mellow mood didn't last long, though.
Pretty soon we heard a whole crowd of souls
coming around the mountain behind us. 90

In the old days there used to be these wild,
raging parties along the banks of the Ismenus
and Asopus rivers. That group of souls came
charging around the corner toward us like
they had just come from one, all hyped up 95
and happy in their hurry toward love and good will.

In a moment they were on us—the whole
enormous mass of those souls on the run. Two
of them were out in front, yelling as they came.
"Mary ran super-quick to the hills!" the first one called 100
out, while the other yelled, "On his way to take Ilerda,
Caesar took Marseilles first, and then hurried on!"
"Quicker, quicker, we can't waste any more time!"
and "Time is love!" yelled others from the back.
"Try to always do good, so grace will return!" 105

It was pretty chaotic, but Virgil was calm and called out:
"O spirits, I'll bet your eagerness is intended to atone
for past mistakes, inspired by a halfhearted desire

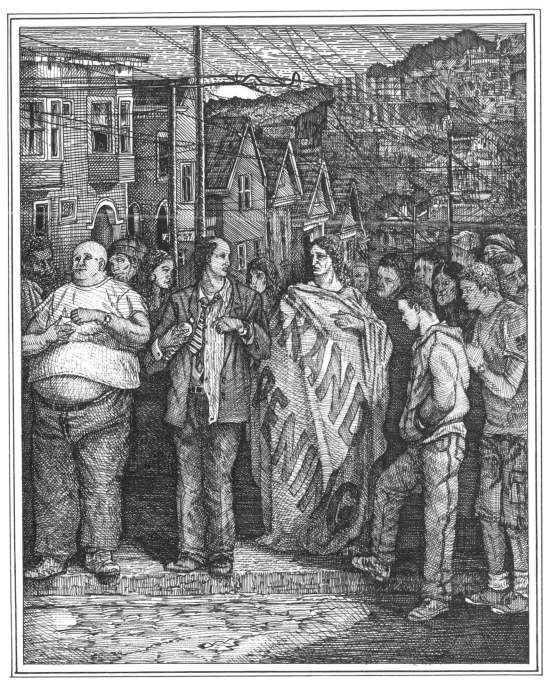

CANTO XVIII, 113–114: THE ABBOT OF SAN ZENO:
*"Just follow us, old man,
and you'll see exactly where you need to go."*

to do good. Well, this gentleman right here—who I swear is
alive!—wants to keep on climbing this mountain when 110
morning comes. Show us the way up, would you please?"

One of the ghosts rushing past slowed down and
answered him, saying, "Just follow us, old man,
and you'll see exactly where you need to go.
We're on a roll and can't stop running—we 115
need to continue our race. Forgive me if our
penance seems a bit self-serving and conceited,
but I was an abbot of San Zeno's in Verona, back
when that good emperor Barbarossa was in charge;
the people in Milan are still talking shit about him. 120
There's a guy there, Alberto della Scala,
who's just about to kick the bucket, and he's
going to seriously regret his control over that
monastery—instead of a proper pastor, that idiot
put Giuseppe, his own deformed bastard son, 125
into the position at San Zeno that I once held."

If he said anything else I didn't hear it because
me and Virg were left in the dust by the crowd.
But I was glad to hear even just that little bit.

As they went, Virgil turned toward me and said, 130
"Look at them go. Check out those two headless
chickens attempting to outrace their own laziness!"

I could see two guys in the back of the crowd shouting.
"Shame on all those Israelites who didn't move quick
enough when the Red Sea was parted for them! 135
And on all those guys who *almost* followed
Aeneas to help found Rome and gave up on the way!
Out of laziness you wasted your own lives!"

As I watched that mad crowd running away
into the distance until they were out of sight, 140
a new thought occurred to me slowly, which
rolled around and bubbled up other thoughts.
But my mind started lazily bouncing from one
idea to another, sleepily, until I finally closed my
eyes and let all those thoughts drift into dreams. 145

CANTO XIX

ARGUMENT

Dante dreams of a hideous woman coming toward him. She represents the sins that are purged on the upper Terraces of Purgatory: Greed, Gluttony, and Lust. As he stares at her she transforms into a beautiful, sexy Siren whose singing captivates him. Another woman appears who scolds Virgil for not protecting Dante, and Virgil rips off the Siren's robe to reveal her rotting belly. The stench of this wakes Dante from his dream and the two poets set off again on their climb. The angel of Zeal appears to them and wipes another P off Dante's forehead. When the two reach the next Terrace, they see crowds of souls bound face down in the dirt, crying and sighing and reciting a prayer from the Psalms. Virgil gives Dante permission to talk to one and it turns out to be the ghost of Pope Adrian V, who explains that this is the Fifth Terrace, where Greed is purged. Since they turned their backs on Heaven in life, now the faces of the souls at this level are forced into the dirt, away from Paradise. Adrian scolds Dante for showing him too much respect, saying that the relationships of people on Earth don't matter in the Afterlife, and finally he expresses his hope that his niece won't be badly influenced by the corruption around her in her life on Earth.

It was in the cool of dawn, when the
warmth of the midday sun hasn't yet
overcome the cold of night and the
morning fog; when astrologers can see
the stars of Fortuna Major rise before 5
the sun, leading the way for it to follow.
I was sleeping and in my dreams I saw a hideous
hag coming toward me, all cross-eyed and
babbling, stumbling along on her deformed
feet, her skin yellow, with hands like claws. 10
I stared at her and as I looked she gradually
began to change, reviving like a flower in the
light of the morning, stretching and straightening
her twisted deformities, flushing with the colors of
health and love. It was as if my stares had freed her, 15
and she began to sing in a way that got inside my
head and I couldn't shake the tune. She sang:

> "Beware the sailors in their ships,
> for I am the Siren of the sea,
> drawing them to me with my lips. 20
> Once they come they usually stay,
> Like Ulysses drawn to me
> from his course and led astray."

Before she had even finished singing
another, more saintly, woman appeared next to 25
me to ruin the Siren's plan. "Virgil!" she cried
out indignantly. "Who's this bitch? Aren't
you supposed to be watching out for him?"

Virgil stepped forward and, while looking at the
newcomer, he grabbed the Siren and in one yank 30
he ripped her gown open down to her waist.
A wave of putrid stink poured out of her and I woke up.

Virgil stood looking down at me. "I've called
you three times already, it's time to get up.
Let's go find that path for you," he said. 35

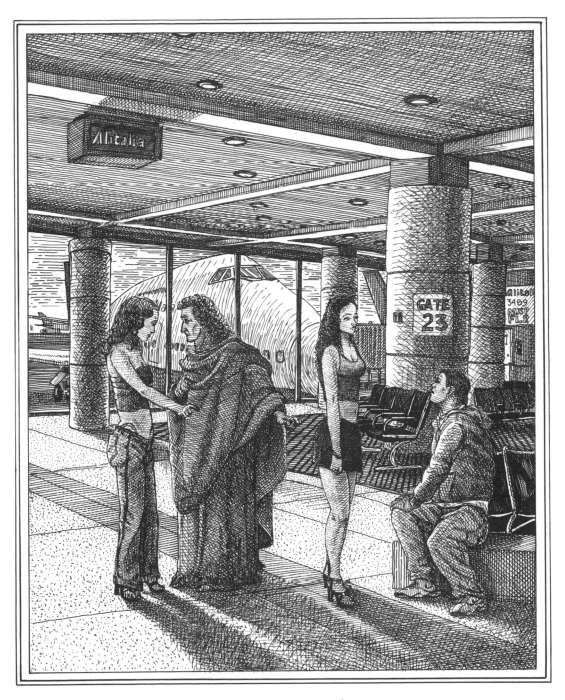

CANTO XIX, 26–28: DANTE'S DREAM:
"Virgil!" she cried
out indignantly. "Who's this bitch? Aren't
you supposed to be watching out for him?"

I got up. It was morning already and
daylight fell on all the cliffs of Purgatory.

With the sun at our backs we started off.
I was following Virgil but I was still thinking
about that gnarly dream I'd had, bumming 40
out a little, until I heard a voice in the air.
"This way," it said in a voice more
soothing and courteous than I'd ever
heard in my life. "Here is the path."
And then the wings of an angel, like a 45
big white swan's wings, waved to us and
pointed toward two high stone walls. The
wings swung over us, brushing my forehead
gently, and said, "Blessed are they who
mourn for they shall be comforted." 50

"What's wrong?" Virgil asked me as
we climbed up past the angel. "What's
got you looking so upset with the world?"

"I had the weirdest dream back there
and it's still creeping me out," I told him. 55
"I still can't get it out of my head."

"What you saw was the immortal witch who
causes those in the levels above us so much sorrow.
You also saw how you can get away from her,"
he reminded me. "But enough about that. Hurry up 60
now, you shouldn't be looking back but should be
concentrating on the heavens spinning above you."

If you put a peanut butter cracker on a table just above
a dog's head, he'll for sure stretch as far as he can
to reach it because he can smell it. Like a dog, 65
I made a final push then to reach the top of
the rocks we climbed, and in a last pull I
grabbed the top rock and scrambled up.

We climbed out of that crevice and stood on the
Fifth Terrace of Purgatory. All over the ground 70
souls were hog-tied and face down in the dirt,

sobbing. They moaned and sighed in unison
and eventually I could make out the words:
"My soul cleaveth to the dust," they sobbed.

"Oh, chosen ones of God, can one of you tell us 75
which way to the stairs?" Virgil called out. "And may
Hope and Justice make your sufferings easier to bear."

"If you don't have to lie here with us,
then sticking to the right side of the ledge
is the easiest way to go," a voice said 80
from somewhere nearby. The guy was
so close that I could see his face mashed
into the dirt. I glanced over at Virgil and
I could see him smiling and nodding in
approval even before I had asked him if I 85
could go and talk to the guy. Now that
I knew I could do whatever I wanted,
I walked over and stood looking over the one
that had just spoken to us. I was ready.

"Excuse me," I said to him. "I can see 90
that your crying probably helps you prepare
for your entry into Paradise, but,
please, can you take a break for a second
and tell me if there's anything I can do
for you back down on Earth to help you out?" 95

"I'll tell you why God has made us turn
our backs on Heaven," he answered.
"But first, you need to know that
I was a successor of Peter, alright?

"My family name comes from the river 100
Lavagna, which flows between the
towns of Sestri and Chiavari near Genoa.
In less than a month after taking office
I learned how heavy the pressures of
that job were and how hard it was to keep 105
from being dragged through the mud. Everything
else is a cakewalk in comparison! Unfortunately
for me my change of heart was too late.

"From that highest office I realized how
life can be deceiving. I saw that one's heart 110
can never rest down on Earth, and that one
can't truly reach higher aspirations. It was
only then that I learned to truly love the Afterlife.

"See, I had been miserable up until then, consumed
by greed and separated from God. You can 115
see now how I'm punished for it. This level is
for the purging of Avarice—it's the toughest
penalty on the mountain. Because we looked
to the things of the world in life, through our
greed, now Justice forces our faces into the dirt, 120
away from Paradise. Since greed made us
forget our love of goodness, which makes
life meaningful, now here we're bound
by the force of Justice, immobile, until
God is satisfied that we've had enough." 125

By then I was on my knees beside him and I
started to say something, but before I could get
two words out he guessed from my tone how
much I respected him. "What are you kneeling for?"
he demanded. "Out of respect for you," I said, 130
"It would feel wrong to me if I didn't."

"Get up, my brother," he answered.
"You shouldn't kneel down to me.
I'm a servant of the Lord just like you are.
If you ever grasped that expression from the 135
Gospels, 'Negue nubent,' about *no one* getting married
after the Resurrection, then you'd know our titles, position, civil
status, *phhht,* it all evaporates here. Now get up
and get out of here. I can't cry properly with you
hanging around, and that just delays my purging. 140

"The only one left alive to me now is
my niece Alagia, and I'm worried
sick that she'll go wrong from all
the bad examples of our family."

CANTO XX

ARGUMENT

Virgil and Dante walk carefully through all the Avaricious souls when one of the souls starts exclaiming examples of Poverty: Mary, for having Jesus in a stable; Fabricius, a Roman politician who enjoyed living in virtuous poverty; and St. Nicholas, who was very generous. The soul talking is named Hugh Capet. He begins to condemn his family for all its greed and then goes on to explain that during the day, the souls must cry out examples of virtue, while at night they rage against examples of Avarice. These include Pygmalion, Halliburton, Imelda Marcos, Midas, Achan, Sapphira, Heliodorus, Polymestor, and Crassus. As Virgil and Dante continue on, the mountain starts shaking and they hear the song "Gloria in excelsis Deo"; they're confused, but continue on.

They say the lesser will bends to the greater one;
and even though I wasn't satisfied yet and still
wanted to talk to him some more, I pulled back
and turned away. Meanwhile, Virgil was already
walking ahead, close to the walls of the cliff, all careful, 5
like a soldier who keeps close to the trees in the jungle.

There were so many souls up there, crying their
sins away, that they covered almost the whole
ground, leaving only a little space to sneak along the edge.

(Goddamn Avarice, you vicious and eternal bitch— 10
your selfish greed and insatiable hunger
have claimed more victims than any other sin!
And you stars above—some men think you
control the whole fricken world! When will
God come down and teach that bitch a lesson?) 15

Me and Virgil moved along pretty slow and careful,
but as we went, all I could think about were those
pitiful souls who were wailing and moaning back
there. Just then, somewhere up the path a bit,
I heard a shout of "Sweet Mary!" and it sounded 20
like some guy in a lot of pain or something.

"It's pretty obvious how poor you were, dear
Mary," the voice moaned. "Everyone could tell
because you had to have Jesus in a stable!"
"And holy Fabricius," the voice went on, 25
"you lived virtuously in complete and happy
poverty instead of in the filth of luxury!"

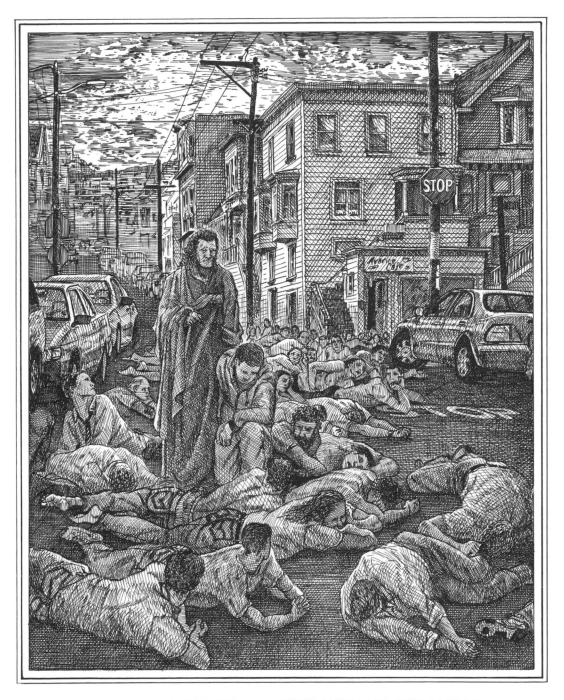

CANTO XX, 7–9: HUGH CAPET AND THE GREEDY:
There were so many souls up there, crying their
sins away, that they covered almost the whole
ground, leaving only a little space to sneak along the edge.

CANTO XX ¹²³

I was so pleased by what the voice said that
I ran up to where I thought it was coming
from, eager to meet the guy. And he kept right 30
on going, praising St. Nicholas's generosity in
donating all that cash to keep the nobleman's
daughters out of the whorehouse.

"O soul," I said, "everything you say
is right on the money; but who are you? And 35
how come no one else praises the praiseworthy?
Don't worry—you'll be rewarded for your answer,
especially after I go back to Earth to finish out
the rest of what will probably be a pretty short life."

"I'll answer you, no worries," he said, "And not 40
because I expect some help from you on Earth, but
because it's obvious that God wants you to be here.

"I was the root of that cancerous tree, the Capetian
monarchy, which ruled over all of Christianity so
poorly, so selfishly, that no good fruit ever grew there. 45
But even so, if the Flemish cities of Douai, Lille, Ghent,
and Bruges were ever strong enough to take on the
French, vengeance would be theirs, God willing!

"Back down on Earth, my name was Hugh Capet," he went on.
"And all the French kings named Louis and Philip 50
come from my lineage, unfortunately. My dad was
nothing more than a cattle rancher from near Paris,
but when all the old line of kings passed on
(except for the one who became a monk),
I suddenly found myself with the power of 55
the government in my hands. That new power
brought me money and so many friends that

eventually the widowed queen of France chose my
very own son to be her husband. Of course all their
kids ended up becoming kings, and while my 60
descendants held on to their modesty, they weren't
worth much—though they did no harm at first. But
then they figured out a way to scam control of Provence!"

By then he had really worked himself up and he went on.
"After that little victory, they got better at using violence 65
and lies to get more land. Later on, because they felt guilty,
they grabbed Ponthieu, Normandy, and Gascony. Charles was
invited to Italy, where promptly he offed old Conradin at
Tagliacozzo, and then poisoned Mr. St. Thomas Aquinas.

"Looking ahead—and not too far up the road!— 70
a second Charles is gonna come from France,
and boy, men'll see what he and his family are like!
He'll come over empty-handed except for the silent
gun of treachery like Judas would've carried, and with one
shot he'll burst the city of Florence wide open! 75
And he won't get land for this, no: only scorn and
shame! And it'll be even worse 'cause he just jokes
about everything and won't take responsibility for it, no!"

Now that he was going there was no stopping him:
"The third Charles, who I foresee being captured on 80
his own ship, is no doubt gonna try to sell his own
daughters, haggling over the price like a carney over
some stuffed animal. O greed! What other shit can you
cause? You've seduced all my heirs, so much that
they have no care at all for their own family! Past 85
and future crimes may seem like nothing, though,
as I see Philip the Fair go to Alagna and Christ

himself being made prisoner! I foresee all the gall
and vinegar refreshed; and Christ mocked again,
a second time killed between a couple living thieves. 90

"And then I see Philip the Fair as Pilate," he ranted.
"He's so pissed off and fucked up that he's
actually destroying the Knights Templar!
God! When am I gonna have the pleasure of seeing
Your mighty retribution on these guys?! 95
Your vengeance is certainly sweet and hidden!

"But hey," he said, suddenly conspiratorial: "You know
what I said earlier about the Virgin Mary and all that?—
the very shout that made you come over to me, in fact—
well, that's the kind of prayers we need to keep 100
up around here. At least as long as it's daytime.

"When it gets dark, that's a whole other story. That's when
we yell out against Pygmalion, Halliburton, Diebold, all the
money-grubbing power freaks, and how their complete and
total lust for gold turned them into hopeless thieving traitors. 105
And against that greedy Midas, whose stupid request,
all self-motivated, made him a starving wretch.
And Imelda Marcos, who's all barefoot now. Oh, the avarice
of hell-bound war profiteers, and then there's the stupidity
of Achan, who stole some of the spoils from Jericho 110
and made Joshua all pissed off, still! Next we
go off on Sapphira and her land-grubbing husband;
we praise the hooves that kicked Heliodorus
in the ass, and the shame of Polymestor killing
Polydorus echoes all over the mountain. 115
And the last yell is like this: 'Crassus, Hurwitz, why don't
you tell us what gold tastes like? *You* should know!'"

He lowered his voice again, "Sometimes, we yell
super-loud, other times softly. It all depends on how we're
feeling at the time—sometimes strong, sometimes 120
we're wiped out. See, I wasn't the only one singing
out stuff today; it was just bad timing that everyone
else was taking a break when you came by."

Before he could take another breath Virgil and I
got out of there. We were trying to go as fast 125
as we could between those pitiful ghosts when
all of a sudden the mountain started shaking
and swaying like a bridge in an earthquake.
It just about gave me a heart attack.
The Island of Delos, where Latona went to 130
give birth to the heavenly bodies of Apollo and Diana,
couldn't even have been shaken as hard as that. And at the
same time a great yell rose up from all the souls on the
mountain. It was so startling that Virgil tried to comfort me, saying,
"Don't worry about anything while I'm still your guide." 135

"*Gloria in excelsis Deo!*" all the souls sang out.
(At least those nearby were singing that hymn,
as far as I could tell by all the racket everywhere.)

Virgil and I stood there until the trembling stopped
and they finished singing, probably like the first 140
shepherds who heard that hymn must've done.
Then we kept going up along that holy road,
past more souls lying facedown on the ground,
lost in their suffering and penance. Never
in my whole life (unless I'm forgetting something) 145

had my lack of knowledge ever riled up such a
yearning to learn the truth as I felt inside myself
then, pounding in my brain as I tried to figure
things out. But I didn't slow us down with any
questions because I knew there were no answers there. 150

I just cruised along, quietly, lost in my thoughts.

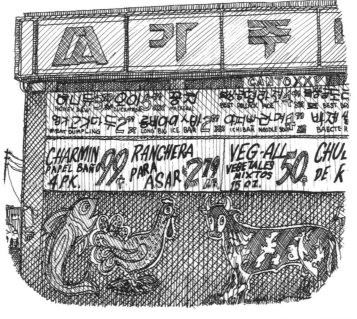

CANTO XXI

ARGUMENT

As Virgil and Dante pick their way along between the bodies of the Greedy, a soul comes up from behind and speaks to them. Virgil explains about Dante and their journey and asks the guy if he knows what caused the earthquake. He explains the laws of Purgatory that govern the weather and instill the desire for suffering in the souls on the mountain. Whenever one is ready to move up, the whole mountain shakes and the others cry out in praise to God. He then says that he is the poet Statius, author of the Thebaid *and the unfinished* Achilleid. *Statius goes on to say that his own work was inspired by this guy Virgil's book, the* Aeneid, *and then catches Dante smiling. This causes Dante to admit that he's smiling because standing right in front of Statius is Virgil himself. Statius gets all gushy and starts to hug Virgil but Virgil reminds him that they are just empty ghosts.*

Man, I had that deep-down spiritual thirst that nothing
can quench except for maybe the kind of drink to be
begged at the well from the woman of Samaria.
This thirst made me hurry along the path
among the sufferers and had me still bummed 5
out at the pain they had to endure, no matter how
just it was. Suddenly a ghost appeared—exactly like
Jesus is supposed to have appeared to the two
disciples on the road to Emmaus. We had been
sidestepping between the bodies on the ground 10
and the guy came up behind us so we didn't
even notice him until he said something.

"May God give you peace, my brothers,"
he said. We spun around, startled, and
Virgil responded to his formal greeting: 15
"May God's True Court lead you in
peace into Paradise, just as it has
condemned me to eternal exile."

"What do you mean by that?" he asked,
following us. "If you guys are shades unwelcome above, 20
then what are you doing climbing around up here?"

"If you take a look at his forehead
you'll see the marks that show he's
destined for Paradise," Virgil answered.
"But the Fates still have to finish spinning 25
the thread of his life on Earth first. You'd
also know that his soul is not allowed to
come up here by itself, like you and I,
because he can't see things like we do.
So I was called up from the very throat 30
of Hell to be his guide, and I'm taking
him as far along the path as I'm allowed.

"But can you tell us why the ground
trembled so hard a moment ago? And
why did everyone on the mountain 35
all cry out at the same time?"

Virgil's question was exactly the same one
I had been thinking myself and I hoped, with
some relief, that it would be answered.

"There are sacred laws that rule this mountain and 40
nothing can happen outside of them," the guy said.
"This whole place is like in a big sort of bubble—
nothing that's not from Heaven or caused
by Heaven can change anything up here.
It never rains or hails or snows around here. 45
There's never even dew or frost or fog once
you're higher than the three steps at the gate
down below. No mist, wind, rain clouds,
lightning, not even Thaumas's daughter Iris,
the rainbow, who flits around down on 50
Earth so quickly, is ever seen around here.
Even if there's an earthquake down below,
from a big one to a little aftershock—not
even like Loma Prieta—they are never
felt this high up. I don't know why. 55

"No, what makes the mountain shake up
here is when some soul finally feels that
it's ready to stand up and climb higher.
Then everyone else shouts out together in
thanks and praise. Just having the desire 60
itself to get up proves that you're ready.
It just takes over your whole soul and wills you
to get up one day and change your company.

"We've all had that desire before, but High Justice
goes against it and actually inspires one to want 65
to suffer instead—just as we once desired to sin.
I myself have been lying here in my own pain
for more than five hundred years and just
now I finally felt the desire to get up out of
the dirt. That's why you felt the shaking 70
and heard everyone shout in praise of God.
I hope He'll call me up to His level soon."

That's how he explained it and I felt a big relief,
like when you want something really badly,
finally getting it seems even sweeter. 75

"Now I understand," Virgil said, nodding. "Now
it all makes sense about why you guys all
stay where you are and about the earthquake
and all the shouting. But I'd still like to know
who you were and why you lay here for so 80
many centuries, if you don't mind telling us."

"Back in the days when Titus, emperor of Rome,
with God's help, captured Jerusalem and avenged
Christ's blood (which Judas had sold in the first
place) my fame was more widespread than 85
Christianity itself. My name is Statius and
people still know me down there," he answered,
nodding his head toward the cliff. "My poetry
was so good that they sent for me from Toulouse
to Rome itself to be honored. I wrote a book 90
about Thebes and was working on another one
about Achilles, but never could quite finish it.

"In all my work, though, I was most inspired by
the fire that sparked inside of me when I first
read the *Aeneid*, the same book that has 95
inspired thousands of others as well. That
book got me going and motivated everything
I did from then on. Without it I wouldn't have
been worth anything. My only regret is
that I wasn't alive in Virgil's time. I'd 100
spend another year on this mountain if
I could have had the chance to meet him."

When he said that I caught Virgil
giving me a look that told me not to
say anything. But sometimes no matter 105
how hard you try not to do something
your emotions can overcome you

CANTO XXI, 131–133: VIRGIL REVEALED TO STATIUS:

*Even as I was speaking he was dropping to his knees, ready
to give old Virgil a hug. "Brother, no!" Virgil stopped him.
"You're a ghost, and so am I, standing here in front of you!"*

and you can't stop them. A smile
flashed on my face in an instant
and I suppressed it as best I could, 110
but the guy stopped and stared
right at me, dead ahead, eye to eye.

"So that your sufferings will purge you, tell
me why you smiled just then," he demanded.
"Tell me what you meant by that look." 115

There I was, stuck in the middle, with one
guy telling me to shut up and the other
one telling me to speak. I stood there,
sighing. But Virgil knew how I felt and said,
"It's OK, don't worry. Go ahead and tell 120
him what he wants to know so badly."

"I'm sorry," I said to Statius. "I didn't mean
to put you off or anything. But this is going
to freak you even more: this guy here who's
leading me to Paradise is the poet Virgil 125
himself, the same guy who inspired you
to write what you did about Gods and
Men. To tell the truth, the only reason
I smiled is because you mentioned his name.
That's what made me smile, I swear." 130

Even as I was speaking he was dropping to his knees, ready
to give old Virgil a hug. "Brother, no!" Virgil stopped him.
"You're a *ghost*, and so am I, standing here in front of you!"

"Now you know how much you mean to me," he explained,
rising. "When you see that I even forgot for a moment 135
where we are and treated shadows like solid things."

CANTO XXII

ARGUMENT

Dante, Virgil, and Statius leave the Fifth Terrace and the angel erases another P from Dante's forehead. Virgil lets Statius know that he's always held him in high regard, ever since word came down about Statius's respect for him, but that he's confused about how such a seemingly nice guy could be greedy. Statius explains that opposite sins are purged on the same level: his was Prodigality. He goes on to say that it was in fact Virgil's Fourth Eclogue that inspired him to become Christian, but that he kept his faith a secret. It was this lack of exuberance that sentenced him to four hundred years back on the Terrace of the Slothful. They come onto the Sixth Terrace as they finish talking, and they notice a sweet-smelling tree in the middle of the road with clear water raining down from its top. As they get closer, a voice starts yelling out examples of the virtue opposed to Gluttony.

By now we'd already moved on past that angel
who directs traffic toward the Sixth Terrace.
He had erased another *P* from my forehead,
saying that everyone who looks for righteousness
is blessed. It made sense: his prayer was all 5
about celebrating thirst rather than hunger.
I felt lighter than ever before and those stairs
seemed less steep or something, and I walked
quickly behind all those nimble souls.

As we went, I listened to Virgil talking to Statius. 10
"Love that's ignited by righteousness always
kindles more love—it's the flame that keeps it alive,"
he explained. "So, ever since Juvenal came down
to Limbo to spend time with us down there,
and he told me of your respect and love for me, 15
I've felt only goodwill toward you, much
more than anyone else I've never even met.
Just walking with you makes the climb seem easier.

"But please tell me—or rather, please speak to
me like a friend, and please forgive me if my 20
questions seem a bit direct and tactless—
how could you, of all people, have greed
in your heart? You seem to have a perfectly
good head on your shoulders. What happened?"

When Virgil said this, Statius gave a little 25
half smile and breathed a deep sigh. "What you're
saying proves you care for me," he replied.

"But let me explain: appearances
can often be very deceiving, especially when
we don't know what the real truth is behind them. 30

"Your question makes it obvious to me that
you're thinking my sin was actually Avarice;
which is no surprise, considering where I am. But in
fact, I don't have any Avarice to purge from my past—
actually, believe it or not, I have too little! The sin 35
I purged down there was Prodigality. And here's
the thing: If I hadn't changed my overly generous
ways after reading what you had said about how
you were pissed off at human nature and wrote,
'How far will you not go, O stinking gold lust, 40
to drive man's eager appetite?'—if I hadn't read that,
I'd still be down below, crumpling under the weight
of those boulders. But when I realized how it was
possible to spread your arms too widely and spend too
much, then I repented that sin, and all others, too. 45

"How many people do you think will rise up bald
on Judgment Day, completely ignorant of the sin
of Prodigality, unable to repent either alive or dead?
And here's the rub: what clashes with this sin here
is its opposite as well," he smiled. "And both 50
sides of the coin rot away in the exact same place.
So while I'm stuck here purging myself along with
the rest who've been busted for Avarice, my sin's
actually just the opposite of theirs," he explained.

"But tell me something," Virgil cut in. "When you 55
wrote about Jocasta's twins in your book the *Thebaid*
and how they suffered so greatly," said the author
of the famed *Eclogues*, "You invoked Clio, the muse of
history, and it seemed to me to be a pagan story,
not something you'd write to praise God. 60
And if that's true, what beam of light
or burst of inspiration lit your path so
that you could follow behind St. Peter?"

"It was thanks to you, dear Virgil!" Statius replied, grinning.
"Your work inspired me to drink from Parnassus's springs. 65
You're the one whose inspiration led me straight to God.
You were that solitary truck driver in the night
who keeps his high beams on all the time, not just
for himself, but so that others can see the road as well!

"I remember you once wrote, 'The world is born again, 70
and Justice returns, and the first age of humans,
and a new prophet comes down from heaven.'
It was because of you that I became a poet, and I
have you to thank for becoming a Christian, too.

"But let me explain what I'm talking about a little better," 75
he went on. "Back then, the whole world was just starting
to discover true Christianity, which was being spread
by the Kingdom's messengers. And your words,
the ones I just quoted, were totally in line with
what the preachers were preaching at the time. 80
I used to go and listen to them every chance I got.
Those guys became so sacred to me that

when Emperor Domitian persecuted 'em,
it was like he was attacking a part of me, too, and
I grieved with them. For as long as I lived I helped 85
those guys out as much as I could, and the truths
that they taught made me turn away from other faiths.

"I was actually baptized even before I wrote
about the Greeks going to Thebes in my epic,
but I had to keep it a secret because I was afraid. 90
I pretended to be a pagan for years, actually. And
it was because of this casualness with my faith that
I had to spend four hundred years running around down
on the Fourth Terrace! But, my dear Virgil," he
continued, "you were the one who enlightened me 95
to the Way I now walk. And since we've still got a ways
to go up this trail, please tell me: Have you seen old
Terence lately? And Plautus and Caecilius and Varius?
Are they all down in Hell with you or what?"

"Well now," Virgil answered, grinning. "All those guys, 100
along with myself and Persius and the others, are
with Homer—who was always the most gifted of us—
and we're all stuck in the First Ring of Hell's
prisons. We talk a lot about that mountain where
our nine old Muses live and wonder what it's like. 105
Euripides is down there with us, and so is
Antiphon, Simonides, and Agathon, as well
as some other Greek poets and such. And there's
a fair few of your characters down there, too:
Antigone and Deiphyle and Argia, and 110
Ismene—who is as sad as ever—as well as

CANTO XXII, 125–127: ON THE SIXTH TERRACE:
*We were able to make better time now
that old Statius walked along with us.
He and Virgil set the pace ahead, chatting.*

the one who showed Langia to the Greeks,
and Thetis, and blind Tiresias's daughter,
and Deidamia and all her sisters as well."

By then we had reached an open area where 115
both the poets stood calmly by the edge of
the Sixth Terrace, eager to see what was ahead.
The four morning stars had faded by then, and
the sun was still on the rise toward noon, so it
must have been about ten or eleven in the morning. 120
Virgil had a look around to get his bearings and said,
"We should keep along the edge of the mountain
with the cliffs on the right, just like we have been."

By then it was familiar to keep in that direction
and we were able to make better time now 125
that old Statius walked along with us.
He and Virgil set the pace ahead, chatting,
and I walked along behind just listening
to their endless conversations about poetry.

Soon we came to a tree in the middle of the 130
road, and it smelled so strongly of fruit that it
made us all stop in our tracks. You know how
the branches on a fir tree grow up toward the sky?
Well, this tree was the opposite, with the branches all
growing down, probably to keep the souls from climbing it. 135
And from the left there was this little waterfall
coming from the rocks and spilling onto the top of the
tree, sprinkling all the highest leaves with cool water.

As the two poets approached it, a weird voice
suddenly came out of the tree and barked at us: 140
"Touching the fruit and water is strictly forbidden!
Mary was more concerned with blessing the
wedding feast than eating anything there,"
the voice intoned. "And now she prays for you!
Back in ancient Rome, the women were fine 145
with drinking nothing but water, and it was
fasting that brought Daniel wisdom as well!
The First Age of Man was a golden era,
when hunger made everything seem tasty,
and thirst made every stream taste like wine. 150
All that John the Baptist had to eat in the
wilderness were roaches and maple tree sap
and he owes his fame and glory to it,
described for you in Matthew's Gospel!"

CANTO XXIII

ARGUMENT

Dante is checking out the tree when Virgil calls him to hurry up. The three poets set off again but soon they are overtaken by a group of emaciated, skeletal souls who look at the trio as they pass them. One recognizes Dante and calls out to him. It turns out to be his friend Forese Donati, unrecognizable in his decimated state. He and Dante talk as they walk, catching up on things, and Forese explains how he's managed to get so high up in Purgatory even though he's only been dead for five years. Then he goes on a rant about the loose women of Florence. Dante explains what he's doing there as well, and Forese says good-bye and hurries off to join his group ahead.

I was standing there looking up into that tree,
trying to see where the voice was coming from, like
someone who wastes his life bird-watching, when
old Virgil, who had been more than a father to
me, called. "Come on now, my son," he started. 5
"We should spend our time more usefully."

I turned and hurried off after those two poets.

Listening to them talk as we went made the
climb seem easier. Soon a sad chanting could
be heard in the air. *"Open my lips, O Lord, and* 10
my mouth shall proclaim your praises," it sang,
inspiring a mix of pain and pleasure inside of me.

"Hey Virg, what do you think that is?" I asked.

"It's probably coming from some souls purging
themselves of their debts to God," he answered. 15

Then from behind us came a crowd of souls
who passed us quickly, glancing back as they
went, silently, with that double take you do
when you think you recognize someone in
public but it turns out it's not who you thought 20
it was. They went quietly, concentrating,
with pale, hollow faces, their eyes sunk deep
in their sockets and their bodies so skinny
you could see all their bones. I bet even
Erysichthon didn't look that skinny when 25
he was at his hungriest and facing starvation.

'Jeez,' I thought to myself, 'look at those guys!
They look like they could be Miriam during the
siege of Jerusalem, or like something from
Auschwitz.' The sockets of their eyes 30
were like open manholes, or black *O*'s, and
their brows and noses formed an *M* so that
their faces seemed to spell "OMO." If you
didn't know it, you'd never believe

they ended up like that just from the fragrance
of fruit, or of springtime itself, even.

I was checking out how skinny and
beat up they looked because I didn't
know what caused it yet, when one
of them turned his lifeless eyes, deep
inside his skull, at me and stared.
"Thank God for this gift!" he cried out.

I would never have recognized him by his hollow
face, but I knew his voice even though it came
from that skinny, ragged soul. It crept into my
brain through my ears and triggered memories
of my friend Forese, so that I saw his face in my
mind even though I didn't see it in front of me.

"Please, my friend," he begged. "Ignore this
scabby face and my horrible rash. Forget
about this wasted body of mine and tell me
what the heck you've been up to! And introduce
me to your two buddies there. Come on,
fill me in. What's up with you, man?"

"Seeing you on your deathbed made me cry
once," I answered. "And now, seeing you like
this, with your face so ruined, is even worse! For God's
sake, tell me what's happened to you! Don't go asking
me stuff, I'm speechless, and you know it's no use
trying to talk when your mind's on something else."

"It's that tree back there," he said. "God designed
that thing so that some kind of power flows through
the water and the tree and makes us shrivel up like
this. All of us here sing while we purify ourselves
through thirst and hunger, while at the same time
we regret having stuffed ourselves so much in life.
The smell of the fruit and the spray of the water
down the leaves make us all super-crazy hungry,

35

40

45

50

55

60

65

CANTO XXIII, 43–45: FORESE AND THE GLUTTONS:
> *I would never have recognized him by his hollow*
> *face, but I knew his voice even though it came*
> *from that skinny, ragged soul.*

and we suffer it over and over as we run around
this ring. Every time we go past the tree it just 70
starts all over again with the pain. (Oops, I guess
I should have said 'comfort' instead of 'pain.')
It's the same desire that keeps us coming
back to the tree again that made Jesus cry out,
'Eli, my God,' as he hung up there on the cross." 75

"Jeez, Forese," I said, "it's only been about five
years since you passed on from that life to this one.
If you were so far gone that you weren't able
to sin in those last moments of your life, then
how is it that you managed to make it so high 80
up this mountain in so short a time? I thought
for sure that I'd find you down below on the
ring where the lazy ones have to pay for the
time they wasted in life with time spent there."

"It's all thanks to my good wife, Nella, 85
now a widow. It's her constant tears that
have moved me up so quickly to this Terrace of
sweet painful thirst. It's her constant prayers
that were able to get me off that Terrace
of waiting and set me free to move up 90
through the other ones. My dear, sweet
Nella who I loved so much—they don't make
many like her. The worst neighborhoods
of Sardinia are nothing compared to that pit
Florence where I left her. Even the Sardinians 95
are more pious than the women are there!

"But I have something to tell you, my friend.
I can see a time in the near future when
there will be bans clamped down on
those floozies in Florence who strut 100
around the streets with their tits out.
What kind of woman is it that you have
to teach them the simple decency of
dressing properly when they go out?

If these sluts had any idea of what's 105
waiting for them here in the Afterlife
they'd be freaking out right now!

"I'll tell you, if what we souls can
foresee from here is right, they'll be
regretting it even before their own kids 110
grow up. But now tell me what's up with
you, good buddy. You can see how everyone
around here is just checking you out,
what with your shadow and all."

"I'll bet that whenever you stop and 115
think about the times you and I spent
together it must bum you out," I said.

"As for me, I was called away from
that life by this guide of mine here
just a few days ago, when the moon 120
was full. So far he's guided me, in my
own living body, through the blackest
night of Hell down below. And since
then we've been climbing higher
and higher up this circular mountain 125
that makes you fix whatever you broke
in your life. Virgil here says he'll
take me as far as where Beatrice is, but
from there I'll have to go on without him.
That's him there," I said, pointing to Virgil. 130

"The other guy has just been released
from his sufferings. You probably felt the
mountain trembling for him not too long ago."

CANTO XXIV

ARGUMENT

Dante and Forese keep talking, and Forese mentions that his sister has already been taken up to Heaven and then starts pointing out some of the Gluttonous: Bonagiunta Orbicciana of Lucca, Elvis, Chris Farley, John Belushi, Carnie Wilson, and Oprah Winfrey, Pope Martin V of Tours, Ubaldino della Pila, Boniface de Fieschi, archbishop of Ravenna, and the Marchese degli Orgoliosi of Forli. Dante starts talking to Bonagiunta, who prophesies that some woman named Gentucca will make Dante appreciate the city of Lucca. He then asks him if he wrote the poem "Ladies Who Have Intelligence of Love" and they talk a bit about it. After they're done talking, the rest of the Gluttonous head off, except for Forese, who prophesies the death of his own brother. Dante is then confronted with another tree in the road, which cries out more examples of Gluttony including drunken Centaurs and some of Gideon's soldiers. Afterward, the angel of Abstinence leads Dante, Virgil, and Statius onto the next Terrace.

Talking didn't slow down our walk, and walking
didn't slow down our talk: we chatted as we went
like a pair of lunch break secretaries on a power walk.
All the ghosts we passed, who looked so beat up it was
like they'd died twice, were blown away by what they saw— 5
a living, breathing, walking man right in their midst!

I picked up right where I'd left off with Forese:
"I guess the old guy is climbing a bit slower
now 'cause of his new buddy, eh? But, hey, do you
have any idea where your sister Piccarda is now? 10
And do you think there are any other ghosts here
I should meet? They're all just gawking at me."

"Well, my dear sister, who was always as good
as she was pretty, is actually up in Heaven
now, all full of joy and hope, of course." 15

He said that, then thought for a minute. "Hmm. I guess
there's no reason I can't tell you the names of these guys—
especially as we're all unrecognizable now, anyways.
Over there," he pointed, "is that Luccan guy,
Bonagiunta; the one behind him with the 20
superhaggard face is Simon de Brie. He was
actually a Pope from Tours, and he's purging
those Bolsena eels he loved cooked in Vernaccia wine."

Then he went on to name a whole bunch of
the others, one by one, and they were fine with it—no one 25
was pissed at being called out. There was Elvis,
Chris Farley, John Belushi, Carnie Wilson, and Oprah Winfrey.

I saw souls actually chewing air they were so hungry:
Ubaldino della Pila, and Boniface of Ravenna,
who fed everyone who followed him and his bishop. 30
And I saw Milord Marchese among the rest. When he

was in Forli he was drinking all the time, but even so,
no one there ever saw him satisfy his thirst.

Sometimes a certain face will stand out in a crowd,
and the same thing happened here. I caught the eye 35
of one guy who seemed to be staring at me.
He mumbled something that sounded like "Gentucca,"
and his parched lips, emaciated by justice,
could barely move enough to form the word.

"Hold on," I said to him. "You act like you want to say 40
something to me, so why don't you pipe up a bit, so
your words can actually communicate like they're supposed to?"

"There's a lady who has already been born," he began,
sputtering. "She's single yet, and she'll be the one who'll
make you respect my poor, misunderstood city of Lucca. 45
Mark my words, Pilgrim," he went on, dryly. "And
if this prophecy seems murky to you now, don't
worry, future happenings will make it all clear.
But tell me something, living one: do I not
see here before me the poet who wrote 50
'Ladies Who Have Intelligence of Love'?"

"Yeah, I wrote that," I admitted. "In my work,
I'm often inspired by Love; and once inspired, it's
all I can do to give it form and bring it into the world."

"Ah, that makes sense," he answered. "Now I can see 55
the obstacle that was holding me and Guittone and
the Notary back from that new style of poetry.
Now it's obvious how your inspiration follows
completely along the path of Love, which is a
lot different than what we were doing, for sure. 60
And I'm probably the expert on the two styles:

no one's more aware of the differences than I am."
Then, all smug and pleased with himself, he moved away.

Traffic bunches up at the tollbooth before the
bridge in a mass, but once through it speeds up again 65
and the pack strings out into a long line of cars.
It was the same with that crowd of souls, who began
to form a line and then took off away from us
as fast as their scrawny legs could carry them.
But like a tired jogger will sometimes slow 70
his pace and move off to the side of the path
to let others pass while he catches his breath,
Forese held back as the others took off, letting them
rush on by while he kept pace with my human bones.
"When will we see each other again?" he asked. 75

"Well, I don't know how long I'll live," I said.
"But even if I end up back here sooner than
later, I'll have already left my heart behind,
'cause the place I was born to live in is
being raped of all good even as we speak; 80
I know it's doomed to destroy itself."

"Don't worry too much," he said. "I foresee that my
brother Corso, the guiltiest bastard of them all, will be
dragged into the depths of Hell by a heinous beast.
And every single hairy step the beast takes will be 85
faster than the last, spinning faster and faster
until finally it throws his body into a mangled
heap. Those stars above, I swear to you, will not
revolve much longer before all this goes down,
even if I'm being a little vague about it. But now 90

it's time for me to split. I've been keeping pace
with you slowpokes for too long, and as you
know, time is very important to us over here."

Sometimes, a teacher will rush
out into some school-yard fight, 95
wanting to make sure no one gets hurt.
Forese took off like that, at a sprint, leaving
me to go my own way at my own pace,
protected by Virgil and his new buddy Statius.

I watched him until he got so far ahead of us 100
that I couldn't make him out any clearer than
his vague predictions had been, and then
I finally turned away. Only then did I see
another tree, its branches hanging with fruit,
right in the middle of the road ahead of us. 105

A bunch of souls were squatting underneath
it, crying out and begging for something up in
the tree. They were like drunken panhandlers who
beg for handouts from people in the street
who ignore them as they pass, eating as they 110
walk and tempting the bums even more.

Finally, the souls gave up and trudged away, so
we were able to walk right up to the tree, which had
remained ambivalent to all their begging and pleading.

"Keep walking. Do not come closer," a weird 115
voice commanded from inside the tree. "Farther
along the road there is the tree that gave its fruit
to Eve. This plant is just an offshoot from it."

CANTO XXIV, 100–103: DANTE AND FORESE:

*I watched him until he got so far ahead of us
that I couldn't make him out any clearer than
his vague predictions had been, and then
I finally turned away.*

Spooked, I kept close to Statius and old Virgil as we
snuck past it, hugging our way along the edge of the cliff. 120

"Remember those filthy Centaurs," the voice
continued, "who drunkenly tried to rape the
princess before being slaughtered by Theseus.
And remember how the soldiers of Gideon's
army dropped their guard when they drank at the 125
river and he left them behind on the road to Midian."

And as we continued past the tree we listened to it
reciting various acts of Gluttony and the
assorted and sordid punishments of its sinners.

Once past it, we continued walking along, 130
calmly and quietly, each of us lost in our thoughts.

We must have gone about a thousand yards or so when
another voice cried out suddenly from nearby,
"You three: what are you thinking about right now?!"

It came so suddenly that it startled me and I 135
jumped. I lifted my head to see where it came
from, and an angel stood on the path beside us,
glowing a brilliant burning red, like the
deepest, hottest coals on a barbeque. "If you're
looking for the way up, kiddo," he smiled, 140
"then turn right here. This is the way to peace."

And even though I was almost blinded by the angel's
glow, I reached out and grabbed Virgil's arm
to stop him and make him turn like the guy said.

Then, softly, like tradewinds across Indonesia, 145
carrying the smells of oranges and incense
in fragrant waves along the beaches, I felt
a breeze brush across my forehead, as if
some gentle wing had stroked it, and I
sensed a sweetness like milk and honey. 150

And the sound of a chorus rang out, singing:

> *"Blessed are the ones so full of grace that*
> *their love of food does not turn them into*
> *pigs, but makes them starve for virtue."*

CANTO XXV

As the three poets are climbing up the Sixth Terrace Stairs, Dante asks what's up with the bodies of the souls—how can they be so skinny if they're just ghosts? Virgil passes the question off to Statius, who goes off on a long, muddled speech about how the "Rational Soul" is formed in the body as the fetus grows and how that soul leaves the body and gets the form that you see in the Afterlife once the body dies. Finally they reach the Seventh Terrace, where the sins of Lust are purged in a roaring fire that shoots out of the cliff and forces them to walk along the very edge of it. The burning souls sing the beatitude of Temperance and recite examples of chastity in the Virgin Mary and the goddess Diana.

I could tell that it was time for us to pick up
the pace a bit, because by then the sun was already
in Taurus and the evening sky was left to
Scorpio's stars. When someone is really focused
and determined to do something, it's usually pretty 5
hard to distract them and they plow right ahead to
the end of it. The three of us went ahead like
that, single file, through a gap and started up
some stairs in the narrow space between the rocks.

And just as an old lady at a crosswalk will 10
hesitate, and then start across a busy street but
then stop and retreat back to the curb,
afraid to begin, I hesitated with my thoughts
and questions as we went. I'd start to say
something, then change my mind, silent. 15

"I can tell you're thinking about something,"
Virgil said to me, even though we were
walking along at a good pace. "Out with it."

"Well, I've been wondering," I started, encouraged.
"I mean, if those guys back there were just ghosts, why 20
are they so skinny, when they don't even need food?"

"If you remember the story of Meleager that
Ovid told," Virgil answered, "about how the wood
in a fire was burned but never consumed,
it shouldn't seem that strange. Or better yet, think 25
about how when you look in a mirror your reflection
moves whenever you do. Get it? But to really
make it clear to that curious brain of yours,
Statius here can probably explain it better.
He'll make sense of it all for you right away." 30

"I'll explain how it works to him,"
Statius said, "but only because I'm
too flattered by you to say no to you."

"Now, let your mind relax and try to
absorb what I'm going tell you and I'll 35
explain what's been bugging you," he began.
"You see, in the body there exists a blood
that's perfect. It's perfect because it
remains inside the heart and doesn't run
through the body's veins—like how good 40
wine improves in the quiet of dark cellars.
It forms in the heart and there it acquires
the power to build out the elements of the
human body, just like an electric current
from the wall socket powers appliances. 45

"In procreation, that blood flows from the
heart down to the unmentionables, where
it mixes with the other blood and the two
become blended. Each one is determined
to play either an active or a passive role, 50
depending on where it came from, and the
two bloods together begin to work on the
emerging embryo. First they clot, then they flow,
molding the fetus into human form. Now the
active blood forms the soul—it's sort of plantlike, 55
but at that point it's still forming—and it soon
reaches a stage where it's like a jellyfish. From this
the organs begin forming, each for its own purpose,
and the whole fetus continues to grow and
swell with the force originated in the heart. 60

"But how from this animal a child is formed,"
he continued, raising a finger for emphasis,
"is still not evident. A smarter brain than
yours even made a wrong turn at this point.
His mistake was separating the soul from 65
the *possible intellect* because he found
no organ for it. But listen closely to my
explanation here: once the articulate brain has
reached perfect form in the embryo, the Maker
comes and breathes the spirit into it. 70

Pleased with His own handiwork,
I'm sure, He gives it the power and
virtue to absorb what it finds active
there, so that the soul is formed as one
complete thing that is alive and sensitive 75
and self-aware. And if you think that sounds
implausible, just think how the sun's heat is
able to work on the vine to form grapes for wine!

"Now, when Fate has spun its course
to the end of life, the soul is freed from 80
the body it carried with it—and from both
the memory of the human and of the Divine.
While the body no longer lives, the soul
contains the memory, intelligence,
and will, in even more refined and 85
attuned states than they were in life.

"The weight of the now-free soul falls to
either of the two shores of the Afterlife,
Purgatory or Hell, and only then
discovers what will come of it. 90
Once a soul is there, in real space,
the informing power comes and
reshapes the form of the body, now lost,
around the soul. And just like light can pass
through the air and create visible forms, such 95
as a rainbow, so the air around the soul must
form itself around the shape of the soul.

"And just as the flame must go wherever the
candle goes, this new form now envelops
the soul. Since it is the air that makes the soul 100
visible, we call it a 'shade' or a 'shadow,' and
it forms the organs for the senses as well.

"And that's how we, as souls, can talk and laugh
and cry and create the songs and moans that you
hear as you wander around the mountain. The 105

CANTO XXV, 109–111: THE FIRES OF THE SEVENTH TERRACE:
By then, thankfully, we had reached the final Terrace
by following the usual right turns. But there I found
something else to worry about.

shade of our souls takes the form of our desires,
it changes as our feelings change. And that,"
he concluded, "is what amazed you back there."

By then, thankfully, we had reached the final Terrace
by following the usual right turns. But there I found 110
something else to worry about: Flames shot straight
out of the rock walls toward the edge of the cliff, where
they met a blast of air shooting up that bent them at the
ends, so there was only a narrow space between
the fire and the drop off the edge. It was there that 115
we had to walk, single file, and I was freaking out—
there was fire on one side and a void on the other!

"Here's where you really have to watch it,"
Virgil said, unnecessarily. "Keep your eyes on
the path because one wrong step and you'll slip." 120

From the very center of the fire I could hear the
sound of voices. *"God of Supreme Clemency,"* they
sang, from the hymn against lust. It made me want
to turn and look from my feet to the fire and back
again, out of curiosity and fear at the same time. 125
I could see souls walking inside the flames.

When the song was over they all cried out in unison,
"Virum non cognosco" (like the Virgin Mary said in amazement
when she was told she'd be pregnant), and then went right
back to the first song again. When they finished it a second 130
time they shouted, "Diana stayed in the forest and chased
Helice out after Jove had seduced her with Venus's poison!"
Then they started in with the same song again, and
when it was over they shouted out praises to couples
who had stayed true to their marriage vows. 135

And I'll bet they're there right now, doing
the same thing, praising abstinence as long as they
have to to purge themselves, burning and singing,
until this last of all their wounds is healed.

CANTO XXVI

ARGUMENT

The souls in the fire are attracted to Dante's shadow and gather around him to ask questions. But another crowd of souls comes along and when the two groups meet, they embrace briefly before shouting out examples of their sins and heading off again in opposite directions. Dante explains who he is and is told in reply that these souls are purging the sins of sex and Lust, and that the group heading the wrong way around the circle are those who have committed sins of a homosexual nature. The speaker identifies himself as the poet Guido Guinizelli. Dante praises him and says he has always loved his writing. Guido bashfully thanks him and points out another poet in the group, the Provençal troubadour Arnaut Daniel—the only character in the Divine Comedy *to address Dante in a vernacular other than Italian.*

While we inched carefully along that little ledge
in single file, Virgil was calling out warnings,
saying stuff like, "Be careful now, pay attention!"

The sun was shining brightly down on my
right shoulder—by now it had started to 5
wash out the blue sky to the west—and for
some reason, as we walked, my shadow seemed
to turn the flames a deeper red, which caused
a few of the souls in the fire to stare at me.
Before long their curiosity became too much for 10
them until finally I overhead one say to another,
"His skin looks pretty fricken real to me!"

A bunch of them started to come toward me,
edging in as close as they could manage,
all careful not to step one foot out of the fire. 15
One of the guys started in on me straightaway.
"Hey now, you over there with the two dead poets—
yeah, you! Could you hold up for a second?
I'm dying to know what the heck you are, and
I'm not the only one around here wondering. 20
All of us here are just, ah, *burning up* to hear
who you are and what you're doing here.
How in God's great name can you walk
around up here casting a shadow? It's
as if you'd never died or something!" 25

And just as I was about to try to explain things
to them, something else kinda odd distracted me:
a whole new group of souls came marching
right down the middle of the road, heading
straight for a face-off with the group in front of me. 30
It was weird: a guy from the new group would come
at a guy from the first bunch and give him a quick,
intense kiss on the lips, and everyone seemed fine
with it. It was like dogs in a city park, how they run
up to each other and quickly sniff each other's ass, 35
and it seems to tell them everything they need to know.

And right after they kissed each other, but
before they started off again, each soul started
yelling out things, with the second group
barking out names like, "Sodom, Gomorrah!" 40
and the others yelling, "Pasiphaë hid in
the wooden cow to be screwed by a bull!"

Just try to picture a relay race or something, with one bunch
of runners jogging one way, passing off the baton,
while the finished group heads back toward the showers. 45
The two groups of souls in the fire were the same,
continuing on in different directions, crying as they
went and chanting out their penances through sobs.

But when that was done, the ones who had
gathered around me came back over to us, 50
bunching in close to hear what I was going to say.

I knew what they wanted to know before they said
anything, so I started right in: "You guys are all
pretty much guaranteed to get to a better place than
this, right? Well here's how it is: I didn't leave my 55
body like you did, naked or whatever, back on Earth.
I'm wearing it, and it's 100 percent
real flesh and bone. See, I'm climbing this mountain here
to learn something, and there's a special lady up
above who pulled some strings to get me in here. 60
But, hey, in hopes that you will all reach your dreamed-of
destination as quickly as possible and make it
upstairs to the great resting place in the sky, please
tell me: Who in Purgatory are you guys? And who
were those other guys who took off so fast? You see, 65
I'm writing this book and I want to include you all in it."

Like a bunch of small-town kids just off the
bus stand flabbergasted and bug-eyed when
they finally see the lights of Times Square, those
ghosts stood gaping at me after my little speech. 70
But they pulled themselves together pretty
quickly, like any decent person does, and the
guy who had first asked me started up again.

"You're one lucky bastard to be able to take what
you learn here back with you to make a better death 75
for yourself! Those guys you just saw going the
wrong way 'round this ring are all here for the
same sin that had some calling Caesar a 'queen.'
That's why you heard 'em all shouting 'Sodom!'
as they ran away from us in humiliation—you see, 80
their shame makes the flames seem hotter to them.

"As for us, well, um, you see . . . our sins were heterosexual.
But because we didn't act like civilized human beings
and let our lives be totally consumed by sex and Lust,
whenever we pass by that other group, we all must 85
acknowledge our own shame, which in our case is
pretty much like that of the bull-screwing nympho
Pasiphaë. I can't tell you all our names, 'cause there's
no time, but there's Tommy Lee, Jenna Jameson,
Hugh Grant, and Traci Lords—we're everywhere. 90
And I guess I can tell you my own name:
I'm Guido Guinizelli, and I'm up this high on
the mountain now 'cause I repented early in life."

Talk about joy! When her whole family had thought her
lost and dead and her two sons found Hypsipyle still alive, 95
I felt almost the same kind of happiness (though not as strong)
when Guido said his name. He was my total hero, one of
my favorite writers and a role model to my elders,
all of whom had written the beautiful poetry of love.
I was so stoked I didn't even hear anything else for 100
a while, I stood just spacing out and staring at old Guido,
as the flames kinda prevented me from getting too close.

Finally, I pulled myself together, and started
gushing to him and going on about how there's
nothing I'd rather do than help him out however I could. 105

"Wow," he said looking at me. "What you just
said has made a very deep impression on
me that even the River Lethe couldn't wash away.
And if you really mean all that stuff you're
spewing, please tell me exactly what I wrote or 110
did to merit such a heap of praise from you!"

CANTO XXVI, 139–142: ARNAUT DANIEL:

His reply came quickly and politely:
"Tan chulas y suaves son tus palabras que me llaman
que no me dejan esconderte mi nombre. Me llaman
el Chavo Arnoldo."

"Guido," I said, "those fantastic poems you wrote
were so amazing that your very pen should be
considered sacred for as long as they can be read."

"Thank you, you're very kind. But please," 115
he said, pointing ahead, "up there is a
much better poet in his own language. He is
Arnaut Daniel and he was much better than all
the poets and even the prose writers put together!
Whoever thinks Guiraut is better is sorely mistaken. 120
Those folks are only judging based on fad and
popular opinion, not on his actual work, and their minds
are made up before they even know the slightest bit
about art. That poet Guittone was only hot shit
from hack reviews, like phony political polls, but by 125
now, most folks know the truth, thank God.

"But hey, if you're going to be privileged enough
to make it up to the top of this place, where
Christ Himself is in charge of things, then
will you please go on and put in a good word 130
for all us down here, at least those of us who
are by now pretty much absolved from evil?"

Then, probably to make room for some other soul,
he sank back into the depths of the fire the way a
shy guy retreats onto the balcony at a party. I headed 135
on up toward the front of the pack and found the poet
that Guido had been talking about. I told him I'd heard
good things about him and I wanted to know his name.

His reply came quickly and politely:

"Tan chulas y suaves son tus palabras que me llaman 140
que no me dejan esconderte mi nombre. Me llaman
el Chavo Arnoldo, el vato que, con las gotas de sus
lágrimas, canta en llantos los recuerdos de sus
aventuras locas del pasado y también las esperanzas
de un futuro bien padre. En el nombre de Dios quien 145
te lleva a la mano y te sube por los escalones hacia
arriba, recuérdame, aquí en mis sufrimientos."

And with that he drifted back into the purifying flames.

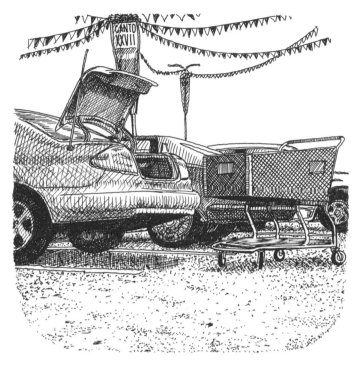

CANTO XXVII

ARGUMENT

As the sun sets, the three poets reach the westernmost point of the mountain and meet the angel of Chastity, who stands beyond the fire at the Pass of Pardon, singing another beatitude. The angel tells them that the only way to continue now is to pass through the flames, and Dante is terrified. But Virgil promises to protect him and is eventually able to persuade him by reminding him of the ever-waiting Beatrice. They finally enter the fire and emerge on the other side, where they hear a welcoming song and are urged to hurry up before night falls. After dark, the three sleep on the steps. And near dawn Dante dreams of the sisters Rachel and Leah from the Old Testament, who represent the contemplative and the active lives, the two forms of Christian life. In the morning the Pilgrim wakes refreshed and races up the remaining stairs. At the top, Virgil summarizes Dante's moral development over the course of their journey and concludes that Dante is now fit to go on without his guidance. They stand on the edges of the beautiful meadows that surround the Earthly Paradise of the Garden of Eden.

It was that time of day when the first rays of dawn were
striking Jerusalem (where God sent His Son to die) and at
the same moment the Ebro River in Spain was flowing
under the stars of Libra at midnight. In India, the heat
of the noon sun was steaming the Ganges, and it was 5
twilight on Purgatory when an angel appeared in front of us.

He stood on the far side of the flames,
singing clearly and beautifully, *"Blessed*
are the pure of heart, for they shall see God."

As we came nearer he spoke to us and said, 10
"You can't go any further without first
suffering the fire. Now, enter: and pay attention
to the words of the song they sing beyond."

When I heard him say that, I thought
I'd probably die right there! I stood, 15
clenching my fists and staring into the flames.
All I could think of were images of human
bodies burned to death. I couldn't do it.

The other two saw me freaking out and Virgil
said, "I'm not going to lie to you, it is going to 20
hurt. But you won't die. Just think about how
I've protected you so far. If I took care of you
when we rode that beast Greyon in Hell, do you
think I'd be careless about you when we're this
close to Paradise? Trust me when I tell you that 25
you could stand in that fire for a thousand
years and you wouldn't even singe an eyebrow.

"But if you still don't believe me, test it out for
yourself: just stick the corner of your sweatshirt in there
and see what happens. Now's the time—for real— 30
to stop being afraid of everything. Take a step
toward me, now, and enter without fear!"

But I couldn't do it. I just stood there, ashamed.

Virgil saw me frozen and started to
get annoyed. "Put it this way," he said, 35
"This is the *only* way to get to Beatrice."

Like Pyramus, as he lay in his last moments
before death, heard Thisbe speak her
name to him and it revived him, briefly, to
see her under their tree—as soon as Virg said 40
Beatrice's name I felt my fear melt away as I
thought of her. I turned and looked at Virgil.
He must have seen my new resolve, because he
smiled back, as if I was a kid won over by a lollipop.

"Well, then," he grinned. "What are we waiting for?" 45

Virgil motioned for Statius, who had been
walking between us since the Sixth Stairs,
to come last, and he stepped into the flames.

The fire was so hot I would have
jumped into a pool of molten lava just 50
to escape the heat. "It's like I can see
her waiting for us already!" Virgil
called to me, encouragingly. And
another voice came to us, guiding
us with a song and, following it, we 55
finally emerged to the last level before
the final ascent to Paradise begins.

There was a blast of light so intense I
had to shield my eyes and turn away. "*Come,
O blessed of my Father,*" it sang, and over that 60
a voice came in my head saying, "The sun is
setting and it's almost night. Hurry up and
don't waste time before it's dark in the west."

Ahead of us was a passageway cut into
the rocks and my shadow was cast over 65
it from the sun at our backs. We started
up the stairs and before long I knew
that the sun had set because my shadow
disappeared. Then we stopped where
we were, before the colors of the sunset 70
had faded to the single black of night,
and each of us chose a step to spend
the night on. We had lost not only our

strength but even the will to keep going,
under the effect of the laws of the mountain. 75

Like how a carload of college kids pulls up at a
keg party and pours out of the car, excited to check
it out and see who's there, rushing in and
mingling, but eventually getting burned out and
sitting tired and drunk and calm on the sofa with 80
their girlfriends watching over them. Or like a mom
with a book who sits reading protectively while
her kids take naps on a towel at the beach—
that's what the three of us looked like on
those stairs: with me all overanxious and tired 85
and the other two calm and protective, all of us
surrounded closely by the walls of stone in the dark.

I could only see a small section of the sky
between the rocks above us, but even so I
could see the stars, and from that high up 90
they seemed bigger, closer, than they do
from Earth. As I lay there staring up at
them I fell into a deep sleep—the kind
of sleep where you have dreams that
you can see the future. It must have been just 95
before dawn, when the first rays of Cytherea's
burning love shines from the east, that
I had a dream where I saw a pretty
young girl walking in a field picking
flowers. She went slowly, singing: 100

> "Rachel sits and contemplates
> her eyes, her nose, her lips, her face.
> She pouts, she smiles, plays with her hair,
> but all day long she just sits there.

> "My sister and I are far from the same, 105
> sitting all day would drive me insane.
> I'd rather pick flowers, myself to adorn,
> and improve the looks with which I was born."

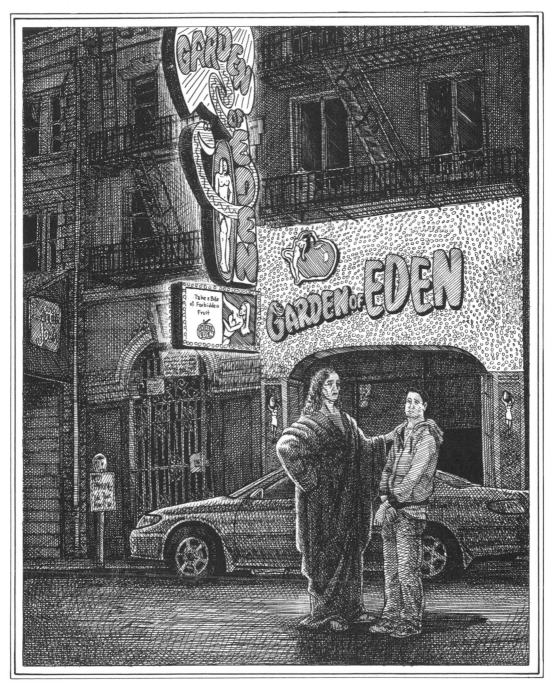

CANTO XXVII, 127–130: THE ENTRANCE TO THE GARDEN OF EDEN:
*"You have now seen for yourself the eternal fires
of Hell and the temporal steps of Purgatory. You
have reached the place where my guidance is no
longer necessary."*

The dawn came beautifully and more welcome
to me now that we were on the last leg of 110
the journey, homeward bound, almost. My
sleepiness seemed to leave me as the darkness
retreated from around us, and I got up and
stretched. The others were already up.

"Today is the day you'll find the peace that all men 115
search for, in so many different ways and places,
to satisfy their hunger." Nothing Virgil had
ever said to me made me more happy than
that statement of his. It felt like he had just
given me a big present to open. It seemed like the 120
higher and the closer we got to the top, the
more I wanted to be up there. I was as excited
as a kid about to get on a plane for the first time.

We hurried on up the last steps of the mountain
and once we stood together, finally, on the top 125
step, Virgil stood before me and said: "My son,
you have now seen for yourself the eternal fires
of Hell and the temporal steps of Purgatory. You
have reached the place where my guidance is no
longer necessary. I've led you here through skill and 130
intellect. But from now on, let pleasure guide your way.

"The narrow paths and the steep climbs are far below
and over. Here the sunlight falls on your face and
ahead of you stretch the soft grasses and all of the
flowers and plants and trees of the Earth itself. 135
May your eyes now welcome joy where once they
conveyed your pain, through tears, to call me to
your aid. Feel free to sit here or to wander around and
do whatever you like, don't look to me for suggestions.
Your own will is now strong and pure and free, and it 140
would be a shame for you not to enjoy its pleasures.

"I now pronounce you lord of yourself!"

CANTO XXVIII

ARGUMENT

Dante the Pilgrim wanders in the forests until he comes to a stream. On the far bank he sees a lady gathering flowers and singing as she goes. He calls to her and she comes nearer and tells him that he is now in Paradise on Earth, the Garden of Eden, the birthplace of the entire human race. She explains that the breeze he feels is caused by the constant rotation of the Earth. She goes on about the different plants in the garden and how they were spread across the Earth. She tells him about the two streams of the garden, Lethe, which washes away all one's memories of sin, and Eunoë, which brings back one's memory of his good deeds in life. She ends by saying that when poets wrote of the Golden Age of Parnassus, they were probably thinking of the garden.

By then I was pretty excited about seeing the
rest of the forest: it was practically oozing green
from every leaf, and the light was soft and pleasant.

Right away I left the bank behind and started
walking toward the open fields ahead. 5
Everything was so lush that I could almost smell the
richness of Earth itself as I went, and a soft,
warm breeze seemed to kiss my forehead lightly,
as steady and gentle as a tropical tradewind.

It was almost too much to take in. The steady 10
wind made every branch and rustling leaf bend
lightly toward the first shadows of the morning
sun. But the wind was not so strong as to stop the
birds in the treetops from singing; instead,
it almost seemed to carry their songs among the 15
branches. And the songs were sweet like you've never
heard before: joyful and full at the coming of the day.
And like in a Disney movie, the leaves and branches
even drummed along in time with the sound of the
pines in evergreen forests along the shores of 20
Chiassi when Aeolus lets the Sirocco winds blow.

By now, even though I'd been walking pretty slow,
I was so far inside that beautiful, ancient forest
that I couldn't even see back to where I had come.
Pretty soon a little stream appeared out of 25
nowhere, snaking along across my path, with little
waves pushing left through the grass along its
banks. It was clear, too—the crystalline lagoons
in Tahiti or the teeming coral atolls of the Maldives
would've seemed like mud puddles in comparison. 30
But even though it was transparent, the waters
were as dark as the depths of the deepest
oceans under a sky without a sun or a moon.
Even though I couldn't go any farther, it didn't
stop my eyes from wandering to the other side 35
and checking out all the crazy, beautiful trees.

And then she showed up. A vision so completely
unexpected, beautiful and strange at the same

time, I suddenly forgot everything else but her.
She was by herself, wandering around on the
far bank, and as she went she was singing
and picking the wildflowers she passed.

"If you'll excuse me, you must be in love, the
way you seem to be glowing," I said to her quietly.
"If your brilliance comes from your heart,
would you please be nice enough to come a
little closer to the riverbank so that I can hear
the lyrics of the songs you're singing? When I see
you like that, it makes me think of what Proserpina
must have looked like when she wandered along on the
day she was lost to Hades, along with eternal Spring."

You know how a ballerina can spin all the way
around without hardly moving her feet at all,
one slipper just next to the other? Well, that's
how this lady seemed to move, among all the
red and yellow flowers. She spun around
gracefully and bashfully lowered her face,
then moved slowly closer like I had asked her to.

And even while she moved, she sang beautifully—
almost like the melody made the words more clear.
And not until she had come to the part of the
riverbank where the little wavelets lapped softly on the
grass did she dare make eye contact with me.

Man! I'd bet that Venus's eyes weren't even as bright as
hers when she was struck by her son Cupid's dart and fell
head over heels for Adonis. Jeez, that girl was gorgeous!
And she was smiling, too, standing on the other side
of the bank, messing with all the flowers in her hands,
flowers that I'd never even seen before on Earth.

The little stream was only a few feet wide,
but it seemed to me like it was as wide as
the stormy straits where Xerxes must
have crossed the Hellespont (whose fate
is a lesson to the proud). I suddenly hated that
little brook, because it wouldn't let me cross.

40

45

50

55

60

65

70

75

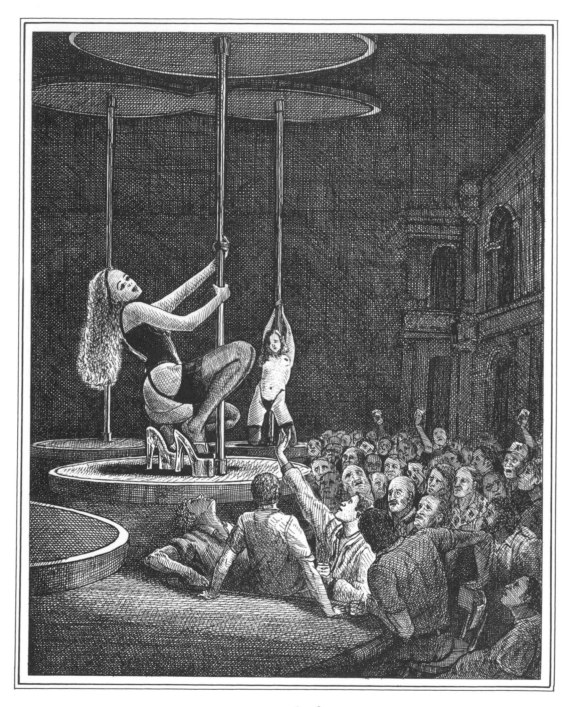

CANTO XXVIII, 56–58: IN THE GARDEN OF EDEN:
She spun around
gracefully and bashfully lowered her face,
then moved slowly closer like I had asked her to.

"You're, uh, new around here, aren't you?" she
asked. "I can see how it must be confusing and
pretty amazing to you to see me like this here,
especially as it's the cradle of humankind and all. But take
a moment and let the words from the Ninety-first Psalm 80
run through your head and clear up any confusion.
And you—the one in front, who just spoke to me—
if there's anything you need or want to know,
I'm here and ready to answer any questions."

"Well, for starters," I said, "all this bubbling water 85
and the music and the forest and all isn't exactly
how I imagined Mount Purgatory would look."

"That's easy," she said. "I can explain how things
work around here, despite what you may've heard
about this place, and why you might have misunderstood. 90

"The Highest Good, or God Himself," she began,
"made Adam for Himself, and made Adam good.
He made Adam to *do* good, and then He made this
place for eternal peace. But because Adam sinned, he
couldn't stay here—because when he sinned, he traded 95
innocence and laughter for the life of toil and
frustration. But so that the calm of this garden wouldn't
be disturbed by the storms of the Earth below—
which are caused by the fogs and vapors of the
sea and Earth being drawn up toward the sun— 100
this mountain was created to rise up so close to
Heaven that storms will never make it up this far.

"But even so," she went on, "the air here is continually
moving due to the primary revolution of the Earth
(unless of course *that* somehow changes). But up 105
here on the mountaintop, isolated from the storms,
this gentle wind is pleasant and warm and
makes the leaves and branches seem to sing.
And the breeze makes every single little plant
spread its own special powers across the Earth, 110
carrying their seeds here and there down

below. And all of the lands will take different
plants and their different powers, all
according to their own climate and soil.

"And if anyone down on Earth knew what I 115
just told you, then no one would be surprised to
see plants growing where there weren't any seeds.
What's more, this sacred land we're standing on is
rich in every single species and often produces some
kinds of fruit that man has never seen before on Earth. 120

"Also, the water up here doesn't come from a spring that
needs rain and mist to keep it replenished, like those
streams back on Earth that change levels all the time.
Here it comes from one constantly flowing source,
unstoppable, which, by God's design, is replenished 125
by what it loses on the other side. The spring divides,
and the water in this creek contains the power to
erase the memory of sin, while the water in the
other stream brings back one's memories of good deeds.
This stream is named Lethe, and the other is 130
called Eunoë. But you have to drink from this one
first, in order for the other one to work its power, too.
And believe me: it's sweeter than any drink you've ever had.

"And now, even if I've quenched your thirst
for knowledge by our little conversation here, 135
I can tell you a little something else, and I
don't think you'll forget any of what I said if
I go on explaining more than I promised, right?"

I shook my head. "Well," she continued, "maybe all
the old poets who used to sing about the blissful 140
'Golden Age' were actually thinking of this place.
Because, you see," she said, smiling at the others,
"here, in an eternal Spring, at the guiltless root of
mankind, sprang every fruit praised by poets."

When she said this, I turned around quickly 145
to my two dear poets; and they couldn't help
but smile a little when she said that last bit.
Then I turned back again to see her beauty.

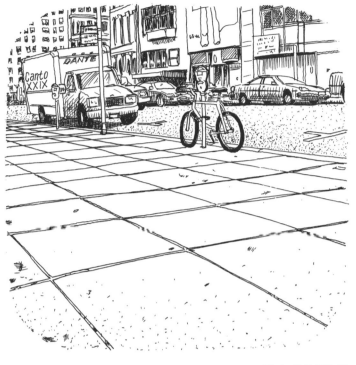

CANTO XXIX

ARGUMENT

The poets follow the lady upstream as she walks along slowly, singing. They soon stop and watch as a flash of light precedes a fantastic procession of characters and beasts that comes toward them. First come seven golden candlesticks burning colored lights that sweep behind and over the procession like rainbows. Next come twenty-four elders, an allusion to the Book of Revelation, each crowned with white lilies. Next are four creatures (representing the Evangelists of the New Testament) who move in formation around a chariot pulled by a Griffin, representing Christ. The eagle half of the Griffin is gold (Divine), while the lion part is dappled red and white (human). Around the right wheel dance three ladies of different colors representing Faith, Hope, and Charity. Around the left dance four women dressed in purple representing the Virtues of Prudence, Justice, Temperance, and Fortitude. (Prudence possesses the third eye of wisdom.) Behind them come two old men, then four more, humbly, and last comes one old man, alone. These last may represent the books of the New Testament, with their red garlands of flowers representing the love of the Gospels. At the sound of thunder, the whole parade stops on the opposite bank.

Then she began to sing, like a love song
(I guess she was done talking to me):
"Happy are they whose faults are taken away!"

And like women do when they're window-
shopping, strolling around from one storefront 5
to another, distracted and random, she began to
walk again along the bank of the river, heading
upstream, and I went along with her, slowly,
on my side, watching her small, elegant steps.

We hadn't gone more than a hundred yards 10
before the river began to bend in a perfect curve,
like a man-made canal, until we were heading
east again. We went on like that a little more until
she stopped and looked across the water at me
and said, "Look, now, my friend, and listen." 15

There was a huge, brilliant flash that lit up the
whole forest, and for a second I thought
it must've been lightning. But lightning just
flashes once and is gone, where this light stayed
on, like stadium lights, and even seemed to be 20
getting brighter. 'What the . . . ?' I was thinking, and
then soft music started floating along, like Musak® in
an elevator. From out of nowhere I was suddenly
filled with a wave of anger at Eve for wrecking everything.
Just to think of her, when every single living thing 25
on Earth and in Heaven was doing just what they were
supposed to, and this one chick comes along and breaks
the rules that He set! If only she'd just done what
she was supposed to, just followed the rules like
everyone else, then I would have been up here sooner, 30
enjoying that place for a lot longer than I could now.

But then I started wandering around in a happy
daze, surrounded by my first taste of eternal
happiness and wanting even more of it, when
the whole air under those green trees was blasted 35
into blazing light and the music became a chant.

(Dear Mother Mary, in remembrance of
all the times I went hungry and cold and
suffered for you, let Mount Helicon's springs flow
for me now and let Urania's choir help me 40
out here as I try to write these lines
about all the impossible things I saw next.)

We went on a little farther, and up ahead
I saw what looked like seven golden trees,
but it turned out that my eyes had been 45
tricked by the distance. As they came
closer and I could make out the details
better, I saw that they were really big
golden candlesticks hovering in the
air, and I could hear that the chants 50
were repeating the word *"Hosanna."*

And above them a bright light shone,
brilliant and white and as clear as
the full moon on a cloudless night.

I was a bit dazed and baffled by it all 55
and I turned to Virgil, but he just looked
back at me like he was as amazed by the
whole thing as I was. I watched the lights
as we walked and they moved along sort
of formally, but so slowly they almost 60

seemed to stand still. "You keep staring at
the lights," the lady said to me, "but don't
you want to see what's coming after them?"
And I looked and saw a whole crowd of
people coming behind, moving slowly, 65
dressed completely in clean white robes.

The light reflected off the water of the river
on my left, which was as smooth as glass in
the still air—I could even see my reflection in
the surface of the water. When I had gone so near 70
the procession that I was on the bank directly
opposite, I stopped to watch as it went. The flames
of the candles moved through the air behind
them, like a boat's wake. The air was transformed
into a wash of colors streaming along over the souls' 75
heads into the distance, as far back as I could see,
ten yards wide and looking like a rainbow
streaming like pennants over their heads.

Strolling along under this rainbow thing,
like I'm trying to explain, came twenty-four 80
old guys, walking along two by two,
wearing lilies on their heads like crowns
and singing, "*Of all Adam's daughters
you and your beauty are blessed.*"

When that whole lot had passed, 85
and I could see the grass and
the flowers again, another even
stranger group came to replace
them, just like the headlining band
comes and replaces the opening act. 90

There were four creatures, each
with six wings, and their wings were
all covered in eyes, kind of like Argus's,
or the intricate tail of a peacock. Each one
of them wore a crown of dark green. 95

I know it sounds pretty weird and hard
to picture, but I can't waste any more
lines here trying to describe them—
I'm trying to keep this short. But if you
want a better idea of them you can read 100
Ezekiel's description. He saw them coming
once in a north wind in the fog—and on fire.
They looked pretty much like he tells it, except
that St. John's description is a bit more like
how they looked when I saw them. 105

It gets funkier. Between those four came a
two-wheeled cart pulled by a harnessed
Griffin with outstretched wings that were
sandwiched in between three and three
candle flames, not touching any. The wings 110
rose up into the sky as high as I could see,
and the birdlike parts of the Griffin were
golden-colored while the rest of him,
the lion parts, were white with red spots.

As for the cart, none of the emperors 115
of ancient Rome ever had as nice a
ride as that chariot—not even the
infamous one that Phaeton stole and
crashed and burned through both the
Earth's prayers and the justice of Jove. 120

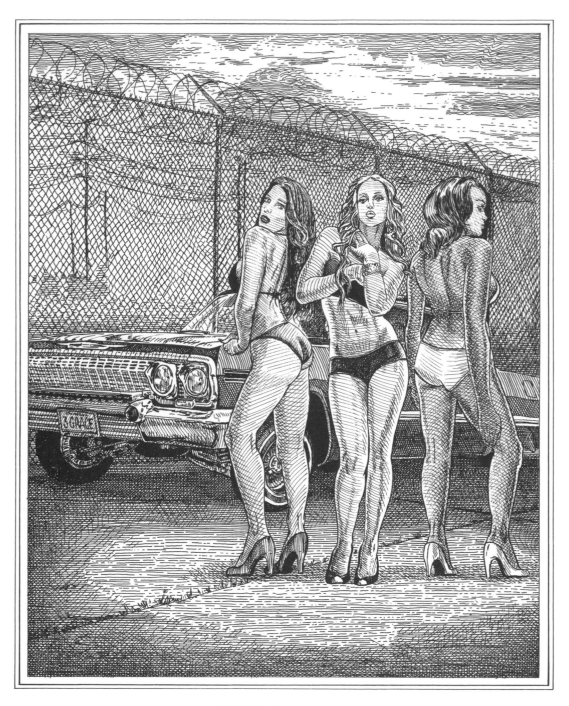

CANTO XXIX, 121–123: FAITH, HOPE, AND CHARITY:
*Three ladies pranced along beside
the right wheel, each one a different
color.*

Three ladies pranced along beside
the right wheel, each one a different
color: one was red, bright like a fire
extinguisher; another one seemed like
she was made out of emeralds she was so 125
green; and the last one was pure white.
The red one was singing and leading the
dancing, but sometimes the white one seemed
to lead them all to the beat of the song.

Four other women danced and pranced 130
around the left wheel, all dressed in purple
robes, and their leader had three eyes.

Behind these dancing women I'm
trying to describe came two old men,
calm and serious and respectful. 135

One was dressed like a newly graduated
doctor who just took the Hippocratic Oath
to protect and save all Nature's creatures. The
other guy was like his opposite: he carried
a sword so shiny and sharp that it gave 140
me chills even seeing it from across the river.
Next came four men, humble and unassuming,
and last of all came an old guy, all alone,
walking along all distant like he was in a trance.

These last seven guys, like the ones up front, 145
all wore white and had crowns of flowers on
their heads, except theirs were red flowers,
like roses and stuff, instead of the white
lilies that the first guys had on. From far
away they looked like little fires in the night. 150

And when the chariot was directly across the river
from me, a clap of thunder rolled through the sky and
the whole procession pulled up short, as if commanded,
and so did the flaming candlesticks at the front.

CANTO XXX

ARGUMENT

The procession comes to a halt across the stream and the members all begin singing in unison. A brilliant light appears and in a cascade of flowers, Beatrice herself emerges, radiant. At seeing her again after all those years, Dante is flooded with emotion and turns to speak to Virgil but finds that the poet is gone. Confused, Dante turns to see Beatrice now standing across from him wearing a pure white veil and a green crown, dressed in a green robe. She calls his name and speaks to him, harshly upbraiding him for having strayed from the right path in life and for taking so long to figure things out. Overcome by shame and guilt, Dante weeps, sending the angels into song again. But Beatrice continues scolding him for having wasted his talents in life. She explains that sending him on the trip through Hell was her last resort.

Those seven lights came guiding that Heavenly
procession just as the seven stars of the
Little Dipper (which never seems to rise or set)
lead the way and guide ships at sea. When
they were across from us on the opposite 5
riverbank, they stopped and the group of old,
truth-telling prophets, who were walking between the
Griffin and the candles, all turned together to face the
car behind them like something big was going to happen.

Then, one of the guys started singing, all solemn. "*Veni,* 10
sponsa, de Libano," he sang from the Song of Solomon, "Come
with me from Lebanon," and everyone else joined in.

When the Judgment Day comes, the souls of the blessed
will rise from their graves shouting "Hallelujah!" with
brand-new bodies and new voices. And that's what it 15
seemed like then. More than a hundred angels in that
procession started singing at the same time in praise
of the elder ministers of God and all the heralds. They all
yelled out, "*Benedictus qui venis!*" and then started tossing
wildflowers into the air like confetti. Then they all shouted, 20
"O give us lilies with full hands!" straight from Virgil's poem the *Aeneid.*

Sometimes, if I've been up all night and it's
almost dawn, I'll see the eastern sky turn pink like a rose
and soft while the rest of the sky stays clear and crisp.
When the sun rises it can look so gentle—maybe 25
because of all the light mist and clouds? But there's
sometimes a few minutes when you can look right at it.

In the middle of that shower of flowers they were
tossing up in the air and that floated down and
covered the chariot, a lady appeared from out of 30
nowhere and it was like that sun at dawn. She had an
olive-covered crown sitting on her snow-white veil and
under a green robe her gown was blazing like the color of fire.

Needless to say, I was pretty stunned. Even though it
had been years and years since I had stood in front of 35
her, overcome by love and in awe of her beauty, and

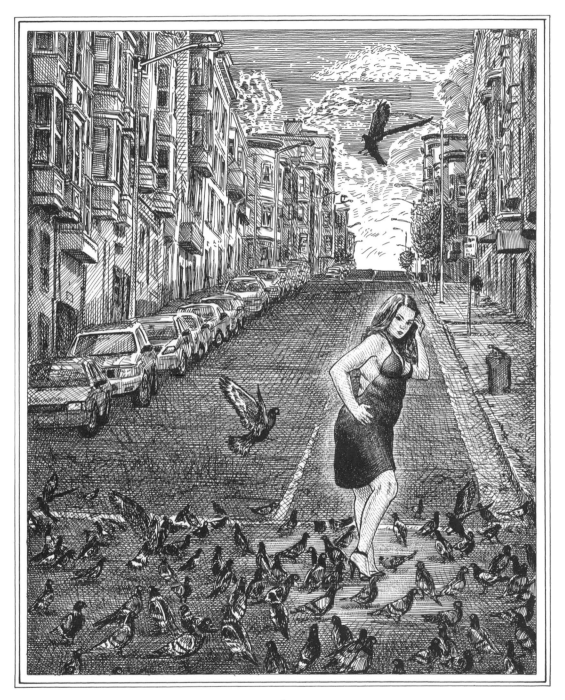

CANTO XXX, 34–36: BEATRICE:

> *Needless to say, I was pretty stunned. Even though it had been years and years since I had stood in front of her, overcome by love and in awe of her beauty.*

even though I couldn't see her too clearly in that
glowing light, I instantly felt like I was just as much
in love with her as back in the day. I was filled
with a rush of emotion, struck almost dumb by this 40
intense feeling of the overwhelming goodness of that
love for her I had since before I was even a teenager.

I turned over to my left—with all the surety of
a little kid running back to its mother's arms
when he's scared or needs something or whatever— 45
and I was about to say to Virgil: "Every single cell
in my body remembers her and is firing up again.
The old flame is completely rekindled inside of me."

But no. Virgil wasn't even there. We were standing on
Mount Purgatory without Virgil, my dear teacher 50
and guide, who I had entrusted with my very soul!
I was shattered. All the beauty around me, all this
Earthly paradise that was lost to man, couldn't keep
a stream of tears from running down my face.

"Dante," a voice said softly. "Though Virgil has left you, 55
don't cry—at least not yet. There will be other things
to cry about, you can be sure. But don't cry just now."

You know how a good foreman will watch over
his workers on a job site from the trailer door,
encouraging 'em to put in an honest day's work? 60
Well, I turned back toward the river when I
heard my name spoken there for the first time
in the Afterlife, and just to the left of the chariot
I saw the woman who had appeared under
that symphony of wildflowers. She stood 65
facing me from across the stream watching
over me like that, protective and encouraging.
Her face was covered by a veil which was held by a
crown of exotic-looking leaves, and I couldn't see her
expression very well. But even so, I could sense 70
that her face was kind as she spoke to me in the
voice of someone who's saving the worst for last.

"Yes, it is really me," she said. "I am Beatrice. So, you
finally decided it was worth the climb up? Did you
finally figure out that this is the road to happiness?" 75

Whoa. I put my head down and looked into the
stream, but when I saw myself reflected in it I was
embarrassed and turned toward the grass instead. Safer.
I felt like a guilty kid facing the music with his mom,
all ashamed under her scolding. And let me tell 80
you, raw, unfettered pity feels pretty harsh, too.
As she finished chastising me, all the other angels
started singing the psalm *"In te, Domine, speravi,"* but
they all stopped before the *"pedes meos"* part about feet.

Hard-packed snow freezes in the mountains in the 85
winter, up by the ski lifts and the pine trees,
and gets blown into drifts by the northeast winds.
Eventually it melts, once the hot winds from the
deserts start to blow in springtime, dripping down
on itself almost like a candle drips melting wax. 90
I felt something like that, with all my emotions
and everything practically frozen deep inside
of me, until I heard those angels start singing.
They must have felt bad for me after Beatrice
treated me that way, scolding me, but the words 95
of the song they sang made the cubes of ice that
had been packed around my heart dissolve and
they gushed out in sobs. All the tension of the trip
seemed to pour out through my mouth and eyes.

And even so, Beatrice just stood there 100
to the left of the chariot, watching me.
Then she turned to the angels and said:
"You guys sure are focused on things. Not even
the blackest nights or the deepest sleep seem to
hide one single thing that happens on Earth from 105
you. All I'm really trying to do here is make the crying
guy over there understand the truth and maybe stop
feeling sorry for himself and start seeing his own guilt.

"You know as well as I do that things down
on Earth don't go along like they're supposed 110
to just because the stars and planets line up.
No, it's God's own good graces that make things
work, coming down from so high up that no one
down there can see that it's Him controlling things.
Now this guy here, he's been so blessed and lucky 115
and given everything he needed—if he'd actually
embraced his gifts, he'd be way better off now.
But you know what they say: the richer the soil, the
more weeds grow there. Especially if you don't
keep an eye on it—who knows what could spring up? 120

"Sure, there was a time when all I needed to get his
attention was my pretty face, and all he had to do was
look into my little-girl eyes and it would set him on the
right path. But when I moved into the Afterworld,
when I exchanged my life for the Real Life, that guy over 125
there—along with a lot of others—forgot all about me.

"It doesn't make sense: When I rose from my body into
pure soul, I became even more beautiful, more worthy
of admiration. But even so, as time went by he loved
me less and less, wandering off the true and righteous 130
path, strolling around through some TV-show world,
which might seem more exciting than the real thing.

"I prayed," she went on without stopping, "boy, how I
prayed, that he'd get inspired by a dream or by a vision
or *something*. But, no, he couldn't have cared less and 135
it was no use. Dante here sank to such pitiful lows that
in the end there was no other way to save his soul except
to have him go straight to Hell and see it for himself.
And I had to go all the way down there *myself*
and talk to Virgil so he'd help out and guide him 140
(since he knows his way around down there and all).

"I'll tell you," she went on, "they'd have to erase the
highest laws of God Himself if he had tried to cross
the Lethe and have a drink out of it before paying
out some of his guilt through those tears of his." 145

CANTO XXXI

ARGUMENT

Beatrice continues to chastise Dante for his lapses on Earth and he's crushed by her berating. Dante sobs and confesses his guilt until finally he's overcome by regret and passes out. He wakes up floating in the river, held by the flower lady, Matilda, who pulls him gently across the stream and dunks his head in the water so he can drink. Now purified, Dante is led to the four Cardinal Virtues dancing around the left wheel of the cart, who set him in front of Beatrice as she stands in the cart. As he stares up into her eyes he can see the Griffin reflected in them, the reflection changing back and forth between the beast's two natures: that of the human and that of the Divine. The other three dancing ladies, Faith, Hope, and Charity, sing a prayer of virtue to Beatrice, asking her to lift her veil so that Dante can see her face.

"And you! Over there on the other side of the river!"
Beatrice yelled at me without even pausing to take a breath
in her tirade, and now turned her sharp words on me again,
even though she'd already let me have it once already.

"What do you think? Speak up! Am I right? It's time 5
for you to own up to my accusations!"

I slouched there frozen by her words and confused,
trying to say something. My lips were moving, but I just
couldn't get a word out. And she just kept on at
me, yelling, "Answer me! What are you waiting 10
for? Speak up! None of your pitiful memories
have been washed away by this river yet!"

I was so ashamed and afraid of her that it was
all I could do to mumble a feeble, "Yes . . ." If
you hadn't seen my lips move, you wouldn't have 15
heard it. Like a full beer bottle dropped on the
pavement that shatters as it hits, the pieces of glass
flying out as it explodes, but their force dampened
by the liquid inside, I was overwhelmed by the flood of
emotions that washed over me under her scrutiny. 20
I sighed and cried, dry-heaving, as I tried to speak.

"In all your innocent desire for me and in
your aspirations to that greater Good which
is above all the other desires of the heart,"
she went on, "what happened to you along 25
the way? What obstacles were so big that
they made you give up hope of going on?
What was it that you saw in those
distractions that seemed so much
better that you had to go after them?" 30

I shrugged and sighed, barely
able to answer. Sobbing, with great
difficulty I managed to blurt, "Those
other things were just the short-lived
pleasures of material things. Once you 35
were gone I let them distract me."

CANTO XXXI, 7–9: BEATRICE'S TIRADE:

I slouched there frozen by her words and confused,
trying to say something. My lips were moving, but I just
couldn't get a word out.

"That's right," she chided. "And if you hadn't
admitted it just now, or even if you had said
nothing to face up to it, the Big Judge up there
would have known anyway and seen that you 40
were guilty. But the way it works in our court
here is that when a sinner admits his mistakes,
then we're able to change the course of events.
So in order for you to truly face up to the shame
of all your sins—so that you'll be stronger when 45
the next temptation comes along—stop sniveling,
buck up, and pay attention, and you'll see the path
that my death should have shown you already.

"Look at it this way: Nothing in all art or nature
has ever seemed as beautiful to you as I once 50
was, and even so my body now lies in dust. Once
you saw that even your love for me was only a
a temporary love for a mortal thing, how could
you let something else come along and tempt you
after I was gone? The first time you felt the pull 55
of those kind of thoughts you should have probably
taken a cold shower and thought about me and
how I was gone. You shouldn't have let any
other girls or your silly crushes distract you
just so you'd get burned again. You can fool a 60
sucker twice, or even three times maybe, but no one
who's been around the block is ever duped
into falling for the same thing more than once!"

I stood there in silence, ashamed, with my head
down, looking at the ground like some schoolkid 65
being scolded who knows he's guilty and
regrets it. "If just hearing the truth bums you
out that much," she said, "then lift up your face
and look at me and you'll really feel sorry."

It would have been easier for me to pull 70
a dump truck full of cement with my teeth
than for me to lift my head and look at
her right then. "Look at me!" she had said!
I could hear the spite in her voice. Even

when I finally managed to raise my eyes 75
I couldn't bring myself to look at her, but
looked over at the dancing girls instead.

They just stood there gawking back at me.

When at last I looked nervously at Beatrice,
I saw she had turned her back to me and 80
was facing the Griffin. Even from the far side
of the river and with a veil over her head she
looked better than I ever remembered her back
on Earth, and she was totally stunning back then.
Immediately I regretted things. The things that 85
I had loved the most, besides her of course, I
suddenly hated more than anything else.
And the shock of that realization was too
much. I blacked out. Boom. Only she
could tell you what happened after that. 90

When I came around, I was floating in the
river up to my neck, looking up into the
face of the first lady I had been following.
She held me in her arms and pulled me
gently across the river, saying softly, 95
"Hang on, don't worry, just hold tight."

As I floated I heard the sound of singing
in the air, in voices so sweet that I can't
even remember the melody, let alone describe
it. *"Cleanse me of sin,"* they sang, and the 100
lady took my head in her arms and dunked
me, just enough to get a drink of the stream.

On the far bank she led me out of the
water, clean now, and over to where the
four girls were dancing. They made a circle 105
around me with their hands and sang:

> *"We're stars in heaven, but we're nymphs here,*
> *and before Beatrice was born we were*
> *destined to serve her—that much was clear.*

Now let us lead you before her eyes. 110
The other three will help you look
as you bask in her sight and become wise."

Then they led me to stand before the Griffin
and Beatrice, who stood in the cart.

"Stand here now and deeply gaze, 115
for you now stand before the eyes
which loved you back in Earthly days."

A huge wave of desire flamed up in me and
I couldn't help but stare into her sparkling
green eyes as she looked at the beast. And 120
in her eyes I saw its image reflected, like in
storefront glass. It was changing shape,
back and forth, with each of its two natures
clearly distinguishable. I mean, just think how
weird that was: I could see the Griffin standing 125
there in front of me, but in the reflection I
could see it constantly changing. And as I
watched I felt inside me like I was eating and
was stuffed, but at the same time like I was starving
and getting hungrier the more I ate. The other 130
three girls came dancing over as I stood there,
but less wildly, and the music was beautiful.

"Beatrice, turn your eyes to look
at this faithful one before you, who
came through Hell and wrote this book. 135
We ask you a favor: with all your grace,
will you lift your veil to let him look
at the second beauty of your face."

O Beatrice of eternal living light! How could
anyone, even if he had bathed in the spring of 140
Apollo and the Muses or spent any time in the
shadow of that mountain, ever find the beautiful
words necessary to describe that moment when, in
that gorgeous place and with those around you,
you finally lifted your veil for me? 145

CANTO XXXII

ARGUMENT

Beatrice lifts her veil and Dante sees her face for the first time in a decade. He stares, then looks away, and is temporarily blinded. When his eyes clear, he sees the procession heading out again. Dante, Statius, and the first lady they met all follow along until they come to a tree. It is the Tree of the Knowledge of Good and Evil, from which Eve plucked the forbidden apple, but now it stands bare. The Griffin attaches the cart to the tree, which instantly bursts into bloom. Everyone starts singing and Dante dozes off. When he wakes up again, he finds that the party has ended and everyone's gone except Beatrice and her seven handmaids, sitting under the tree. She tells Dante to look at the cart, and as he watches, an eagle swoops down through the tree branches and rams into the tree and then the cart. A fox tries to jump into the cart, but Beatrice chases it away and the eagle slams into it again. The ground opens up beneath the cart and a dragon jams its tail up through the floor and shatters it. The wrecked chariot sprouts seven heads and a covering of flowers, and then a whore appears sitting on it and flirts with a giant. When the whore turns toward Dante, the giant beats her and drags the chariot away into the garden.

I couldn't take my eyes off her. It's like they were
trying to make up for more than ten years of desire,
and every other sense took a back seat to vision.
Despite the fact that I'd been indifferent to her
for so long, now my eyes couldn't get enough 5
of her holy smile. I was totally enchanted.

But the voices of the other women
made me turn my head to the left.
"He shouldn't stare so long!" they sang.

And they were right, too. It was like I had been 10
looking straight at the sun or something. I was
totally blinded for a minute, seeing spots.
By the time I had gotten used to the dim light—
dim, that is, in comparison to that beautiful,
radiant being I had turned away from— 15
I noticed that the whole procession following the
seven lights had turned in formation to the right
and was now heading back, in the direction of the sun.
It was like a marching crowd of war protesters that
waits for the ones in front to turn up the street first, 20
and then the whole bunch follows after them.
That's how they looked there, too: all the ones who
were out in front of that big cart had to move
past us before the chariot could turn around.
The dancing ladies took up their spots by the wheel 25
wells and the Griffin pulled the sacred carriage
along so smoothly that not a feather fell out of place.
And as they went, me, Statius, and the lady who
had pulled me across that stream of Lethe
all fell in with them by the rear wheel. 30

We walked along with that parade to the beat
of a heavenly drummer, passing through those
beautiful gardens made empty by Eve's big mistake.

I'm guessing we had gone only about three
hundred yards or so when they stopped again 35
in front of a giant withered tree, and Beatrice
got down out of the cart. A murmur ran through
the group and I heard them mention Adam.

They moved to form a circle around the tree.
It was unlike any tree I'd ever seen anywhere, and 40
what was weird about it was that the higher the branches
were, the wider out they got, like an upside-down pyramid.

As they circled the tree they all started singing,

> "God bless you, dear Griffin, for leaving this
> tree untouched by your sharp beak. Even though 45
> it's delicious, its bark would be painful to eat."

"And that protects the Tree of Justice,"
the Griffin answered them. Then he turned the
cart so that the wooden pole he had been pulling
it with touched up against the tree, and I could tell 50
that it must have been made from a branch of it.

You know how toward the beginning of
spring the sun grows brighter and stronger
as it moves into Aries, and it seems like
all the trees begin to bloom at once and 55
the flowers burst open with all the colors
they had before winter came on? Well, this
tree just seemed to burst into bloom in
an instant, right in front of me, sort of like
a rose and brighter than a violet. 60

They all started singing again, and I didn't recognize
the tune, probably because it has never been sung
on Earth, and even then I didn't hear the whole thing
because I fell asleep. But before you criticize me,

CANTO XXXII, 57–59: THE TREE OF KNOWLEDGE OF GOOD AND EVIL:
Well, this
tree just seemed to burst into bloom in
an instant, right in front of me.

remember that all of Argus's one hundred eyes were 65
lulled to sleep when Mercury told him the story of
the nymph Syrinx, and he lost his head for it! Maybe
if I was an artist I could show you why I fell asleep,
but how does anyone paint something like sleep?
I can't explain it, so I'll just tell you how I woke up: 70
A bright light shined on my eyelids and a voice
called out, "You're still sleeping? Time to get up!"

Back when Peter and John and James were on
their way to the apple tree—the one whose
blossoms make fruit sweet enough for angels and 75
saints to have endless feasts—they fell asleep
too, and they were woken up by the same words
that woke others up from the dead. They looked
around and noticed that some of them were gone—
neither Moses nor Elijah were still with them— 80
and they saw Jesus standing there, come back to life.
I felt like they must have felt then when I woke up
and everyone was gone. Beside me was the flower
lady who had guided me along the stream, and
I was scared for a sec and said, "Where's Beatrice?" 85

"Shhh, don't fret," the lady said calmly. "She's
sitting right there under the tree's new leaves.
See who's sitting around her? All the rest of
them have gone on ahead with the Griffin up to
Heaven, with its sweet music and harp strings." 90

I didn't really listen to anything else she said,
because as soon as I saw Beatrice again, she
was all that I could think about. She was
sitting there in the grass, guarding over
the chariot that the Griffin had tied to the 95
tree. The seven nymphs had all formed

a circle around her, protecting her,
and in their hands they held the candles
that no wind seemed to ever blow out.

"You will only live outside these walls for a little while 100
longer," Beatrice said to me. "After that you'll move in with me,
and we'll forever be citizens of the Rome where Christ is a
Roman, too. Now, for the sake of all the sinners back down
on Earth, look closely at this chariot and when you get back,
make sure to write all this down as it happened, OK?" 105

As she spoke I listened to what she was asking of
me and all I could think of was how best I could do
this simple thing so that maybe I'd make her happy.

And then from out of nowhere, like a SCUD missile
blasting out of the desert in the Persian Gulf, 110
an eagle, Jove's bird, swooped down and ran
straight into the tree in full force, BAM!
It ripped through all the new leaves and tore right
through the bark and scattered all the blossoms.
Then it took another pass and swooped straight 115
into the chariot, tossing it like a little sailboat
caught in a storm and buffeted around by waves.

And that's when things got even freakier. Next, a
scrawny little red fox appeared and jumped into
the cart, all ratty, like it was starving or something. 120
Beatrice was quick to shoo it away, and it took
off as fast as it had come on its skinny legs,
and she chided it as it went. The eagle came
swooping down through the tree again and
this time it ran smack into the cart itself, 125
hitting it hard in an explosion of feathers.

And from the sky a voice cried out, like it was
in pain or something, saying, "Oh, little ship,
what a doomed load you must be carrying!"

And that's when I saw the dragon. The ground opened 130
up beneath the wheels of the cart and the fiery beast
thrust his spiked tail up through the bottom of it.
Then, like a yellow jacket pulls out its stinger,
the beast yanked its tail back and tore off part
of the cart's floor before slithering off again. 135

The rest of the cart lay there in ruins, and
even as we watched it started to sprout green
shoots, like the good earth of a harvested field
will quickly sprout weeds. In an instant it was
completely overgrown with a blanket of flowers 140
in less time than it takes to exhale a drag of smoke.

And as if that wasn't weird enough, the ruined
cart began to grow heads! Three sprouted out of
the chariot's pole, and one more on each corner.
The three on the front were all horned like steers, 145
but the four on the corners only had one horn each.
It sounds insane, I know, but that's what it looked like.

And sitting right on top of the whole mess, like a bent
coat hanger antenna plopped down on a rooftop, a beat-up
whore appeared, batting her eyes all slutty and gross. 150
And there was this giant, too, acting all proud and
protective like the chick's pimp or something,
and he would even start kissing her sometimes.

And get this: she started giving me the eye, I swear.
It got the giant so pissed off he started 155
smacking her around right there, and in a total
jealous rage, the giant ripped the whole cart thing
with the heads and everything completely apart and
chucked it all into the woods until the whole mess—
the hooker, the giant, and the rest—was lost in the trees. 160

CANTO XXXIII

ARGUMENT

The seven Virtues sing a sad song from Psalms and Beatrice gets depressed. She snaps out of it and organizes the group and they set off walking through the forest. As they walk she speaks to Dante, prophesying in obscure metaphors that he has trouble making sense of, and she berates him for being thick-headed. She tells him to be sure to write down everything that she has said exactly so that her words can teach the living. They arrive at a spring, the source of the Lethe and the Eunoë rivers. Beatrice tells the lady, named Matilda—symbolic of the active Christian life—to lead Dante to the spring so he can drink from it. She brings Statius, too. Dante writes that he'd love to describe the wonderful taste of that water but that now he's run out of space in the book, and concludes by saying only that it left him feeling renewed and ready for the stars.

"*Deus venerunt gentes*" (here come the heathens),
the seven women began to sing, all sadly and
beautifully, alternating the verses between their groups
of three and four. Beatrice listened, sighing
and deeply saddened, her face looking as 5
pained as the Virgin Mary's must have looked
as she sat at the foot of the Cross. At a sign
from her, the seven virgins stopped their
singing and Beatrice rose and stood and said:

"Soon you won't be seeing me, 10
my kind, dear sisters.
And soon you'll see me again."

Then she directed all seven to line up
in front of her and motioned with her
head for me, the lady, and old Statius 15
to step in behind her. Then she set off.

But before she had taken even ten steps
toward the forest she looked me in the eye
and said, calmly, "Hurry and catch up,
so in case I want to talk to you, you'll 20
be nearby and can hear me better."

And when I came nearer, like she had told me to,
she said, "Now that you're finally with me, brother,
what's holding you back? Why don't you ask me anything?"

Like a star-struck groupie confronting 25
his idol or like someone stopped by
a cop, I was tongue-tied, short of
breath, and barely able to stammer,
shyly, "Everything I need you already
know, ma'am—and how to satisfy me." 30

"What I want is for you to stop being
afraid of everything and ashamed, and
for you to snap out of your daze and speak
clearly. I want you to know that the cart
the dragon broke back there was once and now 35
is not. And the ones responsible for it will
see that God's vengeance is not easily avoided.

"The eagle that once decorated the cart, which
was first a monster and then a prey, will not
remain without his heirs forever. I'm telling 40
you now because already I can see that the
stars predict, not long from now, that a
Heaven-sent five hundred and fifteen
will come to kill the giant and the whore
he sins with. Maybe what I'm prophesying 45
seems as confusing as the riddles of the Sphinx
or of Themis or Emperor Norton and has only
confused you more instead of convincing you.

"But before long, things will happen that
will clear up the twists of the riddle—and the 50
sheep and crops won't be affected. Now,
remember what I've said and be careful to
write it down exactly as I told you when you teach
the living that life is nothing but a race to death.

"And make sure that you write about how 55
sorry looking the tree is you saw ruined not once,
but twice, where it grows. God made that tree for
Himself and for His use only. Whoever steals
from it or defaces it is committing blasphemy
against Him. Because God's first soul, Adam, 60
ate from the tree he spent more than
five thousand years waiting for Jesus to
come along and pay the penalty for it. You'd
have to be asleep at the wheel if you haven't
figured out why the tree's so tall and why 65
it grows bigger at the top than at the bottom.

"Your thoughts must be swirling around in
your head like the petrifying waters of the Elsa
River in Tuscany, or twittering around like birds
in a Bugs Bunny cartoon if you haven't already 70
guessed, just by looking at it, what the tree's moral
properties are—and see the Justice in them. But
since I can see your head is thick like a rock, and
since rocks are dark and the light of my words isn't
going to penetrate them any, all I'm asking is that 75

if you can't remember what I'm telling you, then
at least try to burn a picture of it in your head
and take that back with you, like a souvenir."

"Don't worry, your words are carved in
stone into the rock of my head," I answered. 80
"But why are you talking like that, all
highbrow and formal and so hard to
understand? The more I try to follow
you the more confused I get."

"You want to know why?" she retorted. "Because 85
maybe by my words you'll be able to understand
the school you've been following and see how
its doctrines measure up to mine. And also so that
maybe you'll realize that the ways of man are
as far from Divine as the Earth is from a star." 90

"But I've never distanced myself from
you!" I protested. "I don't have to
feel guilty about that, at least!"

"Oh yeah?" she smirked. "You don't remember?
Well, I'm sure at least you remember having 95
a drink in the creek back there today.
Wherever there's smoke there's fire, and
your lack of memory of it just proves that
your treatment of me was sinful, since it's
now erased. But I promise, from now on 100
I'll spell things out clearly enough for
your simple brain to understand."

By then it was high noon, when the sun
seems to slow to a crawl across the sky,
depending on where you're standing. 105

Then, like the first car in traffic will hit the
brakes if something falls off a truck in front
of it, the group of seven women up front
stopped short as they came upon a shadow
ahead, which looked as cool and soothing as a 110

CANTO XXXIII, 137–140: THE WATERS OF LETHE AND EUNOË:
I could go on and on about
how sweet that water tasted. It seemed
that the more I drank of it I never would
get full.

swimming pool. From there I thought I could
see two streams bubbling up from one spring,
then parting, slowly, almost reluctantly, like
friends who don't want to go their separate ways.

"Beatrice, light of my life, what in Heaven's name 115
is this stream that comes up and then
bubbles off and flows into two?" I asked.

"Ask Matilda to explain," she answered. And
then the beautiful lady I'd been following spoke
up, as if she felt guilty for hiding something. 120

"I've already told him once," she protested. "That
and a lot of other things. I didn't think he'd forget
everything when he drank the waters of Lethe."

"Maybe he's worried about something
more important," Beatrice said. "Maybe 125
he's confused and it's making him forget
things. But now we're here at the stream
of Eunoë. Take him over and let's see
if its waters might wake him up a bit."

And as Beatrice motioned to her, 130
Matilda politely bowed her head,
as if in submission, and took my
hand to lead me. And she said softly
to Statius, "Why don't you come
along with him?" And we started off. 135

If I had any more pages left to write,
dear Reader, I could go on and on about
how sweet that water tasted. It seemed
that the more I drank of it I never would
get full. But this is the last page I've 140
allowed for this second book and so
I've got to restrain myself a bit. From those
holy waters I came out refreshed,
renewed, cleansed, like a tree in springtime,
excited and ready to reach for the stars. 145

DANTE'S PURGATORIO

CANTO XXXIII, 142–145: AT THE TOP OF THE MOUNTAIN:
*From those
holy waters I came out refreshed,
renewed, cleansed, like a tree in springtime,
excited and ready to reach for the stars.*

ACKNOWLEDGMENTS

The sinning is the best part of repentance. —ARABIC PROVERB

Like most kids growing up in the '80s, I had always thought Purgatory was a so-so heavy metal anthem by Iron Maiden. Later I was convinced it was the proper term for any extended, inescapable bummer. But after plowing through this second part of Dante's *Commedia*, I'm sure that Purgatory is ultimately a place of hope and transition, made bearable not only by the promise of Heaven, but also by the companionship of other semi-lost souls wandering up the Mountain.

Sandow Birk and I have been semi-lost and wandering companions on three continents now, and this entire daunting undertaking would've never happened without his initial spark and fire. "We can do it ourselves," he grinned behind a pint glass a couple years back—and we're just about there.

Brother Michael Meister of Saint Mary's College was our spotlight on the Mountain. Our literary guide through the terraces of the *Purgatorio*, catching our falls before we could see them, his decidedly nonjudgmental sense of humor at our occasionally overliberal adaptations helped ease any lingering childhood Catholic-o-phobia.

Everyone at Trillium Press deserves much thanks.

Indispensable professional advice and encouragement came from Eleana del Rio in Los Angeles, Catharine Clark and her gallery in San Francisco, and Alan Rapp and Stephanie Hawkins at Chronicle Books.

Other companions who've helped with suggestions, advice, or directions include Greg Bellatorre, Jamie Brisick, Marcos Cortez, Shea Gentry, Ryan O'Donnell, Paul Piscopo, Jade Hays, Ted Verdi, Matt Walker, and Matt Warshaw. And Heather Goodman's light has proved invaluable.

Special thanks also to Steve Luczo, who made the Trillium Press version of this book possible.

As wonderful as it's been, Purgatory can't last forever—thank you all for this particular trip up the Mountain.

—MARCUS SANDERS

COLOPHON

ABOUT THIS EDITION AND THE DIVINE COMEDY PROJECT

This book is the trade edition of Sandow Birk and Marcus Sanders's *Dante's Purgatorio*, originally published as a limited-edition, leatherbound book by Trillium Press in 2004. The Trillium edition is illustrated by 73 hand-pulled original lithographs from drawings by Birk, and was printed in an edition of 100. Trillium has published a deluxe edition of *Inferno*, and will produce *Paradiso* in 2005.

Trillium Press is a collaborative printmaking workshop located in Brisbane, California. Since 1979 Trillium has been producing fine art limited-edition prints with established, midcareer, and emerging artists. Trillium graciously provided the prints from which this Chronicle Books edition was created.

Prints and paintings from *Purgatorio* were displayed at the Catharine Clark Gallery, San Francisco, from January 8 to February 14, 2004. The San Jose Museum of Art is planning a major exhibition for the complete *Divine Comedy* for August 2005.